THAT'S THE WAY IT WAS

THAT'S THE WAY IT WAS

STORIES
of STRUGGLE, SURVIVAL *and* SELF-RESPECT *in* TWENTIETH-CENTURY
BLACK
ST. LOUIS

VIDA "SISTER" GOLDMAN PRINCE

THE
History
PRESS

Published by The History Press
Charleston, SC
www.historypress.net

First published 2013

Manufactured in the United States

ISBN 978.1.60949.970.9

Library of Congress CIP data applied for.

In memory of my parents and son

Vida Tucker Goldman
Myron S. Goldman
Lawrence E. Goldman
Ronald Stanford Prince Jr.

In recognizing the humanity of our fellow beings
We pay ourselves the highest tribute.
—Thurgood Marshall

CONTENTS

ACKNOWLEDGEMENTS

The greatest debt of thanks goes to the men and women interviewed in *That's the Way It Was* for their honesty, courage and compassion.

The Missouri Historical Society, now known as the Missouri History Museum, was instrumental in the creation of *That's the Way It Was*, specifically Kathy Corbett, Eric Sandweiss, Tim Fox and Candace O'Conner, who all helped shape this book; with special thanks to Mary Seematter and Emily Jaycox.

George Lipsitz is professor of black and sociology studies at the University of California–Santa Barbara and chairman of the board of directors of the African American Forum. His insight, generosity and encouragement motivated this book beyond words.

My appreciation to photographers Jennifer Colten, Nate Warren and Maurice Meredith.

I am grateful to Karen Levine Coburn and Frank Hamsher for their valuable suggestions.

My heartfelt thanks go to Walter Lee Hayes, Catharine Weston and Eula Flowers.

Doris Gordon Liberman, my friend and my editor, believed in my work. Her encouragement, her skills in editing and her high standards and knowledge of how to prepare a book for publishing have been indispensable to me. Together we worked with love for the words in this book. I could not have done this without her.

The technical expertise of Granddaughter Tess Prince is evident throughout this work.

To Grandson Tripp Prince, my thanks for listening to these stories like his father did.

My husband, Ronnie, became my editor-in-residence. It is hard to imagine completing this work without his keen comments and suggestions

I thank my children, Patti, Ronnie and Susan, and all my grandchildren for their interest and support.

What a grand journey this has been.

INTRODUCTION

The heart of this book grew out of the words of Marian O'Fallon Oldham, a civil rights activist and civic leader, during an oral history interview I conducted with her on July 6, 1987, for the exhibit "I, Too, Sing America: Black St. Louisans in the 1940s" at the Missouri Historical Society. Talking about her early life, Marian described the segregated conditions in downtown St. Louis when she was growing up:

> You have to understand that there was no restaurant where we could eat except a black-owned restaurant. There were no theaters, no movie houses where we could go except in the black community. I think there was not a time that I did not go downtown to, let's say, buy a pair of shoes or dress or something that I did not want to go places and do things that were forbidden to me. When you pass an eating counter naturally you want to eat—particularly children—so I think from a tiny child on, your parents try to shield you from lunch counters, because they know and you know. But there is a hurt and there is a feeling of being less than human.
>
> I think it was marvelous the way our parents went ahead with life and made something out of themselves and their children and had a reasonably healthy existence, despite the real outside world.

As I walked to my car after the interview, my mind was racing with questions. I felt compelled to know what Marian Oldham's words really

meant. What *was* the real outside world? How did the children who lived in that world learn who they were and what were their parents saying to them?

In a telephone conversation with Marian a few years after the oral history interview, I discussed my desire to do an oral history project concerning racism in St. Louis in the twentieth century. Marian replied, "I believe in history, but you know what St. Louis needs—a place where all kinds of people can come together and get to know each other." I hung up the phone realizing that finding the way to get to know each other is the responsibility of each individual person. My way of doing what Marian hoped for was to create a venue—this oral history project—that would open a door to the lives of blacks and how they felt about *the way it was* at that time.

This book is an oral history of thirteen blacks who were born in St. Louis during the first half of the twentieth century. They describe how it was to live in a city that was called "the most southern city in the north." Segregation was a way of life. The climate of St. Louis, the laws—written and unwritten—and the customs of the city governed every aspect of the lives of blacks, including where they were born, where they were allowed to live, their education, their occupations, where they worshipped, where they spent their leisure time and where they were buried.

These oral histories paint a portrait of how parents and children interacted with one another as they faced the pervasiveness of racism in their daily lives and how parents coped with the dilemma of protecting their children from the harsh lessons of that world while at the same time preparing them to live with what they had learned.

This collection also reveals the tradition of respectability and self-respect that runs through the generations of working-class blacks and arms young people with the determination and resilience they need to cope despite the real outside world.

The memories of the thirteen blacks interviewed for this book provide the groundwork for examining the fact that people not only lived this kind of life but also how they felt about *the way it was* as they learned to negotiate in white urban St. Louis.

The people profiled in this book saw themselves as reflections of how their parents and their own communities defined them: with strong bonds of love and protection, discipline and respect. They also live with the reflection of how the world outside their communities defined them—the prejudice, segregation and discrimination that quietly scarred them. They carry the lessons of their parents along with the pain of feeling unwanted. And each

in his or her own way passed those messages on to his or her children, community and the city of St. Louis.

The people I interviewed for this book have become part of my life. The author David Halberstam, in a PBS interview with Charlie Rose, said, "You are who you interview; it changes you, enhances you and makes you larger."

During an interview, Salimah Jones told me, "My father always used to talk about black history and that the last thing he wanted was for somebody white to write his history." I replied, "You mean like I'm trying to do? But this history is going to be in your words."

Landmarks East and West of Grand Avenue in St. Louis, Missouri

Grand Avenue: A major north–south thoroughfare in midtown St. Louis.

West

The Ville: Originally known as Elleardsville, this segregated, self-contained black residential community in north St. Louis has been called "the heart of black culture" in St. Louis.

Sumner High School: A segregated black high school located in the Ville.

Stowe Teachers College: Stowe, a segregated college formerly located in the Ville, merged with Harris Teachers College in 1954. It is now known as Harris Stowe State University and is located at the original site of Vashon High School.

Tandy Community Center and Park: Located in the Ville, Tandy Community Center and Park provided recreational and educational facilities to the black community.

Homer G. Phillips Hospital: This segregated black hospital in the Ville offered medical care and training for over sixty years. The hospital closed in 1979.

East

JEFFERSON AND MARKET STREETS: This intersection marked the location of a large black community; it largely disappeared with clearing of the so-called Mill Creek Valley in the late 1950s.

VASHON HIGH SCHOOL: For the period discussed in these interviews, Vashon High School, founded as an intermediate school in 1927, was located at the present site of Harris Stowe State University. It later moved to 3405 Bell Avenue.

THE PINE STREET Y AND THE PHYLLIS WHEATLEY YWCA: These were the only Christian associations open to African American St. Louisans. Both were located in the Jefferson and Market area. The Pine Street Y also had a storefront branch in the Ville.

CARR SQUARE VILLAGE: Originally an integrated, low-income housing project, Carr Square Village is now an all-black project.

PEOPLE'S HOSPITAL: A segregated black hospital.

SCRUGGS, VANDERVOORT AND BARNEY; FAMOUS BARR; AND STIX, BAER AND FULLER: White-owned downtown department stores.

Excerpts published in the Missouri Historical Society's spring 1997 Gateway Heritage *vol. 17, no. 4, pages 14–29, "That's the Way It Was."*

That's all any story is. You catch this fluidity which is human life and you focus a light on it and you stop it long enough for people to be able to see it.
—William Faulkner

RICHARD A. MARTIN JR.

Richard A. Martin Jr., nephew of Josephine Baker, was born in St. Louis in 1929 and became a tap dancer and founded the Children's Performing Arts Academy.

EARLY HISTORY

My name is Richard A. Martin Jr. We are at least eighth generation here, in St. Louis, on my mother's side. Her great-grandmother was born here. She was part Irish and part Indian, and she married an African American; she married a colored man. They had children and lived where Kiel Auditorium is today.

Then on my father's side, which included Josephine Baker, they were Africans. There was no integration in that. My father's father was named Carson. My grandmother and grandfather were performers; they married, they performed, he left her and she divorced him. And when she divorced him, she married Martin. They came from Arkansas, but her parents were born here. Josephine Baker was my father's sister.

During that period of time, there were integrated neighborhoods in that area there. The Germans were in south St. Louis, the Polish were in north St. Louis and the colored people were right in the downtown area, by the Mississippi River. We're talking about, at the latest, 1800s. Because, don't forget, Scott Joplin and the jazz and ragtime music and everything started

right there in Texarkana, Texas, *really*, and then came to St. Louis on the Mississippi River.

St. Louis, Missouri, is a wonderful city where all this American ethnic togetherness and development and creation of music and dance began right here. St. Louis is something because it was a city that opened up for migration. My grandmother told me that her grandmother and grandfather sailed down the Mississippi River from Ohio in a canoe. Her grandfather was an Indian, and her grandmother was Irish. They couldn't marry in Ohio, so they came here and married.

DIFFERENT COLOR FLOWERS AND GROWING UP WITH PRIDE

I have always lived in a segregated area, but I always knew there were people whose skin was a different color than mine because my grandmother always told me of the different colors of people. It didn't mean anything. Just like my grandfather said, that we were colored because we were just like flowers, so I look at people, at people of different colors as part of the flowers. I really mean that. I didn't see any weaknesses or strong points or any special gifts, you know. They were just colors. I was not aware of segregation. I'm right here in St. Louis, and I was not taught that. I was aware that when we used to go downtown, there were certain areas where we couldn't go. That didn't bother my parents because we had our own. We didn't put ourselves in the position of being rejected. We went to our own movies. There was the Star Theater, the Comet Theater, the Strand Theater, the Criterion Theater and the Regal Theater. This is in Mill Creek, a little bit of north St. Louis where they now call the street Dr. Martin Luther King. Now that was the black neighborhood over there, the colored district. I was born in the City Hospital #2 for colored people; I think it was #2. City Hospital #1 was for whites. I'll have to call my mother. She'll tell me which one is black or white.

We had little businesses on Easton and Franklin and on Market, where I lived, and on Jefferson Avenue to Ewing and then to Grand. All the way over to Park was the colored neighborhood, the colored district. The neighborhood extended all the way downtown. I had a wonderful childhood. I had discipline. In that area, we were family, colored people had the extended family tradition. There was no such thing as relief or anything like that. Everyone pitched in and helped each other. So I had a wonderful

environment. I went to church and Sunday school. My mom would take me out in Kinloch. My mom's grandmother owned property out there, and it was like a farm. We saw chickens, pigs and cows. And we used to go to different playgrounds. We used to go to the movie houses downtown. Yes, I led a segregated life, but it was a segregated life as an extended family. We did not know what prejudice was. Our parents did not teach us that. We had our own little businesses, little stores and restaurants. We had our own schools—we had dancing schools, music schools—we had our churches.

We were downtown people where the Union Station is, where all the businesses were and my school, the Lincoln Elementary School, built in 1867. Lincoln School had wonderful, educated colored people. They were dedicated, they had degrees and they taught us and gave us the inspiration to respect yourself and your family and to study hard. They told us that we were Americans and we had the rights to get anything that we wanted, but we had to work for it. That's what I was taught. And that's what they taught. If you could just meet them [holding up the Alumni Association booklet], you know, they mention all the old folks here, the old friends of Lincoln Elementary School. They decided to develop a social entity that will bring remaining friends together other than at funerals. Lincoln went from kindergarten to eighth grade. I sent my children there.

When I was growing up, you could only attend two high schools: Vashon High School, which is on Laclede, which is now Harris-Stowe State College but was Vashon High School, and Sumner High School in the Ville. I attended Vashon High School for one year, and then they opened up Washington Technical High School, which was a vocational school on Franklin Avenue, the only one in the city for colored children. I changed schools because my father and mother always said you needed skills, so they wanted me to go there. I learned how to do shorthand, bookkeeping and clerical work. Because during that period of time they were hiring, beginning to hire, coloreds in different businesses. I felt fine about changing schools because most kids had the same kind of background that my parents were trying to give me. They wanted skills in mechanics, auto mechanics, skill in carpentry and cooking. This was June 1943. Then I went to Tucker Business College in '43 to '46. I was seventeen and eighteen years old then. And they made it clear to me that there were opportunities available, opening up for people who were qualified. You have to have the skills in order to do these things.

During that period of time, we had Homer G. Phillips Hospital for colored people. They had a nursing school, all for colored people. There was People's Hospital, right on Locust, which was all colored people. And

it was in that way colored people had an opportunity to open the doors for themselves and prepare their youngsters for skills to go into these businesses.

I felt pride, not that we were in any way competing with anyone. We were not competing. We were not competing with whites. We were doing things that we wanted to do. We told ourselves that we could do it. The same way that I founded the Children's Performing Arts Academy because I saw in my background talented disadvantaged and low-income African American children that had the talent, but there was nothing open for them. And I came in and I started working with them, and I've been working with them since 1985. What I say to my kids that they got to respect themselves and respect other people. During that period of time, 1985 and what-have-you, that's when we were having this "black is beautiful" and all of this kind of foolishness. We were not taught that. We were taught that we were beautiful people. We never put color to it. You know, this is what we can do. It's got to be upon yourself and working together. When things were segregated, we had a lot of pride and people learned to pick themselves up and go and do it. We did not know what segregation or discrimination was.

No Place to Go: Integration

Now there is integration. And these children had no place to go. And there was no place to go because we, as an ethnic group, we'd stopped having our own businesses. We started saying, "We want what you got." You know, *we* had it all the time. And by not breaking down that urge of respect for yourself and not hate for anyone else, by stopping that, we stopped having those things. Look at today. We don't have Lincoln Elementary School here that we were proud of. We kept it clean. There were no crimes in the area, and we did not say that because we were black or what-have-you. We could not get those things. And that's the great big difference.

I'm not saying that segregation in itself is right. What I am saying is that because of it, ethnic groups were beginning to know how to develop and create within themselves. That's what I'm saying. You can see today, there are very few black businesses in St. Louis. You know we don't have a hospital anymore. We do not have nightclubs, some restaurants, but we don't have the integrated thing.

We got the integrated system, but the integration has prohibited those developments of different ethnic groups, not respecting one's traditions.

That has stopped being developed. Also one's identification, their ethnic background has been more or less overlooked. For example, integration has destroyed the neighborhoods, where the neighborhoods do not have their own businesses. It is a price to pay for integration, so how can we keep the pride that we had before integration and now live with integration? First of all, before you love anyone else, you must love yourself. And if you love yourself, then you will accept your weaknesses as well as your strong parts. And people can work together that way.

The first time I came in contact with segregation was in 1946, when I went in the service and was stationed at Fort Knox, Kentucky. There were not too many blacks, coloreds, in the service at that time. We were volunteering then. They didn't have, they were supposed to have, but they didn't have segregation in the barracks. This white kid and I decided to go swimming one day in the pool. When we started swimming, one white boy came and said, "No! Black fellas cannot swim at this swimming pool." This white boy and I got very upset. We went to the commanding officer and explained to him that we wanted to swim together. From that time on, they opened up the pools for all of us to swim.

Children of God

My aunt, Josephine Baker, look what she did! She left here at thirteen years old and traveled all through the South and then went to New York. Having Josephine Baker as my aunt has meant that I can do whatever I want to do. That's number one. She gave me the example that all people are people. You know she adopted twelve children. I was able to teach my kids the same way. We love people. And that's what Josephine Baker meant to me. And number two: I have inherited some of her talent. I dance with Irish people, I dance with African people, I dance with all these ethnic groups because they are all similar. They happen to be children of God. And I copy from them and I use exactly what could be used the way my aunt did. That's why she was able to adopt all those children and was able to learn how to speak several languages.

I saw my aunt, Josephine Baker, in 1936 and then I saw her in 1951. I performed with her at the Chicago Theater in 1951 and then in New York in 1973. She came here to St. Louis in 1936 to fight segregation. But she came here to fight segregation with love. She didn't say, "Separate," she said,

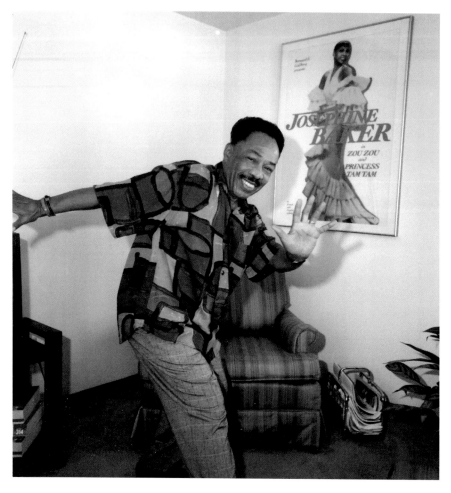

Richard A. Martin Jr. in his home in front of the poster of his aunt, Josephine Baker.
Courtesy of Richard A. Martin Jr.

"Let's come together, we're human beings. Let's love." She performed at Kiel Auditorium and would not perform to a segregated audience. She did it free to desegregate the schools for money and housing. She wouldn't dance unless everybody could come.

My father was an entrepreneur. He was a vendor. And he used to work at one of these coal yards taking coal off the trains and delivering them to businesses. He saved his money and bought his own trucks. As a matter of fact, when my aunt came here, she bought my father two trucks.

Richard A. Martin Jr.

I Danced

When I lived on 23rd and Eugenia, I learned how to tap dance…I watched the fellas in the neighborhood do the shuffles and tap dance and I copied them. Then I got a pair of shoes and got taps on them and I would tap dance. And then I'd learn by tap dancing I would make money. I learned that by shining shoes, so that was during World War II when I went down to the Union Station, I could get money. So, I did that with my buddies in the neighborhood. I danced to sell the shoeshine. I was eight years old when I started that. Now the same way you see kids today get out and they do their rapping, we did tap dancing.

I used to dance on the playgrounds at Lincoln School and L'Ouverture School. You see, I had a dancing teacher, Mildred Franklin. She had her studio at 4062 Cook Avenue, but she also taught in the public schools on the playground. She was a phys ed teacher. She would take me to perform in the different schools throughout the city. We had the YMCA, and I danced and performed in the Pine Street Y. See, we had all these things, colored people coming together developing annual competitive pageants, raising money funds for scholarships, creating parades, the Annie Malone parade, the YMCA had a parade. We did all those things within our own neighborhood. And we had very little crime.

I danced downtown at little taverns, the Red Bud Café, from Scott Joplin, yes, Charley Turpin and the Booker T. Washington Theater. I can remember that theater when I was a little bitty kid. We used to see the stars come into that place, like Bessie Smith, I saw her. The Turpins owned that place. I saw Stepin Fetchit, you know, he had the caricature of comics. I saw Louis Armstrong, Count Basie, all of those people came into the area. I was too little. I had to have my parents take me into that area. But they tore down that theater and put in a filling station when I grew up.

During that period of time, they called it the TOBA Circuit, and I think my aunt, Josephine Baker, performed on that. They said, "Tough on Black Actors" or something like that. That was the circuit in vaudeville in those days, TOBA. I'm just reading a book about Bill Robinson on that. That means they didn't get paid that much. That was the name of the agency. TOBA. They would book people through TOBA. I was too young; that had stopped. I didn't have to go through that.

The American Theatre was a segregated place, but my dancing teacher, when Bill Robinson was there, made it possible for me to come in to dance with him. When I was a little kid, and I did not, and once again, I did not

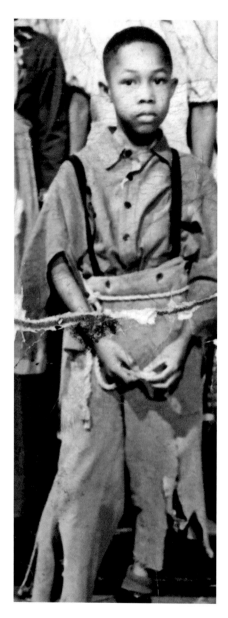

Richard A. Martin Jr., six years old, danced on the stage at the St. Louis Municipal Opera in Forest Park, 1935. *Courtesy of Richard A. Martin Jr.*

realize that it was segregated because I went in the Theatre with Bill Robinson. I understand that we had to go in the back if we wanted to go to the Theatre—in that Theatre. But it didn't—it was not that important to me. I don't know why. I didn't understand. I just thought that all performers were supposed to go in the back.

I danced with Avon Long in *Showboat* at the Municipal Opera. I got a picture of myself when I danced in *Showboat*, and these are the words under the picture: "Richard A. Martin Jr., at six years old, when he performed in *Showboat*, in 1935, dancing on the stage at the St. Louis Municipal Opera in Forest Park, dancing with Mr. Avon Long, a noted African American jazz and tap dancing performer who was the Harlem Cotton Club tapping star."

My dancing teacher, Mildred Franklin, made that possible. She was like a second mother to me. Once again, we had that extended family, and teachers were like mothers or aunts. And it made such a great big difference.

Mildred Franklin taught in the schools in East St. Louis because they didn't have a teacher with her background there. She not only taught tap, she also taught ballet. So she would make appointments and set up dates for her St. Louis kids to come and perform there. That's how I got to perform in East St. Louis.

And Mrs. Franklin would take us to perform on the boats. They used to have boats that were owned by colored people, and they would have these dances and we would go and perform as a show for only blacks, not white audiences. I won't call this segregation. You know, it was an ethnic togetherness. It was a tradition. There were stories told. We knew each other from one generation to another. If it was segregated, it was segregated in such a form of developing one's ethnicity.

It Was About Time

I founded the Pruitt-Igoe Jazz Tap dance classes with sessions held at St. Bridget's Catholic Church, right on Jefferson; Pruitt and Igoe Community Center. You see, in the Mill Creek area, downtown, before the highway came, they sold property and the colored people had to move from that area. Let me tell you what most of our people in our neighborhood thought. We thought it was about time they're going to tear this down and put us in a better place. We moved together. We did not know that it was bad until other people [started] saying it was bad. We thought that the city was doing something good for us because we were all moving together. I believe this was the 1950s and 1960s—during that period of time. This was about the time they started to tear all this down.

And when people moved from that area, Mill Creek, they went to Pruitt and Igoe. We could have moved to the West End, yes, but most of my neighbors and my friends and family moved to Pruitt and Igoe. My mom, she sold her home and she moved in Carr Square Village across the street from Pruitt and Igoe. So when the families moved together, it was easy for me to form a dancing school at St. Bridget's Catholic Church.

I Was Not Taught That Way

How do I feel about race relations today in St. Louis in 1993? I feel there is a lack of understanding, and that lack of understanding has been brought about by the disassociation of identity. And I think that's what the problem is. Everyone, especially the coloreds, seem to want to be separated in such a way that they are superior, and that they may have been downtrodden and

you know they have developed a mistrust, I think that was taught them. I think colored people were taught that by both black and white. They were taught that they were different and by being different there was a separation of opportunities and what-have-you.

When I was growing up, I was just not taught that way. My generation was in the same generation of Dr. Martin Luther King. Now, Dr. Martin Luther King, you know, was against discrimination, but he was against it with love. There was no hatred there at all. He was asking for all of us to come together, and most of the Americans did come together, did they not? Yeah—and I think this is what is lacking today.

My perceptions have not changed through the years. I have worked with Helen Shannon, who is an Irish jig dancer, and we have started having performances combining our students and together, showing the similarities, but yet the differences of Irish jig dancing and tap dancing. Now, tap dancing is an art form that was developed by Irish and African American men. The Irish use stomps and shuffles; they relevé and they use little dots of stuff imbedded in the shoe for the cleating sound. Well, what we did, we put taps on—and we developed that here in this country.

The Irish children were taught to love themselves, and when they love themselves they learn their traditions and they are willing to share. And that is the way I was taught and the way I teach my students—to have a sense of pride, along with the dancing and to learn to feel good about themselves. You will also see that in my aunt Josephine Baker's dancing and her singing—to love people and to share.

Chapter 2

PEARL SHANKS

Pearl McFarland Shanks, born in 1926, worked for the Urban League for more than twenty-five years and then for the Vaughn Cultural Center. She received the Marie Williams Staff Award for outstanding service in 1987.

EARLY LIFE

I lived at 3515 Clark Avenue, between Theresa and Grand Avenue. I lived right there in Mill Creek, which extended east from Grand all the way down to Union Station. I lived with my father, my mother and two older brothers, Raymond Jr. and William. At the time, we didn't know it was Mill Creek. I didn't know we lived in a ghetto. When people say "ghetto," first thing that comes in your mind is *black*; you're in a nasty neighborhood; you don't know how to act; you throw paper on the street; you don't know how to do *anything*. The journalists and the people in the city said that it was a slum. We didn't know we lived in a slum. We had a very nice neighborhood, very nice people there and our houses were clean.

In the early '30s, there were three or four white families on the block. White flight had already begun, but we didn't know it at that time. We were not saying "black" then, we were saying "colored, the colored people." There were Irish, some Dutch and a lot of Catholics because of St. Xavier's College Church on Grand Avenue.

I guess we were considered poor, working poor, but my father always had two jobs. He had finished the eighth grade in school, and he was a janitor and a bartender and would serve parties and bar mitzvahs. I remember the Depression. That was hard times, but we always had food. He was a good provider and always took care of his family. My father never wanted me to work as a domestic. He used to tell me, "I don't want you working in white people's kitchens. I know what goes on there."

My mother was smart, very smart, an educated person. She was a jack-of-all-trades. She was graduated from Miles A&M College in Huntsville, Alabama, in 1906 and majored in music and home economics. She taught school in Oklahoma and Alabama. She couldn't teach school here because at that time, you couldn't be married and teach. She gave music lessons in our home and was an organist for many black churches in the community and played for a number of the early well-known gospel singers.

During the time there was a WPA [Works Progress Administration], my mother took a job doing domestic work. I would hate to see her go off in the morning to that job. My mother had a smart mind, but she had to work for rich white people. She would work about two days a week. My mother could always make something out of nothing. She made my clothes; she could make coats that looked like store-bought. She could manage. It's not like today. My mother and father were hardworking. I was brought up with a washing machine, a telephone, a Frigidaire and lights.

We lived next door to the Donahues. They had three sons: Jimmy, Eddie and Randall. Eddie was my brother William's best friend, and they would play. I didn't play with them too much 'cause I was the only girl, but I knew them. We would talk over the fence, but my brothers would play because they were boys. They would come and sit on our porch and play in our backyard, and sometimes Mrs. Donahue visited with my mother in our kitchen. My mother lent her a coat one time.

My brothers would go the show on Saturday for a nickel. Everything was segregated, so they would go to the Strand down by Union Station. They would see all the chapter plays* and Tom Mix. Eddie would always want to go to the show with my brother. And my brothers would ask, "Eddie, why can't we go to *your* show?"

The Fox Theater was just on Grand Avenue, but we didn't pay too much attention to that because they were friends and playing, so everybody got along together. But that stuck in my mind.

* These were movie serials that were shown for children every Saturday at local theaters.

Pearl Shanks

Goin' South

The first time I knew about racism was when I went to Newport News, Virginia, to visit my grandfather with my mother and my two brothers.

My father did not want to go down South. "Don't take the boys down South," because he said he would get in trouble if something happened to them.

We went to Virginia on the bus, and we had to change to get in the back of the bus, and I heard my mother say, "Oh, we're going across the Mason-Dixon line." I was wondering why we had to go to the back. Well, it was okay. I didn't think too much of it because they made us have the long seat in the back and all of us could sit in the long seat, so of course that didn't bother us.

But then I saw the other people get back in the back of the bus, and that's when my mother told me, "You're goin' down South, the Mason-Dixon line, this is where the colored people have to stay."

And when we would come to the bus stop, and they had black and white toilets, she told me about Jim Crow. I had to go to the toilet, real bad, and had to wait. You see, that's the way it is down South. Just stand up and wait.

My mother had a basket with our lunches, but we had eaten most of it, and when we got to this stop, my brothers wanted to buy a sandwich. We had to wait so long, until all the whites were served, and my mother said, "Just forget about it, because we have some fruit and stuff left until we get to Virginia." And that's when I found out I didn't like it for us to get out of our seat to get to the back of the bus and then go to the colored restroom. And she explained to us what was happening down South, that it's all these different things. When you're colored, you have to follow this line and do as you're told. We asked her why, and she said, "That's the way it is. That's the way white people act." I didn't like it.

We got down to Virginia. My grandfather stayed in a nice house and there was an ice cream store, so we said, "Well, can we go uptown?"

My mother said, "Yes."

We were just going to go walking. We were walking nice, and we would always clean up. In the summertime, your parents would always see that you'd put on your nice fresh clean clothes, and if we were home, we would sit on the porch. And so I was going uptown with my brothers to get some ice cream. We did not know we were doing the wrong thing. We opened the door and we ran in the store.

People were standing in there and my brother said, "We want some, we want an ice cream cone."

And that man said, "You get out-a here, you big black nigger!"

And we *flew*. We ran out of the store. We looked at each other and we ran. We were so scared, and when we got home, mother said, "Where's your ice cream?"

"That man told us to 'Get out-a-the store you big black nigger.'"

My middle brother fell and broke his tooth. My father found out about it, and he told my mother to send them home, and so they left. She put my brothers on the bus and I stayed; they didn't like nothin' about the South. They didn't like the cooking; they didn't like *anything* about it. Because my mother was coming to see her father, the neighbors would bring us all the food, and it was the first time I ever tasted prune ice cream. The neighbors were so nice, but my brothers wanted to go back home. I liked the part about the friendship of the neighbors, that was very good, but I didn't like that part of the, I didn't like that, how my brothers ended up, 'cause we were really scared. We were *terrified*.

That's when I found out about racism, because I was about ten years old and my mother was telling me about how certain people can try to make you look silly—pat you on the head, rubbing your head for good luck and things like that, always want you to smile and grin in the face. "Just look a person in the eye when you're talking to them, you know."

She explained those things to us, and it stays with me today.

Sᴛᴀɴᴅɪɴɢ ᴀᴛ ᴛʜᴇ Eᴀᴛɪɴɢ Cᴏᴜɴᴛᴇʀ Dᴏᴡɴᴛᴏᴡɴ ᴀᴛ McCʀᴏʀʏ's

When I was small, about ten years old, they had the eating counter downtown. I think it was in McCrory's dime store on the corner of Broadway and Washington. My mother would take us there, and it was so crowded. There was this long counter with stools. I said, "Mother, let's get a seat over there."

"No, you can't do that."

"Let's."

"No, that's only for whites."

And near that long counter with its stools my mother said we couldn't sit on was a freight elevator. It had been cleaned out, and there were two or four wooden school desks in it, and if you were lucky enough you got to sit down

there to eat. And then they had a little counter for coloreds, and people would stand around the counter there in the aisle.

You had to say, "Well, yes, I want a hamburger, I want this, I want that."

Then people would hand it back to you and you stand right there and you eat, and you block that aisle full of people trying to go to the counter you couldn't go to.

Passing

I was in grade school, eighth grade, and I was walking on Grand Avenue with my friends. It wasn't far from where I lived on Clark Avenue; just around the corner. We were walking toward the Fox Theater, and we saw one of our teachers standing in the line. We didn't speak to her, but we knew she was passing for white. She looked at us and we looked at her, and we left. We went on and she stood in line. It was a shock.

We said to each other, "Didn't that look like, didn't it…was that…do you think…that *was* her, that *was* her!"

You stand, you're looking and then you go on, but you *know*, you *know* what you saw. Black people did pass. Many times they did, many times. I knew of a girl, a mulatto; she was half-white, and she was working in a place downtown where they didn't hire colored. I saw her and knew she was passing and didn't want to be given away.

We would never think of calling out to our teacher. It would be embarrassing to the person. You knew you were not supposed to go to the Fox. You knew that you had your place. There were many people that had relatives that were fair-skinned and they didn't pass so, no, no, no, no, I wouldn't call out to her.

When I saw my teacher at school, it was never mentioned. You didn't mention anything like that. I knew someone at school who was very, very fair—she looked white. When we graduated, I would see her working in certain places where you knew they didn't hire black people. It's okay with me if that's the way she could get a job up in the big office. That was before the so-called affirmative action, of course.

Some people pass so they can be treated like everybody else, so you don't hold that judgment about them sometimes passing for white, the ones that really look white. The main thing they crossed over to white was to have a job. That was the main thing; it wasn't social, it was economics.

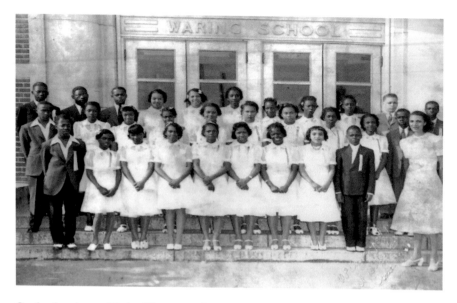

Graduating class at Waring Elementary School in 1941. Pearl Shanks is in the second row, second girl from right. *Courtesy of Pearl Shanks.*

And when you passed, you were treated fairly. You were treated like a human being. You were respected more than if you were black. You felt part of your country. You felt part of America.

When I was a teenager in the '40s, I would ride the streetcar downtown. St. Louis wasn't like the South that I remember where you had to go to the back of the bus. But if there was a vacant seat and you just sat down and all of a sudden the white person gets up, and you know you're not doing anything, you notice it and say, "Ummm, okay, if that's the way you want to do it, stand."

This wasn't Jim Crow, although it was racism here. But just that little bit, you know it was really ignorant. Whenever anybody would get up like that, the other colored people—that's what they were saying at that time—would look around and say, "Hum, well."

Or if there was a seat beside somebody and there was a place for a white person to sit and they would rather stand—well, not all, not all, no, not all people act like that. But just like it is today, some people.

THE TOM POWELL POST NO. 77

The Tom Powell Post No. 77 was the colored American Legion post. See this picture, there's some history there. My brothers, they were teenagers. It was a good feeling because it was a select group of young men, and their fathers had to be veterans and so just anybody could not pop up in there. You had to be the son of a Legionnaire. And when you belonged to the Tom Powell Post, you were a member of something special. Believe me, you were proud to put on that uniform of the Drum and Bugle Corps. They would practice every Saturday over on West Belle.

In the later years, when World War II started and the boys started going to war, that was when the girls got in. I was in it then. The boys handed the tams and capes down to us. The first time we marched we had about twelve girls, and we marched in the parade behind them.

Ours was the only colored unit in the Armistice Day Parade, which is now the Veterans' Day Parade. Everybody would look forward to that. The colored unit would always be at the end of the parade, and they would

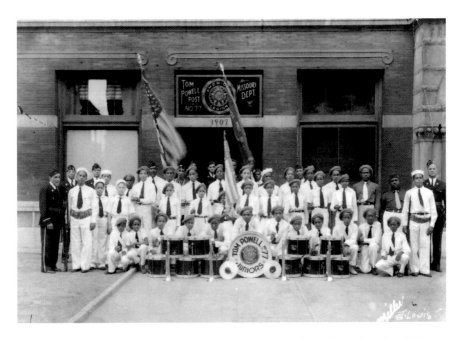

Junior Legionnaires, thirteen to sixteen years old, in 1936 in front of the Tom Powell Post No. 77 Headquarters, 3907 West Belle, where they held dances and social functions. *Courtesy of Pearl Shanks.*

Former Junior Legionnaires of Tom Powell Post No. 77 after World War II at their informal social club. Raymond Shanks Jr. is in the back row, third from right. *Courtesy of Pearl Shanks.*

always stand there and stand there and stand there. Every time they would be on the tail end.

And then one time they did lead the parade. That was an honor. Ah, you feel proud; you feel so proud when they lead the parade. At this time, they were the first and only colored American Legion Drum and Bugle Corps in the state of Missouri, and one year they took the American Legion State Championship.

They were a crack Drum and Bugle Corps. They really were.

THE VEILED PROPHET

We lived just a few blocks away from the dens on Rankin; that's where they stored the floats for the parade. We were little kids then, and we were excited about the floats. I won't lie about that. The parade was good, and my mother would always take us to see it on Olive Street close to Grand. We

would stand in the front row and look and wave at the guys on the floats. A lot of people from the south side would come over, so it wasn't an all-black crowd. We would wave at the clowns and they would cross over and shake a white hand and cross over and shake another white hand.

My mother said, "Put your hand down. Put your hand down. They don't want to be bothered with you."

And they didn't. That was just a snub. When you have your hand out and the clowns come by near you, I know they can't shake every kid's hand, but a lot of times they just didn't want to take my hand; that really made me feel bad. I didn't like that. The only colored people in the parade were carrying the number signs telling you #1 Float, #2 Float.

The ball was beautiful. My mother dressed some debutantes for the ball, you know, the big rich. She would go there to button them up. When you worked for rich white people, they asked you to do things if they had a good girl*—you know, a *good* girl.

My mother told me, "Those are the big, rich people and their daughters, the businessmen, the commerce of St. Louis. The Veiled Prophet is the biggest mover and shaker, and you won't ever see his face. You won't ever know who's behind that mask or who would be the Queen of Love and Beauty."

When I got older and saw the Queen's picture in the newspaper the next day, I would say, "She's not my Queen of Love and Beauty," but as a child, I loved the parade, I loved the lights. I loved all of that.

We always had to draw a picture of a float when we would go back to school the next day. Percy Green† changed all that, and it was great.

COLOR IN THE TEAROOM

Discrimination based on skin color was probably about the same at Stix and Famous. But I do know at Famous, in the Tearoom, most of the "colored girls"—I'm saying the word going back to that era—most were coffee-cream color to medium brown. This is how we distinguished each other.

* A good worker, presentable, who was favored by her employer and who "knew her place."

† Percy Green headed a civil rights group called ACTION in the late 1960s that challenged the role of the Veiled Prophet organization in St. Louis. The elite organization of prominent white St. Louisans eventually broadened its membership to include some African Americans. The traditional parade evolved into an event held at the waterfront during the Fourth of July weekend for all St. Louisans.

Most white people would say when they saw your brown skin, "You're colored." We don't say that. We say, "You're light brown, dark brown or chocolate brown." If a person is fair or real light, she's almost white looking. We distinguish our colors.

The Famous-Barr girls on the Locust Street or Olive Street side—all of the very, *very* fair girls—ran that elevator where the businessmen were. The girls were real coffee-olive-toned color. Some of the escalator girls were after-school girls, and they would be brown-skinned and olive-toned, and the stock girls were dark, about my color. That's the way it was there. You'd notice that when you'd go downtown.

Pearl Shanks's Vashon High School class picture, 1944. The inscription, "To Slats," was her husband Rudy Shanks's nickname. *Courtesy of Pearl Shanks.*

Did we judge each other by the color of our skin? Sometimes you would and sometimes you wouldn't. Some people did. Some of it was due to some whites, and some was due to some blacks, too. People used to say, "When you're white you're right. When you're black you get back." So maybe that was stemming in some of your mind.

They don't do this anymore, but one time when I was looking for a job, the Union-May-Stern Company on Twelfth Street ran an ad in the newspaper: "Elevator Operator, light-skinned colored girl, twenty-five cents an hour." They based it on color. Okay, that Xed me out. I can't go look for that job. I guess they thought black girls, darker-skinned girls, were not attractive and they didn't appeal to the white clientele. Well, you know it's not true.

THE INVISIBLE WOMAN

Most of the people in the department stores, they didn't want to wait on you. They would see you come up to the counter, and if you and a white lady would get up to the counter at the same time, you know the sales clerk would not wait on you first. She would wait on this white lady, even if you were there. But you don't say anything. Maybe she had a bad day.

So then maybe another person or two white ladies would come over. The sales girl sees you, and you've been there for some time. You're a nice person, and you're not going to say anything.

In the back of your mind, you say, "She playing games with me. Let me see if another white person comes along and she will not recognize me, then I will have to, I will have to make her see me. And *then* she's going to wait on me."

And you say, "Lady, lady, I've been standing here."

"Oh, oh, I didn't see you."

If you were to make a commotion—well, sometimes you just walk away. The next day you would come back again and they would do the same thing. When they did wait on you, sometimes they throw the money on the counter, don't want to touch your hand—all that kind of stuff. It's just unnecessary.

What did that do? How did I feel? It made me mad, and I would burn like I'm getting mad now. It makes you real mad, and I said, "I'm not taking this anymore," 'cause you can tell when they go, "Uh hum, um—here they are." It's in the back of their mind, and you can read them. I read faces. There's a lot you can see in a person's eyes. My mother told me that. It is the window of your soul.

Some sales ladies are so nice. They say, "Hello." They might be big racists, but they're doing their job. That's all I want. "Do your job. I mean, don't treat me—I haven't—*I can't help the way I look.* If you don't want to work with the public, it's not my fault, but I'm not taking it anymore." So when they throw the money at me, I throw it back at them. My mother did not teach me that.

Many times, if a white customer is standing next to me, I would say, "She was there before me." And some whites were very nice people. They would know that you're standing there and the saleslady would go to the white person first and the white person would say, "I'm sorry, but this lady has been standing here a long time." The girl behind the counter would turn red.

And I would say, "Thank you," 'cause you don't want to go down fussing all the time.

SHAPLEIGH'S

I could type my head off when I was in school. I passed a business course, and I wanted to get a typing job. My friend and I went to Sonnenfeld's, but they only had black elevator girls and stock girls. So we went over to, I believe it was, Shapleigh's Hardware Company on Spruce. It was where Busch Stadium is now. There used to be a lot of factories over there.

We went inside Shapleigh's and asked a girl, "Are there any openings?" And she told us, "We don't hire any niggers."

We looked at each other. That was the first time anybody had been blunt. That was the first time anybody ever came out—the other things were just vibes that they sent. We looked at each other, and we walked out, and we walked out very proud. And when we got around the corner we looked at each other, and we cried, cried, cried, cried and cried. We were hurt. And we left. I didn't tell my mother. I just forgot all about it. I *just forgot all about it*. People say that to *stun* you. People say it to *hurt* you. But you get to the point where it's not hurting anymore, so you throw it right back at them.

I'd call them, "*You poor white trash*." But my mother didn't teach me that.

Eqᴜᴀʟ Oᴘᴘᴏʀᴛᴜɴɪᴛʏ

How did I form my opinions of white people? Ah, it was sort of—don't trust them. You *never* trust them 'cause they don't mean what they say. Stab you in the back. They want to pick your brain, and they speak with forked tongue.

My mother always told my brothers, "You go as far as they let you go." You go as far, you go as far—I got tired of hearing it. You go as far as they let you go, which just means, you get all the degrees you can and do everything that you possibly can do; you can be smart as a whip; but you don't have any power and you don't hold anything in your hand.

There's so many brilliant black people now. They're just aching for somebody to pick them up, to give them a job. I worked for the Urban League for twenty-five years. Most of my years were in employment as secretary to Mrs. Marie Williams during the time when they were searching for people to break into the big companies here like Emerson Electric. All the big companies knew and respected her. We sent qualified black people—*overqualified*—so they wouldn't turn them down. If they asked for one year of college, we sent them someone with two years of college. Today I hear people on the radio call-in programs talking about affirmative action, saying that during this time we sent people that were not qualified, that we sent "the spook" to sit at the door, meaning that you sent a black face because the government wanted a black face, maybe just one, maybe one. But we would go through the records and Mrs. Williams made very sure that everything, all of the qualifications from head to toe, were right.

Pearl Shanks

Bi-State

In the early 1950s, one of my co-workers came in one morning and said, "Guess what? I rode a bus today and they had a colored bus driver."

We were all really proud to see the black bus drivers. They were so neat, so courteous and it was a nice-paying job, just like you're proud of the postman too. Oh yeah, when you had a black postman, you'd hear someone tell you, "We had a black postman on our route." Yes, that was a big deal; they were nice mannerly people.

My husband was one of the first black drivers. He began driving in 1953, and he was with Bi-State for thirty-five years. When the bus drivers would get on the bus—the black boys, good-looking young men at that time—somebody would say, "Oh, we got a nigger driving this morning." The bus might have bumped two or three times. "Look who's driving it." They took a lot of stuff off some of the white passengers. Sometimes in south St. Louis they didn't want to pay. Rudy finally refused to drive over there because he didn't want to get into a fight. Even with the white bus drivers, the black bus drivers had to contend with racism on the job. They got the lousiest runs. In those days, they took a lot.

You know what my mother did? My mother got on my husband's bus. She told me, "I got on Rudy's bus today—got a transfer from him," and she *saved* the transfer. I got it somewhere, because I got all his stuff. She wrote "Rudy" on the transfer; my mother, she tagged everything.

When Rudy first started driving, I never could get to see him on a bus, but when there was a black driver, we'd all look real hard at them and they didn't want to smile. They'd say, "Step up, please."

We were just so proud to get on that bus, you would feel so proud. And they were doing their job, calling their stops. Made you feel good, made you feel *real* good.

Fighting Words

When you have children, it kind of changes you. I had experienced prejudice as a child, but I wanted to shield my children from it as long as I could. I love children, white or whatever. I wouldn't let anything harm a child.

My oldest son came home one day saying, "Oh, Mama, they called me a nigger!"

The kids were crossing the street, and this white lady was in her car. My son didn't cross the street fast enough coming home from school, and she called the kids this name.

I said, "*What* did they call you?"

"She called me a black nigger."

"Well, you are black," I told him. "You are black, and don't you ever forget it, but you're not a nigger." He was crying because we don't call people names.

Most people say, "Well, blacks call each other 'nigger, nigger,'" but I don't want my kids to start doing it. Everybody, I think in every black family, said, "nigger," but the way white people say "nigger," those are fighting words.

LADY AND THE TRAMP

When I was coming up, I went to everything in the city. My parents took me to all that was happening. My mother took me to stage plays at the American Theatre on Eighth and Market when it was segregated. We went to see *Green Pastures*, a black stage play, and it was really good. I think it was Bill Robinson that came. We had to sit *way* up in the balcony, *way* back up there. We had to, and I just hated it!

I asked my mother, "Why can't we sit down there?"

My mother told me, "There is where you have to sit. There is where the colored people sit."

It was only twice that I went there, and from the balcony you see the other little girls with their mothers down there. We would dress and look just as nice as they did.

When I got grown, whenever I got tickets I said, "I will *not* sit up in the balcony, that high up if I could get me a ticket downstairs."

When I was a mother, I heard at work that blacks were now able to go to the Loews Theater downtown, and I wanted to take my two children. So I got up one morning, I didn't tell anyone what I was going to do. I didn't want them to be disappointed. They just thought we were going shopping downtown. I fixed them up. We were dressed, not overdressed. I said, "I'm going to see if we can go to a picture show."

The reason I did was because when Elaine was small and we went downtown on the bus, as we passed the Loews Orpheum she would ask, "Oh Mama, can't we go in there, can't we go in there?"

She was about seven, and I told her, "No."

And she said, "Why?"

"We can't go."

"Why can't we go?"

I said, "Because we're colored and you can't go in there."

Elaine asked, "Can't Aunt Lela go?"

Well, Aunt Lela, she's fair-skinned, and I told Elaine, "No, she can't go, she's colored too."

Elaine said, "We can't go? That's not fair; that's just not fair," and she shook her head. She was looking at the people going in the movie theater, and I wished I could get her in the show. Ever since then that stayed on my mind. So when they finally opened up, I thought, "I'm going to see if they would take her."

And so we went to the Loews and we walked up to the window to buy our tickets. All they can tell me is "No," and when I put my money there and the lady asked, "Oh, for the children too?" I said, "Oh, thank you."

She took my money. Well, they didn't know what I was feeling inside. I said, "I don't believe it. I don't believe it." We went to see *Lady and the Tramp*, a Walt Disney movie.

Wow! They had a fit. I had a fit. I had a fit when she accepted my money. I said, "We really can go in this show. It's no lie."

NOT A PRETTY PICTURE

I told my kids about being black and going downtown. They knew about a lot of stuff maybe some people their age did not. I felt they should know about these things like my mother told me, that it hasn't been a pretty picture, and I didn't want my children to get hurt.

I want them to know what's out there when they go, because my mother taught us how to ride the bus and to go downtown. There are things that you have to do. When we were a certain age, she would let us go downtown and go to Famous, go to Stix and, of course, you're going to come in contact with white people, so you can't be afraid, but there are certain prejudices you're going to experience.

My mother didn't tell me what to say. It was in me. I can tell when a person is prejudiced. The vibes are there, because when you see it, when you come up to a counter, you can see the look on their face.

But we always had good manners—we *always* had good manners.

Chapter 3

CLIFTON FITZPATRICK

Clifton Fitzpatrick, born in St. Louis in 1923 in City Hospital #2, served in the navy during World War II and worked at the post office for thirty-eight years. He was a counselor at Hyland Center, St. Anthony's Hospital, and in 1982, he was the first to receive the Alcohol and Industry Award from the National Council of Alcoholism's Institutional Membership Association.

GROWING UP

My parents, Clarence and Kittie Fitzpatrick, migrated here from Hennings, Tennessee, about 1920. That's the same area where Alex Haley and all of them was from, and I think they knew some of them. Hennings was strictly a country town. When my parents got married, they kind of wanted to move into the big city, thought it would be a better opportunity for children they planned to have. The colored people that came here wasn't used to city living. Just like if I come up and get me a place, I'd send for you, and you'd come up, maybe seven or eight people living in a house 'til we able to sprout out a little bit. And then you get you a little ten- or twelve-dollar-a-week menial type job and you sprout out and get you one of these houses, which ran about seven, eight to ten dollars a month rent.

It was hard to try and bring yourself up on those salaries. Nobody had anything. When I was born, my father was working as a porter at Emerson Electric Company. They was down at 2018 Washington Avenue, and he

would walk fifteen or eighteen blocks to work from 2703 Eugenia Street, Beaumont and Eugenia, where we stayed. I had a good childhood, very good, *spoiled*. I was their only child.

My mother was one of fourteen kids. She was the only girl, and they all gradually migrated to St. Louis and Chicago. My father was the oldest of about six or seven kids, and they all eventually come here, and seemed like I was the center of attraction at that time.

We lived very, *very* humbly. You know, I think we had no more than three rooms and periodically, I remember, I was sleeping on the floor. They made my bed every night. My parents had one of those feather mattresses. It wasn't as we know it now with the box springs and all that type stuff. I was quite happy with the arrangements; didn't know anything else.

Everybody did what they needed to do just to exist. If you didn't have closets, you put a nail or something in the wall to hang your things on. We had a big potbellied stove in the parlor, and as I remember, they kept the coffeepot on it—darn thing must have stayed on all day. I imagine by the end of the day it was pretty strong. And in the kitchen we had a table, and if I remember correctly just a little gas stove. They had "Quick Meal" gas stoves with the legs on them, nothing fancy, and the linoleum—you could wear the pattern off pretty easily.

My mother was a very clean lady. I remember she used Red Devil lye to scrub the floors and steps, and if we had throw rugs anywhere, she took them outside and beat 'em. The bathroom facilities was way out in the back. When we stayed close to Union Station—that was heaven—I'd go down there and use their toilets. We had cold running water and no central heating. On winter days when the temperature would drop below freezing, you had to have the water running. If we left a glass of water in the kitchen overnight, it would be frozen solid in the morning.

We didn't take our baths in the kitchen because it wasn't warm enough. We got that potbellied stove in the parlor just about red hot. My wife, Luvenia, got a big burn on her leg from that type thing; didn't have a bathtub. You had this big old number three tub and you put some hot water in it and add some cold in there and get it as near to the stove as you could and take your bath to get warm. When I got old enough, I took my showers and swam at the Pine Street Y. There were bathhouses built around town at various places, and I used to go to the one there on Jefferson and Spruce. It was Bathhouse #5, and they built that about 1935. It was Adams then—Jefferson and Adams—Adams eventually became Spruce when it passed Jefferson.

I will never forget when Luvenia and I got married and moved to 2645 Pine, where A.G. Edwards is now: twelve dollars a week, two rooms with a centrally located bathroom on the second floor where everybody from the apartment come into. I was getting my stuff together to go down to the bathhouse, and my wife said, "You're going to take your bath here at home." She got the teakettle, heated that water and poured it in that number three tub, got the fire hot, had my long underwear hanging. I hadn't taken a bath in a tub since I was a kid, because being into sports I go to all those places where they had showers.

I have some semblance of pride now that I've been able to enjoy some of the luxuries that my parents didn't, you know, like the hot and cold water we take for granted. And when I was little, a big truck would come up to dump the coal down on the sidewalk and we had to shovel it in the basement. Kids now don't know how to make a fire, I don't think. That was my job every night, and when it was real cold, we never let the fire go out. I'd push the coals over to the side, bank it, keep it going all night. The next morning—strike the match.

My parents would run me to the store to get a can of coal oil, and you had to put the wick down in there, light it and turn it up. That was our electricity. For our refrigeration, we had one of those orange crates hanging outside the window, and that's where we'd put our milk and stuff, whatever little milk we had at that time. I think I drank canned milk most of the time—Carnation— and they mixed it with, I wonder if it was called Karo Syrup? We also had a wooden icebox. We had the iceman to come by—put the sign in the window. The sign had 25, 50, 75, 100, and you turn it to whatever you wanted. The ice lasted a day and it cost about fifteen, twenty cents, dime, something like that.

My mother worked. My mother did housecleaning for a lady whose husband was an official with the Kroger Company. Their names was Canter, and every Christmas this lady would send me toys, little miniature pinball machines. And periodically, if for some reason I didn't go to school and my mother had to take me out there while she was working, I'd be out there playing with their children. She rode the streetcar. At that time they ran real regular; nobody hardly had automobiles.

You talk about latchkey children today, we had that old long skeleton-looking key under a mat, and I'd come in from school. My job then, as a kid, was to empty the pan in the icebox where the ice had melted. Then I get out and shoot marbles or stuff until my parents come home from work and mother fixed dinner. But it was a very happy childhood, extremely happy.

You could leave your door open, you could go to anybody's house to eat, always had a meal for somebody, very trusting, very religious.

My whole family was Baptist. The Southern Mission Baptist Church was on Montrose and Market, right in back of Vashon High School, which is now Harris-Stowe. It was a very important part of the community. I was raised up in that church. My mother walked from Eugenia, which was about six or eight blocks, up to the church at night. They would have prayer meetings and late goings-on.

My father attended church four or five days a week and was on the Usher Board. He had a deep low bass voice and sang spirituals in the church choir for thirty-five years. My mother was on the Usher Board, and she belonged to the Elks, and all of those organizations was separate, black and white at that time. She was very active in that type thing.

My father used to talk about before he left the South, that they had a little marching band and everybody played, nobody could read music. He played the baritone and the bass horn. I used to sit around this potbellied stove, and I'd hear him talk about it when the band would come marching through this little town. It was something. My father had ties back there, and he eventually brought his father, my grandfather, up here. And of course, he stayed in the general area, which is now called Martin Luther King but was Franklin Avenue then. I remember my grandfather, very strong man, tall. His name was Merrick Washington Fitzpatrick—a proud man.

THAT'S THE WAY IT WAS

We had a very decent school with a proud and distinguished-looking principal, John W. Evans, who would come to your house and sit down at your table. I attended Lincoln Elementary School, and it was surrounded by houses of prostitution. At that particular time, I thought prostitution was something that happened everywhere, didn't faze me none whatsoever. My dad talked about it like crazy; I didn't think nothin' about it. My dad would always downgrade it, but the homes that you rented was cheap rent, eight to ten dollars a month. Sometimes he would have to rent right upstairs over them. So my dad was caught up in the cheap rent. He couldn't pull out. He couldn't afford to move, but he didn't like it, didn't like it at all.

There was a lot of gambling going on in those various places, and they had a lot of little storefront-type churches, Baptist churches. A lot of people

were caught up in these various little churches, contributing. It was just a coexistence type thing, it wasn't like now, you could get a group together, get some money and fight the prostitution and gambling. As I said before, nobody had anything. You argue against it, you didn't like it, but you, as an individual, couldn't stop it. Even the police would take a dollar or two to turn the other way. Decent people were trying to grow and live in this environment and try to teach their children against it.

I think it's hard for anybody who didn't live in the area to know what was going on. People fought against the rats, but you must realize, then you had ash pits, you had garbage cans out in the back. You tried to set up standards, but they were rat infested. And I partially fault the city for a lot of it, plus the absentee landlords. You would report to them that you had bugs or rats, but nothing was ever done about it. Even the city administration would do a lot of just quasi-type things about it, but the people I knew would try to fight it, and they did the very best they could, the *very* best they could. They bought rat poison, but with the rat-infested ash pits and with the lousy sanitary systems, and no real outside help, if they had, say, put a war out on all that, they could have really made a greater impact.

Coming up, I was a mischievous kid. I knew the streets, I fought, I started playing hooky from school. I was in groups and getting locked up. My father tried to keep me on the straight and narrow, he did his best and he wouldn't let me bring anything stolen in the house; couldn't nobody come in and say, "I found a bicycle or I found a jacket." Luvenia and I didn't go for anything like that, and he didn't neither. He said, "If I didn't buy it, don't bring it in this house." He was a very rigid, proud man.

My dad said he would not go around the corner to get me out of jail—and he meant it, too—so my mother would have to come and get me. My parents were hurt when I did something wrong, and they beat my butt, didn't kick me or stomp me or anything like that, and my dad, if I come in late, would make me go to bed without eating. Mom, I remember her sneaking in and bring food to me. They had a lot of pride, and I respected them for that.

My dad would put my grandfather on me. He wasn't working, and he'd be there to admonish me coming to and from school; a very strong and proud man. I understand down South he did his own farming and everything; he couldn't stand the racism. We didn't call it that in those days, so he stayed a little off to himself. He was a loner, proud, a strong guy. He gave respect and he commanded it, and he walked straight and tall and had a gray mustache; very firm, all business, not a lot of education, none of them had it then. My dad was similar to that also. He was pretty much a loner and non-trusting,

as far as this race stuff goes. He resented being left out from everything, so consequently he stayed away as much as he could from any of the white-type things. For instance, at work, like his father, he stayed to himself. He didn't like cursing, he tended to his business. He gave respect and demanded it from everybody. They respected him a lot down there at work for that, *a lot*, so when I got big enough to get a job, he got me a job there with no problem. I think that's the way, you can beat 'em more that way.

Christmas was great, tremendous. You may get one item that was new—maybe a jacket or new shoes—and you got apples, candy. But what was the big deal, Mayor Dickmann, Bernard F. Dickmann, used to have what they called Dickmann Dinners. They started at the old coliseum on Jefferson and Market where the Jefferson Bank is located now. The coliseum is where they had all the boxing and wrastlin' matches, and later they moved it down to the Kiel Auditorium. The dinner was for everybody, black and white, mostly white. It was citywide, and you would hear about it on the radio and in the newspaper. He would get that place for Christmas and give out candy,

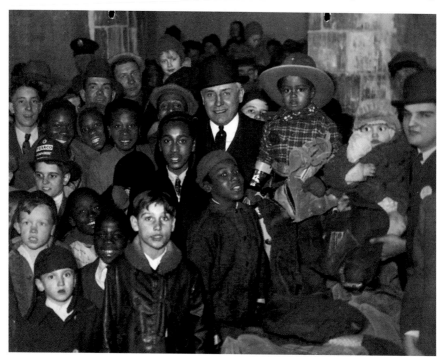

Mayor Bernard F. Dickmann at the Mayor's Christmas Party, 1938. *Courtesy of Missouri History Museum Photographs and Prints Collections. Richard Moore Collection n01163.*

eggs and had a big turkey, and a lot of volunteer entertainers, like if Cab Calloway or anybody was in town, they had them come over and entertain.

The day after Christmas, up at the Pine Street Y, they had the Worthy Boys' Dinner, also a turkey dinner. It was open to all kids in the neighborhood; most everybody was poor. Black entertainers and businessmen in the community helped get it together with the Pine Street Y, the black Y, the only one we could go to in the city at that time.

Here's what you got to realize. There was a tremendous amount of white people on our side that helped us. Along with the black ministers and churches, the white priests and nuns helped to keep kids off the streets. They had places for them to go, basketball leagues, softball leagues and different activities going on at the various churches. It was just more than what's going on right now to keep children off the streets, in my estimation. I boxed at St. Elizabeth's, 2700 block of Lawton, and same thing down at St. Nicholas, at Eighteenth and Lucas. They had dances and instilled a lot of pride in us.

OUR HEROES

I learned very early on that there were people whose skin was a different color than mine, because my mother would take me downtown, and I knew we couldn't use any of the restrooms or eat anywhere, and sometimes she would take a little something in her handbag for me to eat. We were programmed at a very young age to feel a little inferior.

We had our heroes when we were growing up. Everybody loved Joe Louis and, before him, Jack Johnson, the fighter. We had black baseball players, football players and basketball, but we didn't think they were good enough to be in the Major Leagues. But the real reason was because of their color. And so in 1947, Jackie Robinson finally broke the color barrier and was in the Major Leagues. I remember we couldn't sit in the grandstands out here in Sportsman's Park, you could only sit in the pavilion and the bleachers, and man, we filled that up; *pride*, the whole bit.

As I said, it was a certain amount of inferiority that had been fed to us when we were young. We liked Stepin Fetchit. Some of the guys would shuffle until some of the more intelligent, educated people were saying, "Them guys is wrong portraying us like that." Then, of course, you boycott *Amos 'n' Andy* and all those people. At first, we didn't think nothin' about it, but in time, we were involved in a complete revolution. We protested against that kind of stereotyping.

TURFS

My wife was from around Fourteenth and Biddle, down around Columbus Square area. Well, when you get out of your neighborhood, you was subject to getting beat up. But we all eventually met at Vashon High School. That's how I met Luvenia, but at night, I might want to go down and see her, I'd have to run all the way back home. It wasn't the killing type, just a bunch of guys getting on you. I was raised around Jefferson and Market, where A.G. Edwards is now. She was down around where the Post-Dispatch building is. Each neighborhood was different. The Southside, south of the railroad tracks, LaSalle, Hickory, Montrose, very good friends of mine over there, but at night, you didn't go there. That wasn't my turf.

West of Grand, they were the elite. That's where all of our schoolteachers lived. Sumner High School had quite a few elite, and they were our adversaries, on the baseball, football fields and basketball. We didn't mix with them except for dances. They had a dance hall out there on Sarah and Finney, Carioca, and we had the Castle Ballroom. They come down there, we sort of respected each other's turfs. Beautiful dance hall, Castle Ballroom, they mandated that you dress decently, a jacket, you couldn't come in looking like a bunch of thugs. They had big bands, Count Basie and Jimmie Lunceford. They had ladies' night—ladies get in free and men had to pay fifteen cents. I had a tough time raising that fifteen cents. It was just tremendous, and I saved my lunch money.

"LITTLE MEMPHIS"

A lot of the people who migrated to St. Louis from the South lived in the area from Jefferson on down to Union Station. Some called it "Brownsville," and some called it "Little Memphis." They even had a little popularity thing going on that we elected a mayor of "Little Memphis." He would be sort of like a politician, the connection with city hall or something of that nature.

The first guy I remember, Dave Fields, was the mayor of "Little Memphis," and then they had an alderman up there, Billy Morant, and three others, Langston Harrison, Quintney Clark and Charlie Turpin. And those were our four connections to the city hall. These committeemen got us the garbage men jobs and jobs cleaning up city hall and stuff like that. I was quite young at the time. I think the *St. Louis Argus*, one of the black papers,

put out a poll on "You Want to Be Mayor." Dave Fields owned a club that all the entertainment was female impersonators, right there on 2100 Walnut. They had chorus girls or chorus boys, whatever you want to call them. He named the club after his wife, Julia Ann. I was too young to go in, but I *peeked* in the windows!

EMERSON ELECTRIC

I remember when I got my first job after I got out of school. I had taken up machine shop in high school. I could read a micrometer and various gauges, and I was armed with my stuff. The very first day after graduation, my dad said, "Come down to Emerson Electric in the morning, I can get you a job." He was planning to send me up to Detroit in the fall to enroll me in Wayne University; he wanted me to be a doctor. I would stay with my uncle. I was going to work through the summer.

I go that first day and I step into the employment office, and it was loaded with people. I was the only black person coming in. The guy looked up and he said, "Nothing for colored today." And I said, "But…"

He said, "Look, I don't have time to fool with you, nothing for colored today." I left, pretty downhearted. And so when my dad get home that evening, he said, "I thought I told you to come up, I was going to get you this job." I said, "I did. The man wouldn't even let me talk to him." He said, "Well, you come up in the morning." My dad was a very firm guy.

When I get there the next morning, my dad was standing out there with the personnel director, who said to me, "How come you didn't tell me you was Clarence's son?" I said, "You didn't give me a chance." And I had my little book, and I was going to show him some of my credentials, and he told me, "You won't need any of that. You go to the porter gang." You know, do cleaning. Everything was separate, the locker rooms, even the section that you worked in. They were very menial jobs, regardless of your credentials.

World War II was just beginning to break out, so we all had to register for the draft. And then also I get married; my wife was about three months pregnant. That was the biggest disappointment to my father because he was planning on me going up to Wayne that fall. Of course, that was out the window, so I began working at Emerson. They got the largest machine gun turret contract in the world, and they eventually moved out here to 8100 West Florissant, and the porter gang moved with them. We wanted

some of the skilled jobs; we knew how to run machines. They had a training program, and they wouldn't give it to us. We picketed, and they said, "No way, you got what you're gonna get."

When President Roosevelt wrote that FEPC, Fair Employment Practices [Commission], they had to give certain percentage of jobs to minorities for blacks, and that was it. It didn't specify what jobs, so we had a running battle going. We hired two black lawyers, McClamore and Clymer. They were a heck of civil rights lawyers at that time. They really was instrumental in that '54 desegregation case. They told us to get a petition together. We had it notarized and sent it up to Washington to the President's Committee on Fair Employment Practices. Everybody was afraid to start off signing this list, you could get fired, so we drew a big circle on a piece of paper and you signed your name anywhere, and they couldn't tell who was the instigator and who was *first*.

About six months later, they said, "All colored employees out on the back platform." We wondered, "What's going on?" We go out in the back, and they confronted us with this: "Why didn't you guys negotiate with *us*? We ain't gonna tolerate this stuff, but we're gonna work with ya."

And eventually, because of the petition we sent to Washington, they did open up jobs to us. They were mandated, so they trained us, sent us to working in the machine shops at Vashon High School at night after we had worked ten hours a day at Emerson, on the same machines we had went through high school with. And so when we came back and got the jobs as machinists, they had cleared out a whole section for us. I think we had six blacks on the day shift, six blacks on the night shift—better jobs, but still segregated. But they took the jobs away from white people and moved them to another section.

I will never forget the night when I went to work on those machines, the other whole plant stopped. The whites refused to work while we had those jobs. I went to the union guy and said, "Hey, we're part of the union too." He said, "We weren't complaining about you having those jobs, but you took it away from these other guys," and they had started us at a higher rate of pay than they were making. It wasn't so high, but they didn't start us at the entrance level because we were already working there. So our raise was higher than the money the whites had started with at entry. They say that's what it was, but that wasn't what it was. *It was our color!*

Stuart Symington was president of Emerson Electric at that time, and the announcement came on the loud speaker, "Everybody that quit work here is not going to get paid, and *these people* are *all* gonna work." We worked

that night, and finally you'd hear the machines start up gradually again, and they went back to work. This kind of change was sprouting up all over the country in different ways like that. It wasn't until after I left there in 1949 that they integrated the restrooms and had people working in the personnel department, tool and die workers and other areas.

All the time I was out at Emerson we were constantly fighting for dignity, jobs, even in the unions. We paid the same dues, but they had us in a miscellaneous category. In other words, when layoffs came, a black could only bump another black, even though he had more seniority than some of the whites.

The toilet had a big sign there, "Colored," drawn on our toilet, and we constantly took it down and destroyed it. So they call us in the personnel office. We told them it was disgraceful and humiliating to us to have that sign hanging there. So they told us they would take the sign down, "as long as you know where you're supposed to go."

They had an area roped off for us in the cafeteria, and we resented that too. And so we come in the cafeteria and started sitting everywhere, and they rounded us up, and going to fire us, and eight or ten guys did lose their jobs, so they said, "We'll take the rope down, but when you guys sit, just go sit together." We didn't agree to it, and they thought they were going to hold us to it.

I was only seventeen, my dad was still working at Emerson; he wasn't militant at all, he pretty much backed me in what I did. He said, "I guess we didn't have the guts to do anything like that, but you guys got to work, you're going to lose your jobs." But he never did downgrade me for it. I had a lot to lose, had a young family. We thought it was an injustice. It was very degrading, *very* degrading, but it was being tolerated at that time by the various people who had migrated here from the South because it was a way of life. It was a little better than it was in the South.

We had fun. I didn't let it bug me. None of us did. We joked about it, carried little chips on our shoulders but generally didn't let it interfere with our having fun. It's not like these dudes are now. We didn't carry around a lot of hate and hostility, just tried to work with the system and in the system, get a piece of the pie.

When I was at Emerson and still down on 2018 Washington, I was working on the sixth floor right next to the white restrooms. They had two colored restrooms, one in the basement and the other on the second floor, so if I had to go to a restroom, I had to get on the elevator and go down to two or the basement. One day, I had to go pretty bad, and I didn't think I

could make it down to the second floor, we was doing piece work and I didn't want to lose that time, so I ran into the white toilet right next to me. None of the stalls where the commodes were had any doors on 'em, and one of the powers that be come in to use the restroom. He walked by and he took a double take. He saw me and *boy* he got quite upset; went back out on the floor and got the floor superintendent, my immediate supervisor, and a few other big wheels. And if you can imagine, I'm sitting on the stool and they come and ganged around me; I didn't even hardly look up at 'em. Then they went on out, and when I came out the door they was in a football huddle, and they called me over.

The immediate boss that we had was Pat Crawford, a beautiful person, a decent man. He apologized so vehemently. He said, "Cliff, I'm embarrassed by this, but you've caused quite a bit of concern about your using that white restroom. I'm mandated to tell you, you have to use the ones on two or in the basement. As far as I'm concerned, I don't care how long it takes you or how many times you go, but you have to go down there and use it. These aren't my orders, they're the orders from the people above, and they are going to reprimand you for going in that toilet." And I think I did get a day off, but he said, "I'll let you make some overtime, make it up."

Sure, I felt extremely hostile about this, but I needed the job and I didn't want to embarrass my father who had been there for many years. But what this did, and that's what happened to my father too, I think unconsciously, it gave me the impetus to try and fix it so my children wouldn't have to go through anything of that nature, you see, to fight harder. Respect people, but also command respect like my grandfather, and the only way you're going to get it is if you give it. But I still always get a little hotheaded.

CARR SQUARE VILLAGE

We moved into Carr Square Village, I think, in 1942 or 1943. Our family was the first to move in the 1700 block of Carr Drive. It was brand-new, integrated, and people were well screened. I think I was only eighteen or nineteen years old. At first they told me they didn't think I was old enough to sign a lease, but they did let me, and we moved in. Everything was brand-new. Can you imagine moving into a brand-new apartment? Hot and cold running water you didn't have to heat yourself, or a furnace you didn't have to make a fire in or stoke. *It was heaven.* We had a refrigerator, we had

a bathtub, had cabinets around the kitchen wall. We really appreciated that. That was quite a luxury in them days, and we were quite proud of it. They gave us the privilege of painting our own apartments and they gave us the paint, and boy, I'd be up 'til eleven, twelve o'clock at night paintin' it. And they gave us grass seeds to take care of our yards. It was really nice. Each of the kids had a bedroom, and as I had another kid, they give you a larger apartment.

None of us down there, white or black, had cars at that time, and one of the largest shopping areas, the markets, was right down on Tenth and Biddle and Cole. It was called Biddle Market, sort of like Soulard Market. We walked down there and shopped. I bought a little coaster wagon for my son to play in during the week, but Saturdays, I used it to shop in.

I had to move away from there in '48 or '49 when I started at the post office, and it was very sad because we took pride in the place. You had to take in your check stubs every year to see how much money you made, and they would raise your rent according to that and then we hit that ceiling and

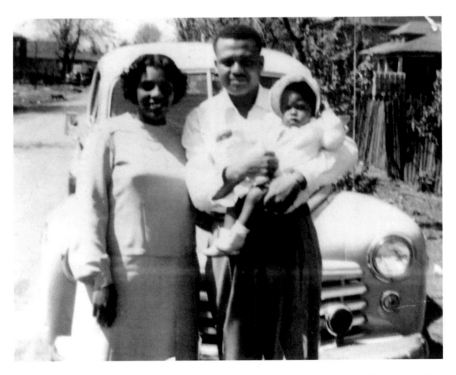

Clifton and Luvenia Fitzpatrick and their daughter Connie, 1941. *Courtesy of Clifton Fitzpatrick.*

they tell you that you got to go. It doesn't make sense. They call them low-income housing projects, and none of them across the country have ever succeeded in a long-range deal. I think in retrospect they realize the mistake they made.

POST OFFICE

When I went into the navy, during World War II, I had been working as a machine operator at Emerson, but when I got out of the navy in 1946, I had to go back to my prewar job, to the porter gang. I worked at Emerson for three more years in various jobs in the black category, which were porter, traffic, you know, pushing the carts around and cleaning scrap metal out of the machines. Eventually I did get into the plating shop, but I wanted a better job. I wouldn't move up anywhere there, so I took the federal exam and went on and worked for the government, the post office, for thirty-eight years. I needed security. I had a family.

I worked both places for about three months. The post office was almost the same way as Emerson. You had certain areas where you sat, like in the cafeteria. You couldn't work in none of the offices, like the personnel department. In other words, promotion was almost out of the question. If you come in as a letter carrier or mail handler or a clerk, that's the way you retired. It was a good, secure job.

I was a sub for about seven years, and every morning I used to go to the assignment unit at the main post office. You'd get there at five o'clock in the morning, trying to get a route. Sometime they would send you upstairs to have you sorting mail. If a route come open, a carrier call in sick from a station and they needed an extra carrier, they would call you in to work. Sometime we would just sit out on the platform or in the swing room, we used to call it. As they worked down the list they would call your name, "Clifton Fitzpatrick," and if you didn't have an automobile, which most of us didn't have, they would give us this empty mailbag to get on the bus. The post office had an agreement with the public service company that anytime a mailman got on a streetcar or a bus with his bag, he didn't have to pay, that was his transportation. They would tell us, "Report to Lemay Station, Webster Groves, University City, Broadway or Clayton Station." They sent me out to various places. You wanted to work, you would go. Though black letter carriers were supposed to work everywhere,

they primarily were placed in black neighborhoods, but when the post office got stuck, they'd send you anywhere.

First thing you were looking around for in white neighborhoods would be facilities, eating and toilet facilities. Of course, you wouldn't drink a lot of water and stuff so you would have to go. You'd knock on somebody's door, I did on a couple of occasions ask, "Could I use the bathroom?" and they told me, "No," and slammed the door, and so I just went by a *tree* or a *car*, whatever I could. *It was really tough.*

These experiences were an everyday routine. I was delivering mail to a tavern in a poor white neighborhood on the south side, and the bartender asked me to bring him some stamps. I told him I would, and when I brought him the stamps, he said, "You want a little drink, mailman?" I said, "Yeah, I'll take a little drink." He set the whiskey bottle down and proceeded to get a soda bottle and started to washing it out. He said, "Some of these people—it ain't me—some of these people around there might resent drinking out of a glass behind you." And I said, "Well, forget it." He was apologetic, but he was going to get a soda bottle that somebody else had evidently drank out of and he was going to wash it out for me. I had been in deals like that before.

Once when I was a sub, I was helping a white fella to carry and we stopped at a sandwich shop on Chouteau near Kingshighway for a sandwich. We sat down at a table, and the guy at the counter said to the other carrier, "*You* can eat here, but we can't serve *him*." The white letter carrier proceeds to start trying to raise hell about it, and I said, "Just forget about it, don't worry about it." You get used to going all day without lunch.

They did a lot of gerrymandering with them routes, like the good choice routes downtown. They'd send the white guys down there, even though they hadn't reached their names on the list. Your name might be ahead of theirs; you had no idea it was going on. We couldn't even work or bid on routes below Twelfth Street, down like Famous, Stix, all those were choice routes because you'd be inside all day delivering mail.

It wasn't until we start to get some decent people in the National Postal Alliance Union and they really start to fight that some changes were made. Before the '50s, the whites had the seniority, but then we begin to come in and build seniority. I think it was in the late '50s before we started getting any black carriers downtown. Even though we had the bid system, they'd play games with the bids. Yeah, they'd pull names.

CARRYING MAIL

As a sub letter carrier, we got paid by the hour, no overtime, no time and a half. I told my boss, "I need to work a lot of hours. I have kids; I need the money." He said, "Okay, there's a fella on sick leave. I can put you on his route, but it's a lot of prostitution and pimps, and it's rough; it's tough; it's blighted; it's slums. I won't care how much time it takes you to finish the route, just finish it every day and you can work on it until he comes back to work." It was the route that I was born on, Jefferson and Market. Just as I always say, "Like throwing the rabbit in the briar patch."

I was a mischievous boy comin' up in the neighborhood, so when I started carrying the mail, and when people saw me they called out, "Hey, here's Kittie's boy carrying mail. Mama, come here. Here's Cliff, carrying mail." And the lady hollered, "Boy, I thought you'd be in jail 'bout now."

I became a regular around 1956, and I stayed on that route; the letter carrier who was on sick leave retired. I bid on the route and I got it. Of course, I didn't have much competition—not many people wanted it. I stayed on that route until they tore the Mill Creek area out. I was sick about losing that route because going to work was like paying me to go play every day.

Then I went to a route over on Kingshighway and Chouteau, I was working out of Chouteau Station, 4500 Gibson, 4500 West Papin, just over from Barnes Hospital, 4500 Chouteau, up in that area. It was white. It wasn't too bad because it was on the fringe of a black area. I'd finish my route, go into the black area, do what I wanted to do and then go back to the station. I had no problem there.

I must have been on that route for three or four years, I imagine, before I eventually bid on another route back over this way near where Harris-Stowe College is now, the old Vashon High School. They were also tearing down that area to build those Laclede town houses and places all up in there. But I bid on that route, under the Compton Bridge, the railroad tracks, Fitzsimmon Coal Company, and then I finally bid on a route around Compton and Delmar and that was all black. I gave that route up. It was just a little too rough for me. By then, I had a goodly amount of seniority, and I got the Shell Building, Jefferson Hotel and Christ Church Cathedral—a one-block route in which you made three deliveries—which was a very choice route.

I almost didn't get it through some hanky-panky, but I eventually got it. They wanted to back bid, but by that time they had black people in the personnel department. One fella had told me I had the route, and the next

thing I heard was I didn't, and I began to raise my voice in dissent against 'em. They figured I must know something, 'cause I couldn't hardly rest that weekend knowing how I was going to handle this thing on Monday morning. But when I got in on Monday morning, they said, "The other fella that beat you out of that route for some reason withdrew, and you got the route." I got it, and I stayed on it for about ten years until eventually I got the job as an employee assistance counselor. The post office picked me and my friend Marty Fitzgerald to do this because of our own personal involvement with alcohol and because Marty and I had been helping people through our union on a volunteer basis, and they knew the work we had done. They started sending us out to Washington University for training sessions to learn to help people with drug and alcohol problems. A lot of people would be debt ridden, and I would send them out to the Consumer Credit Corporation so they could keep their jobs. I had to train for that job, and I took courses at Southern Illinois University and then up at Rutgers University.

My friend Marty Fitzgerald and I would go out to St. Louis University and lecture the first-year medical students on industrial chemical dependency. We were in demand all over, and the post office gave us free rein to do that. We named a wing of our program the PAR Unit, Program for Alcohol Recovery. They eventually gave us a secretary, and that's where I retired from.

REFLECTIONS ON THE POST OFFICE

In the 1940s and 1950s, it was hard carrying mail in the white neighborhoods because it was impossible to fulfill your basic daily human needs for food and toilet facilities; therefore you ended up "staying in your place." The average white person would rebel *vehemently* against carrying in the black neighborhoods, and they definitely wouldn't bid on any of them. Today, I don't think there is any discrimination assigning routes or carrying mail into different neighborhoods.

Working at the post office was like going to a *university*; we called it a "graveyard of education." People with master's degrees taught school during the day and worked at the post office at night to supplement their salary. Those were the only jobs that we could mainly get with a little dignity. You could wear a necktie, a shirt, you know what I'm saying, it was a prestigious job years ago; people who would come right out of college and were going into

the postal service or Pullman porters or police force, these type jobs. And you used to have per capita more college graduates among the black employees in the post office than you did any other place practically. You'd go there and get stuck there; a lot of the guys did that. We learned a lot from them.

I had a fella I started with at the post office and eventually he disappeared, a white fella. Next time I saw him, he had a pencil behind his ear and he was working in the office upstairs. I thought immediately, "Boy, that guy's real smart." I wasn't facing the *reality*; the only reason I couldn't go up there was because of my *color*. You're always taught that they are taking the best qualified, they told us that. It's survival. I think these young people now is letting a lot of this stuff destroy them. We didn't have *nothing*, went on our merry

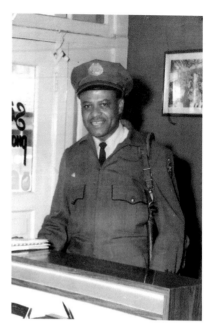

Clifton Fitzpatrick, letter carrier, at 3338 Washington Avenue, 1963. *Courtesy of Clifton Fitzpatrick.*

way, fought within the system pretty good. We're the reasons they opened up a lot of the theaters. We picketed, had lay-ins at banks and lunch counters, but yet I have some of my children tell me, "Dad, how did you tolerate all that? It must have been embarrassing having to go to the back door to go to the toilet, to do this or that." *It was a way of life.*

EYE ON THE PRIZE

I would have liked for things to have been better, but I was happy. I wasn't tormented about a lot of things. Back then, black people didn't mainly go to psychiatrists to be analyzed. You'd be discriminated against, you'd laugh about it, put it behind you, go on your merry way, and nobody hardly had any darn thing.

I think we would have went crazy had we just wallowed in frustration about all the stuff we was deprived of. We laughed at it. We enjoyed

our segregated schools and sporting events. They let us have the boat the *St. Paul* Monday nights down on the river. That was Black Night. We enjoyed ourselves. We didn't let all that other stuff stop us from having fun.

As far as race relations were concerned, we were elated over any gains that were made, but we didn't take out our hostilities in any brutality or stuff of that nature. The progress was very slow. We began to make more money, began to get used to better living conditions and sometimes there were even setbacks and that was pretty bitter to take, but we never let it shake our faith in God that things would be better. We had our churches, we would pray, we would go to school trying to get educated, trying to improve ourselves and act better. We always thought that we had so much to prove, *just had so much to prove*, just kept trying hard—still doing that, as a matter of fact, trying to prove ourselves. As soon as you think you're making some kind of progress, some kind of bits of racism will slap you in the face. But you just keep going.

A TENSE TIME

When things began to open up and blacks could go where they wanted to go, I was a little apprehensive, self-conscious. You were very careful in your choices. You didn't venture way out, and by word of mouth you would find out where you would be comfortable. I was quite uncomfortable when they opened up the movies. I had cleaned up around the Fox and different places like that, and I was a little gun-shy about it, going down to the Ambassador downtown and those various theaters. You didn't feel welcome. You felt like somebody was gonna say something to you, and some of them whites were uncomfortable also. You'd sit in a seat and they move, stuff of that nature, still a tense type of thing, that integration. And they didn't just slam it on, like they had a black lunch counter down at Woolworth's and they had a balcony lunch place for black people at Famous Barr department store. I don't know if Stix Baer and Fuller or Famous opened first, but they begin to gradually open, and I think those were some of the first places I felt comfortable going. And when they threw the city open, so to speak, you were afraid to go to the south side places. They wouldn't serve you anyway, even though the various laws had passed. It was quite a tense period.

I'm comfortable everywhere now, real comfortable. The best friend I have, outside of Chris Newman, is Marty. He's white and stays way south. I go to his house, I know his kids, watched them grow. They run up and hug me. We tease each other. His name is Fitzgerald. I'd call him on the phone and say, "Are you Fitzpatrick or Fitzgerald?" When his son got to managing the post office out in Chesterfield, and they had an open house some years ago, his dad was in the hospital so I went. He told everyone, "My dad will be here," and when I hit the front door, he hollered, "Dad." We had a lot of fun with it. Yes, I'm quite comfortable.

A JOB WELL DONE

I'll tell you what I lived for and that's the reason I can sit back now, and that was to really do a good job raising our five children. When our children were growing up, most black women did domestic work. My wife refused to do

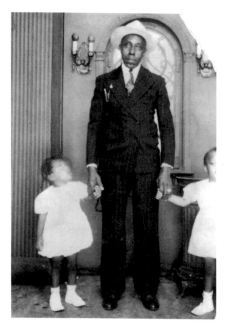

that type. She said she wasn't going to work and raise children, so for the first fifteen years of our marriage she stayed home. Later on I had two jobs, janitorial or whatever, to make a little extra money, and we were able to help get five children through college. It wasn't easy, making twelve to fifteen dollars a week. Reason my folks left the South and come here, they wanted something better for me, and I also wanted something better for my children. We stressed respect, education, education, education and respect. Luvenia and I are both appreciative of the fact that our children have such good educations and have accomplished so much. She was in that struggle right along with me. We have so much satisfaction out of seeing them so successful.

Clarence Fitzpatrick, Clifton Fitzpatrick's father, with his two oldest granddaughters, Chris and Connie, 1944. *Courtesy of Clifton Fitzpatrick.*

The Fitzpatricks in Paris. *Courtesy of Clifton Fitzpatrick.*

You ask, if I could have lived in any time, what would I pick? God, the time I was in. I'm glad I came up in the little period that I did, didn't have anything; had something to strive for. And I think I have seen this country make some tremendous changes, *tremendous*—I wouldn't change a thing. Then, when I was in that terrific struggle for equality, I would have liked to change everything, believe me, 'cause it was tough being black and extremely poor and to be turned down on jobs. You couldn't go to this place and eat; you couldn't go to this place to do that. It was rough. *It was rough.* If I could have seen in the future how my children turned out, I could have relaxed a little back then, but I always lived in constant fear that they wouldn't get the opportunities that I didn't have.

God, this America, if they only lived up to the true meaning of its creed it could be beautiful, the concept, beautiful. Forget all of this darn race stuff and let's live!

EDNA McKINNEY

Edna McKinney was born in 1929 at City Hospital. She was employed by the City of St. Louis in the Collector of Revenue Office in the Earnings Tax Department. She also worked for the St. Louis Metropolitan Bar Association in the Lawyer Referral Service.

ACROSS THE BRIDGE

Originally, blacks in St. Louis lived south, below Grand Avenue, and when I was born, my family lived south, on LaSalle Street and on Hickory Street prior to that. They went to the Compton Hill Baptist Church and would go to Carondelet Park for picnics.

I don't know why we moved north. I was too little to know, but we came north across the Grand Avenue Bridge. We used to go back across the Grand Avenue Bridge every Sunday to go to church. Our roots were there, it was understood. We kept in contact. And coming back home after church, we'd stop at the Pevely Dairy ice cream parlor and get our ice cream cones. It was understood you would walk. Very few people had cars. If a black family had a car, they were considered really well off.

A funny thing happened. If the black kids who remained on the south side didn't know you, some of them became a little hostile because you came from the north side. Consequently, there used to be fights across the bridge. For instance, there was not a community center on this side that we could go to, that we knew of right away, so we'd go to Buder, what they called a

bathhouse. It was on the south side, I think near Jefferson. We would go back over to this Buder recreational facility, see, all this kept us in contact too, and the kids would say, "Oh, *you* don't belong over here." And they would run us across the bridge. The bridge would be like a battleground sometimes. It would be nothing like today where kids had weapons, nothing like that. It would just be, they thought you were northerners, you were outside, you lived on the north side. *What are you coming here for?* Everyone had their territories, that sort of thing.

I've always been kind of adventuresome. It didn't bother me too much to move. All of us kids came together at picnics, so you saw them. You didn't really lose friendship completely, do you know what I mean?

The Compton Hill Baptist Church has an annual picnic called the South Side Picnic. I went just last year, saw people who knew me. I didn't know *all* of them, but they were from "across the bridge," as we call it, from the south St. Louis area. I enjoy going back. I remember that the *church* kept us together.

OUR HOMES

I started kindergarten at the Lincoln Elementary School, and when we moved north to Lucas Avenue, I went to Banneker. When we moved to the house on Laclede, I changed to Waring and graduated from there and then Vashon High School.

Our homes on Laclede and Lucas were big houses. You see, we had *roomers*, and the main reason to move was to get bigger houses, so we could have more roomers and boarders and make more money.

My mother and father were separated. I lived with my mother and her sister, two uncles and a cousin. My mother worked at a laundry and my aunt did the cooking, she kept the house going.

In the 1930s, everybody had rooming houses. You could rent as big a house as you wanted and make money. You didn't have to own it. Some people did own their own houses, but very few blacks did. They rented and sub-rented. Blacks didn't rent apartments in those days, so there were always people looking for rooms to rent. They had rooms, well now they call them studios, but we used to call them kitchenettes, a sleeping room is what it was. There would be a bed, a dresser, and if there weren't enough closets, they had a chifforobe, and sometimes those were built into the wall.

Usually, we had the first floor; that was the family's floor with rooms on the hall; me and my mother shared a room and a bed. My aunt had her room, and then there would be my cousin, and then the kitchen and the dining room. The living room—they called it the parlor—was always immaculate and was off limits for children. Now some of the rooms in the house had what you call linoleums, but the parlor had carpeting. The parlor was kept special for company, no kids allowed, and if there was company, the kids would go outside or you'd be in the kitchen or some other part of the house, but no, *not in the parlor*, honey, *that's for grown-ups.*

ROOMERS AND BOARDERS

Roomers were on the second floor, and you could have a tenant in the attic on the third floor and there might be a kitchen there too. We often had tenants, roomers, that ran on the road, *the railroad.* They were not there all the time. They kept their rooms for when they were in town. My aunt liked to deal with men tenants because they wanted meals cooked and that meant more money, so when they were in town my aunt did the cooking for them. So we had a combination rooming and boardinghouse. These people paid for the food and rental if they didn't cook. Everybody locked their own doors and went and came when they got ready. You didn't go to hotels in those days. I don't believe there were any for black people.

I was always in and out of the tenants' rooms. I had to know *everything.* My aunt didn't like it too much, and she kept watch on me. The railroad men traveled out of town and came and went at various times. There was one man that used to sing and play a harmonica. I would always go to his room and listen, and I wanted to hear stories, because at the time, the well-to-do people rode the railroad a lot, of course, everybody did, 'cause they didn't have a lot of flying going on. Those railroad men used to tell me about the tips these people gave them. Yeah, that was *big* money. I don't think they were paid a lot, so their tips earned them extra money. Some were porters, some were cooks, and my aunt like to experiment with their different recipes. She was ticky about the kitchen, but she would let one or two of them that she liked come into the kitchen and cook.

I always said, "Someday *I'm* going to ride on the train, and *I'm* going to tip people *too.*" I was always a big dreamer about that, and later on, *I did it!*

Another roomer, a lady, I don't remember her name. I don't know if you've seen, I call them street peddlers. So this lady, she cooked, she had a big oven in her own room. All of them didn't eat in our kitchen.

I would go to the store with her. Have you seen slab bacon? She would get the skins, in those days they'd tie it up in big bundles and it just fascinated me to this day. I get real tickled today when I see these bacon skins in these little bags, because they're not good. *Hers* were the ones—*the originals*.

She would bring those bundles home and untie them and lay them out in long pans and put them in the oven, and of course they would get real crispy. When they would cool, she would let me help her break them up. She had little bags, and she would put those skins in there, and then she had little bottles of hot sauce and she would carry all of this in a big wicker basket with a handle. She would go out to these taverns at night and sell these skins. And of course, I ate all I could. *Why?* Because I was helping her.

In those days, people did a lot of that, neighborhood peddlers, pushcarts, and nobody really bothered them. Where I lived, the ice cream man would come; then they had the bin with the tamales, and then the vegetable men. Mostly the Italian people would bring the fresh vegetables. They had a bell and would ring and my aunt would say, "Oh, Edna Mae, go on out in the yard and tell 'em I'll be down." And she would take off her apron and go on down and bring the money out. And there would be the iceman. He came every day in the summer. It was always a *parade of folk* comin' up and down the street with bells ringing and this and that and the other, you know, and people would come out. You got things at the store, but these people were just folk that you traded with, and my aunt always thought the vegetables were fresher than at the grocery store because too many people handled them. As I said before, she was ticky about people handling our food.

TWO FAMILIES

The other part of my family, my father, he pitched his money in with his mother and sister, and they all bought a family home out in the Ville. Now they didn't have any roomers, this was *their* house. I never went up in that area until they bought this home, and then when school was out at Vashon I would spend summers with them. Let me tell you, it was *segregation* of a different sort, I mean among your *own* people. It's just one of those

things. The system has made it that way because they had divided us within ourselves. I say the system, the *white* system, the *only* system we have.

The only people who could live in the Ville were professional blacks, your teachers and doctors. They were the ones who could afford to buy these homes. When the football teams came together, Vashon would play against Sumner, of course I was kind of divided because I had friends, as they say, "in the Ville" and then down here below Grand where I actually lived.

When I went out in the Ville in the summer to stay with my father's family, the kids that I made friends with out there, they accepted you, but some of them had a snooty attitude. And you know what blacks would do at that time? They would say, "Where does *your* mother work?" My mother worked in a laundry, and they kind of turned up their nose at that because maybe this person's father would be a doctor or a lawyer. See, it's a wonderful thing for blacks to attain *anything at all* under the system, but when they do it and then look down on those that have been left behind, that's the problem right there, among blacks themselves. This is what I'm trying to tell you. OK? So as you grew up, there was this stigma thing about where you came from, *across* Grand or *below* Grand or *west* of Grand.

MY MOTHER

My mother didn't deal with people too much because she said they created problems. She said women who didn't work were problem women because all they did was sit around and gossip. I realize now that my mother was afraid of them because people tend to, as she said, "put your business in the streets." They like to find out what's going on in your home and how you make it and tell others. She said, "Your life is private," and she would tell my aunt when they had arguments, "If you would stay off that back fence," she would be hanging clothes, you know, they hung clothes in those days, nobody never had no laundromat. Anyway, my aunt Lula was considered the gossiper, but she was a very sweet person, very ladylike. I learned a lot from her because I was with her in the kitchen all the time. My aunt was a big cook and she'd say, "Do you think it's enough seasoning in here, Edna Mae?" And sometimes I'd say, "Let me see," so I could have a little more, and sometimes I could pinch off some dough and put it in a pan and she'd let me bake somethin'. I *loved* to get those tidbits.

I learned about men from my mother. My father was a gambler, and he drank. I never lived with my father because they separated before I was born. My mother told me, "If you've been mistreated, you don't stay with a man." She told me, "Some people, some women, are long suffering." The longer I live the more I realize what she said. People have their fortieth anniversary and she'd say, "You never know what's going on behind closed doors. People keep up a false front." They have a public face, but you never know what they are doing behind the scenes.

My mother was a wise woman. She was not educated, but she had, what is that they call it, "mother wit," *good common sense.*

She told me, "You got your head in a book all the time, but when you get down to it, life is what I tell you. People will betray you and you've got to be careful, you just have to be careful."

She said, "Look at my sister, the tenants walk all over her." The roomers didn't always pay on time, and some of the men on the railroad would come in and tell their wonderful stories about their travels and bring her sweets and so they satisfied her. I learned to do that myself. If I wanted to be out a little later and my mother wasn't home, I would bring her a candy bar or a strawberry ice cream and she'd say, "Oh, Edna Mae, you're the *sweetest* child." She'd get in her rocking chair, and I'd ask her about old times. I wanted to know more about my family. Mother wouldn't talk about it too much. My aunt was the type of person that did all the talking. You could ask my aunt anything, but my mother, *no,* she would just go so far and then cut you off and that would be the end of it.

DAY AFTER DAY

My mother worked in a laundry, National Laundry, very hard work, on what they call a mangle. I always wanted to work and have money, and one summer before I started high school, I wanted to get me some new clothes. My mother said she'd talk to her boss. This laundry was over on Laclede Avenue. They would have this door opened because they didn't have any air conditioning in those days. The laundry workers would come outside for their break, and these little peddling people would come by with cold sodas.

They hired me and put me on one of those mangle things to show me how to fold these sheets. In those days, everybody had white sheets and they had to be starched. The sheet would come out of the mangle and you had to

catch them. Then one person would catch one end, you catch the other and they did it so fast, you dare not drop one, but I did. They would bring them together and then that person would walk with you, one end and then the other, and by the time they walked back they had it folded, and it would go on a big long slab table and then you'd go right back. It was an assembly line where, let me tell you, my little hands hurt so bad, when the twelve o'clock whistle blew, that was the break and everybody would go outside.

My mother said, "You were kind of slow, but you'll catch on."

I said, "I'm going home, mother." I walked out of there, went home and told my aunt. She said, "Well, you wanted to make money, and *that's* the way and your mother does it *every day*."

"I don't know how she does that," and my aunt told me, "well, don't you worry about it, you just keep on with your books. You can do something different."

My mother's hands would be all red from that heat and then that starch. I had a *healthy respect* for what my mother did, *day after day after day.*

A Little Rag Doll

My mother was never home. I realize now that I was a late in life child and she had to work extra hard. When you have a baby at forty-four, that late in life and unexpected, to an uneducated woman, and you and your husband are separated, you don't know how you're going to make it. They didn't have the laws then that they do now, as far as child support and that sort of thing.

My aunts were very encouraging. They played more a part in my life than anything, because I had two, one on each end, my father's sister and my mother's sister, they always really kept me pumped up. And I loved them *dearly*. I loved my mother, but I didn't see a lot of her because when she would come in from work, she wanted to be quiet, she was resting up and she didn't go a lot of places. She went to church though and she would church you to death!

My father's sister, my aunt in the Ville, was Jeanette Davis, but everyone called her Aunt Janey. She never had children, and she took me places and exposed me to things I'd never seen before. She took me to the country. I saw that blacks had a farm right next to a white farm. A funny thing about country people, it seemed to me that they were more integrated. Aunt Janey liked to sew, and she always took extra time to make me dresses. When I'd

stay out there in the summer, I knew that she would be sewing so I could have nice clothes, because my mother didn't make much money, and the rooming and boardinghouse money, that was divided between Aunt Lula and my mother. Aunt Janey was so inspirational to me. She always encouraged me to, as she used to say, "Lift my head up and do other things," not just working in low-paying jobs and not just dating *any* boy. She had, as my cousin said, "more class than most people." She just had high ideals; I'll put it that way. She made me reach!

My mother's sister, Aunt Lula, was that way too. She was always there when I needed her if I had crying spells about anything that happened at school, mainly about clothes. Aunt Lula kept the household running while my mother was away working, and if any problems came up, she was there, because I would tell her things before my mother got home. She would be my problem solver. If I didn't have my aunts, I think I would have been a little rag doll, you know what I mean?

The Way It Was

Here's the thing I really couldn't stand. I worked ever since I was twelve. I worked for Mr. and Mrs. Fischer, so I had money. I wanted to buy different things. I liked clothes, and if you went to Sumner, you had to have clothes. You could get away with not looking too good at Vashon because it was just a different class of blacks that went there, but at Sumner, because their parents were professional people, they had better clothing. I felt pressure about this, but I loved going out to the Ville. I wanted to let them know I was an honor student. They didn't make as good grades as I did, and to me, that was the *most* important. In a way, going to Sumner was sort of like going to a white school, but it was more like going into a sorority where you had to really *shine*.

When there were different parties going on, some of my friends below Grand would say, "Oh, you're going to be with your West End friends." That really got me, because to me, if you were my friend, you were my friend. I didn't care where you came from, but that's the way they looked on it. I also caught abuse because I always had my head in a book. They thought honor students were just "too much."

So this was during World War II. Blacks made good money then because they finally hired them in defense plants, and then there was that problem

of *eating*. The black employees couldn't eat in restaurants in certain areas of the city. Whites had that "food thing," but you know, even now when I look back on it, I think it's so amusing because their cooks would be black. I wouldn't want anybody to nurse my baby or cook my food. I'd rather just go to the movies with you and sit beside you but not handle the food. But that's the way it was.

So anyway, at age twelve, I went to work for Mr. and Mrs. Sam Fischer. They had this Fischer's Restaurant. It was right over here on Theresa, a black restaurant in a black neighborhood. People would buy food on what they called a meal ticket plan. They had a punch card, they got their meals, they punched the card, and when they got paid, they paid it off. The purpose was to get food to the black defense workers, and they needed a girl to work after school. They had two operations. This is how they made *big* bucks. They had this one side set aside for an ice cream parlor and a jukebox, and the kids would come in after school and congregate there. I'd fix up the malted milks. Then there was the restaurant side where people came in with the meal tickets. They had this big truck, and they had long pans of corn bread made, ham and beans and stews, and I would help pack all these plates and load the trucks and they would take it out to the defense plants for blacks who couldn't get into a restaurant to eat. This was an everyday thing. That way they got their hot food, they call it soul food now, but it was home cooking. Anybody could come out to the truck if they wanted to and buy something, but the main purpose was to stop this food segregation or help them to combat it by getting food. People could bring sandwiches from home, but they couldn't go into a sit-down restaurant. They didn't serve coloreds at that time. So this Mr. and Mrs. Fischer caught on to this and decided they would help, and they made money. I worked on Saturdays too, and that money helped me to buy my clothes and to get through school.

THE SAME BUT DIFFERENT

When I was young, I knew from history that Missouri was a borderline state and a lot of people came here from the South. Although we did have some slavery selling and that sort of thing here, it wasn't like what the kids that came here from the South told me about their relatives being hung. See, *those* black people came up with that. *They saw it.* We were insulted and we were segregated, but it's a different type thing than when you walk out in your

yard and see somebody hanging your folk. We never saw *anything* like that here. I knew it happened, I read about it so I wanted to go to their houses and hear it firsthand. And I wanted to find out about this food that they were talking about all the time. Southern people cook differently than northern people. I never heard of grits before.

I remember this girl, going to their house, their people all slept on the floor, *they slept on the floor*! And I told my mother they didn't have any beds. Maybe the mother and father had the bed, but the children, that I recall, had homemade quilts.

The whole idea of comin' here was for their children to have a better place. You know, it's been several escapes in the black race. People escaped from slavery and then wherever they settled they escaped from that situation, and living conditions were so bad they would come further north where it would be better.

I have a friend that never was into a racial situation. She was born near Canada, or further up near the tip, as I call the States, weren't born into the slavery thing. Her family, they were *free* people.

Anyhow, these blacks from the South moved into the city, the Jefferson and Market area—of course you know blacks had to move in certain areas—okay, so they came here because work was more plentiful. I've learned since I've become grown that some of the black people who lived in this town and grew up in this town felt that they were comin' and they would be takin' jobs from them, and see, it happened, because southern people would work for less and would do most anything to earn a living because they had come here with nothing.

My mother said she never saw so many children in her life until people came from the South—they always had either eight or nine children. It was almost like they were foreigners, because, well—they talked—their language was so different and the favorite term that they used to use all the time would just make me fall out laughing, "I reckon." I know a girl, she's been here forty-two years, but she still says, "I reckon" or "you reckon?" We would say, "Yes, ma'am" and "No, ma'am," we were taught that way, but they would say, "Yessum" or "yessir," something like that—they just had that southern twang.

Here's what I was guilty of. We would say that we were going to go downtown. There were no buses, you know, way back then. At that time we had streetcars, and these kids were fascinated by streetcars. They didn't have any where they came from. We would pay a nickel or a dime to go downtown, and sometimes we would walk. We would get ourselves an ice cream cone, but we couldn't eat it in the store.

Well, this girl and her family always said, "Can we go? Are you going uptown?"

And we'd say, "No."

"Are you all going uptown?"

I said, "Didn't I tell you that it's not *uptown*, country girl?" I said, "Mother, do you hear this girl?"

"I don't want to hear it."

But see, I guess it was a habit from the South. I don't understand, but wherever they shopped, it was uptown from where they lived. When I would tell my mother the stories about the South that the kids told me, she would get angry. She didn't like hearing that they were so mistreated, like they couldn't even walk on the sidewalks down South.

They would be afraid about the stores, whether they could go in or not. I'd say, "You've got money—yeah, you can go in there, but you can't eat lunch there." Well, that didn't surprise them, because they were accustomed to that. But some places where they came from they couldn't go into some of the stores and shop even though they had the money. This puzzled me.

How did I feel about them? I must confess, I did feel superior to them because I was always trying to tell them what they could do. And the kids at school—and I was one of the ringleaders with that—would sometimes make fun of them. You know, how when the teachers would call on them, the way they would pronounce the words. The teachers would get after you about it, 'cause the teachers treated them fairly and helped them with pronunciation. Well, see, I've always been, as Mama would say, "a tickle box." I used to get tickled about everything until I realized the seriousness of it. This was my experience with my *own* people coming from a different part of the country.

A lot of those people from the South did domestic work, but most of the men were laborers and had worked in the fields. There wasn't that sort of work here. They had a program for the poor people, I think Roosevelt started it, called the WPA. My uncles worked in the WPA. Later, when things got better, then they worked in the foundries.

But some of them caught on quick. There were some, *oh Lord, yes*, there were always some that caught on, but they wouldn't always help the others. I was always trained, if you know something, tell somebody else, help somebody else. But everybody is not alike. Well, anyway, some of those people that came from the South never learned, never wanted to learn, but I think now, that they felt they had gotten as far as they were going to go in

coming here, as far as they were going to go. And then there were others who fought to do and go to the highest. I know some who are professors now and have done a lot of things and surpassed anybody who was born and raised in the North. But it was *determination!*

THE VIEW FROM THE PARK—AND OTHER PLACES

Grand Avenue played a big part in my life when I lived down on Laclede. There was a park across the street from the Fox Theater. It was a place where all lovers walked. You'd stroll up Laclede, Lawton or Pine, hold hands with a friend and go to the big Walgreens Drug Store on Grand and Olive. I used to date a fella that worked in there, and he would give me different little things from the store. He worked in stock.

You could go in Walgreens and buy things but you couldn't sit down, so you would get your ice cream, jellybeans or hot peanuts, take it out and go into the park and eat it.

The reason everybody liked to go there was because you could look into the Fox Theater as people were going in, and of course, blacks could not go to the Fox, and that was one of my dreams, *wanting to go to the Fox.* See, they had a doorman then, and when the wealthy people would come out of their limousines, the doorman would help 'em on in goin' into the theater. I would sit there in the park, I don't care who I was with, and I would say, "Oh, *I wished* I could go to the Fox."

My mother would get so mad at me because she'd say, "You *can't* go there. *Why* do you keep running up there and looking and looking and looking?" I couldn't help it, and I would cry. *Anything*—to me—that was forbidden, I *wanted* to do it. I was very intense about that.

The downtown area bothered me. I didn't want to eat at the Famous Barr Department Store's little attic-like counter that was set aside for, well, they said "colored" at that time—different titles, but the same thing. And I remember how I used to go there once or twice and eat a hot dog, but I would *choke* on it. Whether I walked downtown or took the streetcar, I would come home in time to eat because I didn't want to eat at that segregated lunch counter. I guess I could have brought a sandwich from home and eaten it in the park across from Union Station, but you couldn't sit there too long because they always watched black kids because they thought they were going to do something. We're talking 1940s now.

Edna McKinney

There were blacks who were determined that they were going to break up that "not eating business" downtown, and they started having demonstrations. I watched all that. My mother thought that nothing was going to come of it. But it did. *It really did.* Later in life when I worked at Famous Credit Office, I used to get so tickled and I said, "I'm sitting up here in this office now and I can eat in Famous' dining room," and you know, those things are something that you don't let go of right away.

My mother had passed, but I wondered if she could see this. *I'm* the one giving orders about "you better pay on your charge," you know, giving them a little threat. I felt good about that, and the idea that I could go downstairs and have one of the white salon people do my hair. I tell my daughter—"we have come a *long* way, quiet as it's kept, because I can recall when you just couldn't do certain things in these stores."

So then, my neighbor down the hall, she worked on Grand Avenue in that big hotel, the Melbourne, I don't know if you remember that. We had a friend, and he was a famous doorman there. They wrote him up every now and then in the newspapers. I think his name was—they called him "Snow." He wore his uniform in such a way, you know, and he handled the ladies in such a way, I used to walk around there, and I said, "One day I'm gonna' go in there, the Melbourne Hotel. I want to go in a hotel and have 'em take my arm and escort me in and show me, you know, whatever." It's something that you wanted to do within you, but I knew better than to discuss it too much with my mother, because it would make her angry. But on the other hand, my aunt Lula, you could talk to her about anything, and she said, "Well, you can have your dreams," but she really didn't think that would ever happen, and of course, she outlived my mother and she got to see that the Fox was open to blacks.

I was so excited when I got to go in these places—and I wouldn't date anybody that wouldn't take me there. I *never ever* would go out with any man that didn't have the means or didn't have the same ideas. That's one thing that broke up my marriage. My husband said, "You're too much of a dreamer." He was just content to be and do whatever he did, but that never satisfied me. After our divorce, I became involved with a person that was in a higher position in politics, and I got to go and do everything that I ever wanted to do.

Oh *yes*, it made a *difference*. It did help make the hurt go away. I felt like I was on the same level with other human beings. You know what I mean? Before, I felt like I was just, how shall I put it? My mother always said, "Nobody is any better than you; don't look down on yourself." But I just felt

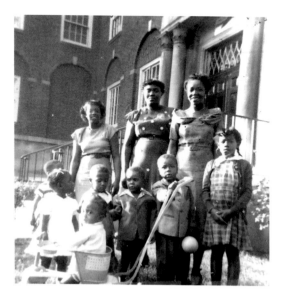

Edna McKinney (left) at her daughter Rosalind's second birthday party in front of the Phyllis Wheatley YWCA, 709 North Garrison, 1951. *Courtesy of Edna McKinney.*

like, "Well, *why can't I do these things?*" But as I grew older, I understood that there were some things that were done socially that a lot of the whites couldn't do either because they didn't have the means, and I thought, "It goes back to the almighty dollar, not always racial."

In the beginning, I went to the Fox and then to the hotels for dinner, and I wanted to be waited on by a Caucasian person. I didn't care if it was a Latin or whoever, I didn't want a black to wait on me. I just wanted to *feel different.* Do you understand what I'm saying? I just wanted to do *all* those things.

Some black people will say—it's an expression that blacks use—"*you want to be too much.*" I don't know if you've heard that term, "you want to be too much." Now my mother put it this way: "It takes *too much* to do you, Edna Mae. You're *never* satisfied."

I said, "No, I'm not." That's why I always work two or three jobs. Being poor, you felt that you wanted things that were beyond you and you were never going to attain them. But I felt that I *could* have my dreams if I wanted to, and I was going to somehow manage to do those things, and—I did them!

Now the younger generation, well, they take that for granted, because, see they are born into a different time. Things are already open for them. But for us, it was—each thing was an achievement, and that's the way I felt about goin' to the Fox. When they opened it, I just had to get there, because, all my life I wanted to get in there.

Edna McKinney

The Young Democrats

In the early 1950s, I went with my girlfriend to the Young Democrats meeting at Jordan Chambers Democratic Club headquarters at Cardinal and Franklin Avenue. The headquarters was in an old house, and there were meeting rooms, a lounge, a bar and a kitchen where they sold food and entertained. The Young Democrats were newly registered young people, just turned twenty-one. At that time you had to be twenty-one to vote. It was like a training field, young troops sent out to do the grass-roots work, to ring doorbells, register people to vote, help get the message around. I was fascinated and became involved. I went to meetings, solicited people to vote and did other volunteer work at the headquarters. I was eventually selected to be a delegate to the Young Democratic Convention in Cape Girardeau.

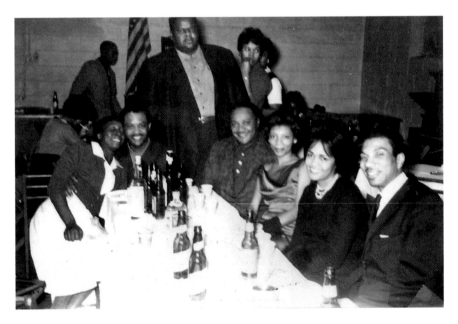

A group of young Democrats under Jordan Chamber's charter after a meeting at Jordan Chamber's Nineteenth Ward Regular Democratic Organization Headquarters, 3100 Franklin Avenue, in the early 1950s. *Courtesy of Edna Mckinney.*

JORDAN CHAMBERS

Pop [often referred to as Pops] Chambers, that's what everybody called him, was, at that time, the grandfather of it all in St. Louis, as far as the black politicians were concerned. He was the Democratic committeeman for the city's Nineteenth Ward and had the charter for the Young Democrats. His business, the Peoples Undertaking Parlor, was in a row of flats next to his headquarters, 3100 Franklin Avenue. He did a lot of embalming for the city. He also owned the Riviera Club at 4400 Delmar. He was a constable in the city, had his own office at the civil courts and his own deputy staff. They mainly took care of evictions, served papers and other things.

He was *all powerful*, and his power was not only just in the black community but also in the white community. When he walked into city hall or the courts—everything stopped. If you wanted to get on the police board, you had to go through him. He put the first black clerks in the state office where you get the license plates for your cars. They never had black clerks there; in fact, he put the first black clerks into the city system. They were all matrons before.

See, he *updated* his people. He didn't take jobs mainly because they were just handed to him. He wanted the people to have better conditions, better salaries and this is one thing I admired about him. I thought anybody could

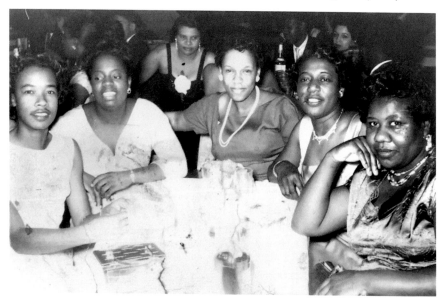

Ladies' night out in the 1950s. *Courtesy of Edna McKinney.*

sling a mop or a broom, and a lot of people did raise their families by being porters and matrons, but they couldn't get any better.

When he would come to address our Young Democrats meetings, he would always say, "Stay in school" or "Go to night school. Do something to advance yourself, so if I get the openings for a job, you'll be qualified." I liked that about him. He taught that, and back then, a high school diploma was equal to getting some kind of job, what they used to call a clean-cut job.

He got these jobs *through his power*. See, he had the *black vote*. If there was a citywide election where the black vote made the difference, the white politicians *had to come to him*. The majority of black people would not vote unless Pop Chambers endorsed that particular candidate. But he would not back a candidate, white or black, unless he felt they would offer decent jobs for blacks.

I'll tell you what else I admired him for. His organization would always give a lot to the needy. Now, near his business there on Cardinal and Franklin, there were people who lived in—what you would call now—cold-water flats. He would see that these people would have heat, like if they burned coal. And I also remember turning in lists of people who needed food baskets and things of that nature. He was always trying to help people, and if he couldn't get them a political job, he hired a lot of people at his Riviera Club.

You'd see him downtown. You'd be walking across the street at city hall, and people would come up there and say, "Uh, Pop, uh, I don't have any lunch money, I need this or that," and he'd go in his pocket and give 'em five dollars or so. He was a generous person. That's just the way that was.

THE RIVIERA

The Riviera Club was not only a club for entertainment. It was a meeting place of officials from all over this city—black and white. They would come in, have meetings in his place and enjoy the entertainment. It was live chorus girls. You had people like Dinah Washington, Nat King Cole, people like that came there.

There were people who had their tables reserved for them and there were dignitaries. They had a cocktail lounge and a private meeting room, so the city treasurer and all the bigwigs who wanted to talk politics in smoke-filled rooms went there. A lot of deals were hatched right there. A lot of people who couldn't get in touch with Jordan Chambers downtown contacted him there. So the Riviera was the place to be.

MONEY AND CLOUT

Jordan Chambers decided that he would have a contest among his ladies to determine who could raise the most money for the main organization. The winner would be the first queen of the Nineteenth Ward Regular Democratic Organization, and that girl would reign for one year. She would have political clout, like when we went to Jefferson City she would preside with him in all the big events. And, in those days, you had to have different evening gowns for every occasion. And "you stepped out," as my aunt would say, and *I* stepped *out*, babe.

I was crowned queen of the Nineteenth Ward Regular Democratic Organization at the Riviera Club, Jordan Chamber's nightclub, in 1959. I raised the most money, I beat 'em all good, and I won that crown. I entertained at the bar and I sold barbecue. I knew how to cook 'cause my folks used to have a barbecue business in the yard next to our house. So I brought those dinners down to city hall and sold them. That's how I became queen. So now, I was in both organizations, the Young Democrats and the parent organization. So then I would go as an alternate delegate to the big conventions. It all boils down to money and clout.

I got to meet a lot of people and do a lot of things. Then I started writing a few speeches and, oh, I really got involved with the whole thing. I was very excited about it, and I liked it.

My girlfriend—she was real sharp—told me, "You work yourself into a job." And after a few years, Chambers called me in and told me there was a girl I was replacing at city hall and he said, "If your first paycheck isn't what I tell you it is, give it back." I mainly started as a clerk filing in the Earnings Tax Department.

BUT NOT THE POWER

Jordan Chambers not only operated in the city, he backed senators and people from different counties that ran for election in the state. He had far-reaching power. And he had a private railroad coach that would hook onto the train that would go through to Kansas City and they would unhook us at Jefferson City. We'd go there for meetings and the Governor's Ball and everybody would say, "Mr. Chambers is here." He wore this ten-gallon white hat—that was his trademark—and this little string tie thing, and he was

Edna McKinney

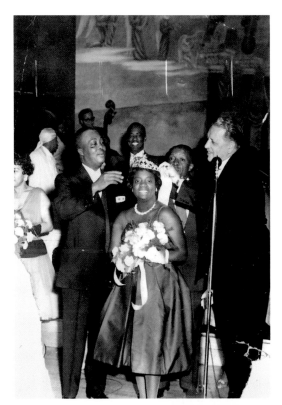

Right: Coronation of queen of the Nineteenth Ward Regular Democratic Organization. *Left to right*: Sam Goldston, vice-president of Jordan Chamber's Democratic Organization; Edna McKinney; Mark Holloran, candidate for mayor of St. Louis. The Riviera, 4460 Delmar, 1959. *Courtesy of Edna McKinney.*

Below: Edna's retirement as queen in 1961. *Courtesy of Edna McKinney.*

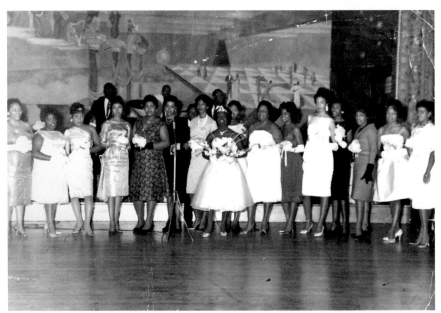

accorded a seat right up with Governor Donnelly and everybody, and we were always invited to the hotels and the best places.

Now, when he died, he was honored just that way. That was in 1962, and I was still working as a clerk at city hall. He was laid out at his own funeral parlor, Peoples Funeral Parlor, oh, I think about three or four days. People came from all over the state—from all these different towns, the various mayors, senators and people.

Governor Donnelly came—*everybody* came. They had this funeral march. Governor Donnelly led the body all through the streets. It was *something*. The streets were blocked off—the police had their motorcade. The procession was *endless*. I'm telling you it was a sight to behold.

People were just running around everywhere. The political folk were scattering, trying to get things together because they had deals that this man, Jordan Chambers, had put into operation—a lot of deals pending—that were at stake for the coming election. So people were in little groups, like bees, conversing all during the time of the funeral as to who was going to be the successor. Who was trained to handle these things? They thought the organization would be weakened because he was gone, and some were concerned if they could possibly lose their jobs.

The black community lost a *great power*. Jordan Chambers *was* the *power*. I can remember thinking, "I don't know who they have in the organization that—well, they won't have his power. They'll have his position, but *not the power*."

THEY CREATED A MONSTER

African Americans wouldn't be here if the whites hadn't wanted to have free labor, so they brought them here as slaves. They had no intention of one day letting us go free and get into their society. That was not intended. Once the slaves were let loose—as they say—what to do with them now? Now you have to pay them and the whites would have to lose some of their richness. Well, I can imagine it would be hard. I think it would be hard if I had someone doing everything for free and then all at once the law said I had to pay them.

They would let you into a position, maybe in the big corporation, but not, as a rule, at the salary that the person you replaced had—even though you worked yourself into it.

The black person is the monster that they have let loose and has gotten into their society, into their financial world, and they have to deal with him, and they have to pay him and now more than likely, in most positions, they're going to have to pay him according to what they should pay another person.

How can we get rid of this monster? This is the $64,000 question. I don't know if it will ever be settled, and I don't think in my lifetime, I really don't. People would say, I guess, that all of those racist people would have to die out. Well, that's not going to happen—not all of them. But you have to deal with it.

The way I taught my daughter was this: You are equal to anybody. You must have the opportunity, but first, *you must study*. My daughter said she didn't want to stay in and study her typewriter and do all of this shorthand. I made her turn off the television. I told her, "You can't go anyplace, and nobody can come in 'til you finish your studies." Now she's GS6, she's secretary to a major—she's had good positions.

My whole life has been based on money. My mother told me that *everything* is about money. If you take my money then you should treat me equally or give me services that you're supposed to render to anyone else for that amount of money—and pay me equally for services that I give. Otherwise, I feel I'm being cheated. If I'm going to pay to get on a bus, I'm going to sit where I want to sit.

I put it a little different to my daughter. I told her, "The color of the skin is different, but *the money is all green.*"

Chapter 5

DEMOSTHENES DUBOSE

Demosthenes DuBose was born in City Hospital #2 in St. Louis, Missouri, in 1924. He received his master's degree from Washington University in 1972. He was associated with the St. Louis public school system as a teacher and president of the Teachers' Union Local. He was director of employee relations for the board of education.

EARLY LIFE

My father was my role model. He was a foundry worker, a metal chipper at Magnus Metal, on Clayton Avenue, for about thirty years. He used an air jackhammer, a huge and heavy device, very much like those things that they break up streets with except it was built to be held in your hand. I didn't know exactly what he was doing, but it seemed like awfully hard work to me. During World War II, they went on a twenty-four-hour shift, and he was one of the persons they chose to work at night. Because it was unsupervised and they were their own bosses, he was pretty proud that they had selected him for that, and he made more money doing it too.

My father was disciplined. He could make up his mind what he thought was best, and he'd stick to it. When I grew up, in all the jobs I had, when I quit on Friday, I had another job on Monday. I never had a gap. I thought it was sinful to miss a payday, and I still think so. I got that discipline from my father.

My mother did domestic work, mostly washing and ironing and sometimes housecleaning. She got along well with the people she worked for, but she

would tell us that she felt they were doing a very poor job of disciplining their children. Her solution was to slap the hell out of you; that's what she'd do when she got angry and would turn on me. I learned to grab her and turn her around, then I would run out of the house and come back after she had cooled off.

I don't think either of my parents got past the tenth grade. We would always eat dinner together, and after dinner they would read the newspaper and then discuss what they had read. I think that's where my sisters and I got in the habit of reading. I remember reading newspapers at a very young age. Though we didn't participate in our parents' discussions, we sat there listening to them. With no television, we used to listen to programs on the radio. We only had one radio, so we listened as a family, and sometimes that was discussed. They liked to play cards, whist. My dad played with my mother, and I played with my sisters.

We were all given Greek names; my sisters' names were Deliska and Ione. My mother claims they came from the volumes of Greek classics we had in our home.

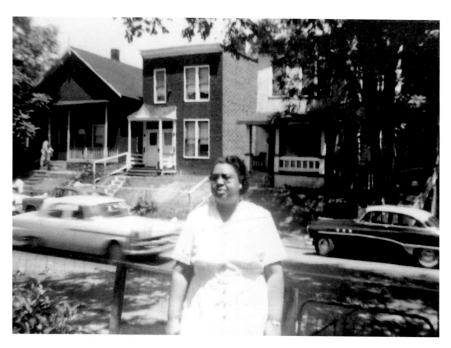

Pauline Carter, DuBose's mother, 4350 St. Louis Avenue, 1950s. *Courtesy of Demosthenes DuBose.*

My parents especially liked to go on picnics. We walked from the Ville to O'Fallon Park, and at the time it seemed like a hundred miles. My dad never owned a car during the entire time that he lived.

My parents were very proud of what they had done and how well they maintained the family. They were very strict about saving. They wouldn't save *much*, but they always saved a little every week. They kept a strict budget for groceries. I do recall them discussing it, and we would sit and watch them. They'd make a list of what they needed to buy and how much it was going to cost and they would stick to that. And, of course, that was during the time that for five dollars it took all five of us to bring home whatever we bought.

If my parents had any prejudices, if they disliked a person, there was no big deal made of it. There was obviously remarks made about blacks and whites and things whites did that they didn't like, but there was no real discussion of it. They taught us to treat people the way you want to be treated. And both my dad and my mother would go out of their way to help someone, and I pretty much do the same thing.

Status Quo

What first made me aware that there were people whose skin was a different color than mine? I have no idea except that the difference was so obvious if you grew up in a self-contained community like I did. The Ville was peopled primarily, almost exclusively, by blacks except for the people who owned the stores. There were restaurants, movies, nightclubs and schools. There was the Ameytis Theater in the Poro College Building on Pendleton, the Douglas Theater on Whittier and Finney and the crème de la crème, the Comet Theater on Sarah and Finney. It was the newest, and they got most of the first-run movies and they would put you out for loud talking. You had to behave yourself there. They also had live performances at midnight, and I saw Billy Eckstine there for the first time. I remember how I walked there from St. Louis Avenue and walked back with no fear. Oh, you may have gotten a bloody nose or got a hit on the head, but you didn't have to worry about getting killed. People had guns, but nobody carried a gun around to shoot anyone.

There was a time when you could have stayed completely in the black community for almost everything, and on Friday and Saturday nights you could have gone to hear Jimmy Forrest and some of the great jazzmen. They all played here in these little nightclubs and bars. You could have spent your

whole weekend doing that every week and never see the same person twice. But you can't do it now. They don't exist any longer, because it's diffused. It just doesn't exist.

These were pleasurable experiences. I thought we had some good times, maybe I didn't know what good times were, but I thought I did. We just closed out all the other stuff that had to do with race and anything like that. It was *always* in the back of your mind, I'm sure. You just didn't pay that much attention to it, because it didn't enter too much into your everyday life. It was only when you went outside that cocoon—which wasn't that often, except to go downtown shopping or to O'Fallon Park or Forest Park.

We would go downtown to shop, and my parents would comment about the fact that blacks weren't permitted to work downtown in the stores unless they were running elevators or pushing a broom and that the only facility where blacks could eat was a waist-high counter—either at Famous or Scruggs—where blacks had to *stand up* and *eat*. My parents *refused* to eat there. If they ever got hungry, they would just do without until they got home. But their comments were only conversations. They didn't go into it in any depth because they didn't need to, they didn't feel the need to and they didn't. My sisters and I were aware of what was happening. It made you feel unwanted, especially in relation to the restaurants—things like that. Yes, you would feel *unwanted*, but it was a part of the status quo so it really didn't bother you that much, because you knew that was the way things were.

I don't really feel that wanted now, to tell you the truth, and that may be a happenstance of childhood. I had been *born* into this. I resented it, of course, because there were certain things I wanted to do, especially after I got to high school and I played on the basketball team at Sumner. I was captain of the team for a while, and we played in a black league that was composed of some teams from Illinois and some teams here in Missouri. We always felt we were much better than the white teams that played. When they won their tournaments, we felt we could have beaten them, but we never played any of them. They would never play us. They weren't allowed to. *It was against the law.*

EAST AND WEST OF GRAND

When I grew up in the Ville, Grand Avenue was the dividing line between two major black communities. Blacks generally lived in a corridor starting east of Jefferson and Market running almost straight west in a sort of a line

to about Taylor Avenue, give or take a few blocks on either side. There were some small enclaves of blacks on the north as far as Sacramento or San Francisco and also on the south side around Carondelet. These people had lived there all of their lives. There was very little interaction between the black people who lived east of Grand and west of Grand. If you lived west of Grand, some people thought you'd moved up a notch. We might have thought of the difference as being class, but no one was really that advanced over anyone else.

There was a huge black community around Jefferson and Market, and the people on the south side participated in that area. They walked north over the bridge across the railroad tracks to get to schools, the movies and restaurants. They were pretty much in the same area, although they were somewhat isolated because they were on the other side of the railroad yard.

You could get in all kinds of trouble being caught east of Grand by the wrong people, and I mean black people. Sumner played basketball against Vashon, and we had a fierce rivalry with them. They would come out to the Ville to play us at Tandy Community Center, and we would go down to play them at the Pine Street Y, which was like a little bandbox or a small gym. You can believe we would be well escorted by our male teachers to get us in

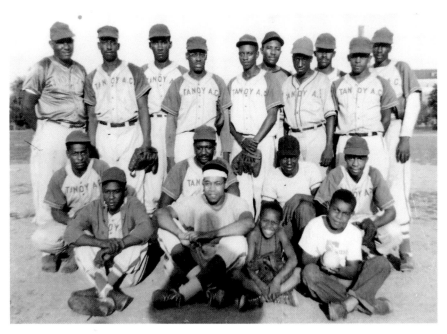

Tandy Municipal Softball League, Tandy Athletic Club, 1946. *Courtesy of Demosthenes DuBose.*

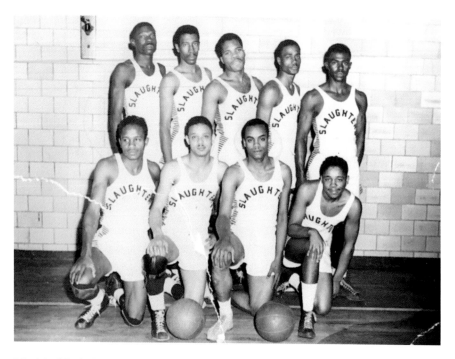

Municipal Basketball League sponsored by Slaughter's Cleaners, Tandy Community Center, 1946. *Courtesy of Demosthenes DuBose.*

and out of there to prevent any mishaps from occurring. We're talking 1939, '40, '41. We also played basketball against Venice, Illinois; Lincoln High School in East St. Louis, and the enclaves of blacks who lived in Webster and Kirkwood, and it was like oil and water with them also.

The likelihood of you marrying someone from east of Grand was remote because you had no interaction with them unless you went to college at Stowe Teachers College or Lincoln University in Jefferson City. I would never have met my wife had it not been for the fact that we both went to Lincoln. She lived over on the south side off of Compton near Lafayette and had gone to Vashon High School.

Many of the people we had lifelong rivalries with, we ran into at college and we became very, very good friends. We used to laugh at how we treated one another and how we hated one another and how well we got along with each other once we got up to Lincoln.

REMEMBERING PARKMOOR AND HOWARD JOHNSON'S

I could tell you some things from childhood that took a long time to get over. Now there is a Parkmoor Restaurant on Clayton Road at Big Bend across from the Esquire Theater, but there used to be a Parkmoor at Cote Brilliante and Kingshighway in the heart of the black neighborhood. They never allowed a black to come in there unless they went in to get a take-out order. I remember how they treated blacks then because we lived over in that neighborhood. It was a long time after they moved and integration came along that they would permit blacks to eat there, and it was a long time after that before I could bring myself to go to the Parkmoor.

There was a Howard Johnson's at Kingshighway and Natural Bridge, and the manager made the remark that he'd never have a black come in and eat. But eventually he did—he had to—and it was a long time before I could go in there too.

I was angry. I wanted to throw a *firebomb* in that restaurant.

HOLLYWOOD

I feel Hollywood would be a good place to put some of the blame for stereotypes. I can recall a movie that we were shown when I was in elementary school depicting blacks with black faces, red eyes and huge white lips. These materials were selected by the audio-visual department of the board of education and shown regularly in the school I attended. They were funny cartoons, and everyone laughed at them.

It was called "entertainment."

I WANTED TO BLOW UP DALLAS

My army experiences didn't really change me. All it did was make me realize that what we had done as black soldiers didn't amount to anything. It just didn't make any difference. As long as you were black, you were going to be whatever you had been previously. It was not going to change anything. And I think all the other guys who went through that felt the same way.

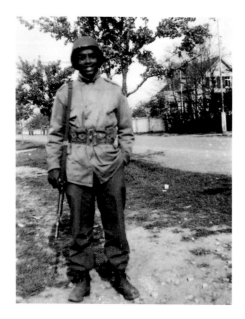

Private First Class Demosthenes DuBose on patrol duty near the Elbe River, Germany, in 1945. *Courtesy of Demosthenes DuBose.*

During World War II, I fought in the Ardennes Forest in Germany in a combat platoon, a self-contained platoon of fifty blacks in the Thirty-ninth Infantry Regiment of the Ninth Division. I came home and went on furlough. I reported to Jefferson Barracks to go to my next assignment, which was Camp Swift, Texas. There were about a dozen of us; three or four of us were black. We caught the train here in St. Louis, and in Texarkana they put us in a Jim Crow car. We all rode together up to that point, and then *they put us in a Jim Crow car.*

We got to Dallas, and the white sergeant who had the meal tickets said, "I'll be right back fellas, I'm going to find someplace for us to eat." We settled down and we *waited* and *waited* and *waited*. Finally he came back and said, "Fellas, I'm sorry, I cannot find anywhere that will let us eat *together*." He said, "I'll just give you your meal tickets and you try to do the best you can." I had on my combat infantry badge and I had all my ribbons, and it just didn't make any *difference*.

We went on from Dallas to Camp Swift, another segregated army post where all the blacks were sitting in one corner of the facility and the whites were in another. There was one movie theater and one PX where blacks were permitted to go.

We didn't try to do anything about this since most of us were anticipating being discharged very shortly. Under normal circumstances, if we were sitting there waiting to go overseas and not knowing what was going to happen, we wouldn't have put up with it. But we decided we just couldn't afford to get into any difficulty that would keep us from being discharged and end up in the guardhouse.

We took all that crap. You wouldn't have done it under any other circumstances. *You just wouldn't have done it.*

Demosthenes DuBose

Cochran Garden Center

While I was going to school in the early 1960s, I got a job working part time for City Recreation as a recreation leader in the Cochran Garden Center down on Ninth Street. They have finally built a gym down there now to house it, but we ran our recreation center from various rooms and basements and whatever areas we could get. The City Recreation Division provided us with all the equipment and everything we needed. Cochran was an all-black public housing project. It was a group of buildings, nine to twelve stories, and *oh God*, there were thousands of people who lived in that area, and we were the only recreation that there was down there.

Grace Hill House had a settlement there, and we always worked closely with them. Eight out of every ten children down there didn't have fathers. I would get off of teaching—then I went down there and worked and in order to get in forty hours, I had to work on Saturday and sometimes a few hours on Sunday. I spent more time down there than I spent at home.

The children were starved for any kind of activity. The other teachers and I would say, "Let's have a track meet," and we'd put up a sign and we would be inundated with anxious children ready to do everything. Since there were only four of us, we had to use the older children to maintain order, to act as officials.

We put on a pageant where we had a queen, and someone said, "Why don't we do a Veiled Prophet?" We got all the children together, and we decorated every wagon in the project. The little four- and five-year-old kids, we couldn't find anything for them to do, so we made them horses—they pulled the wagons. We bolted chairs into the wagons for the queen and her consorts. We had to try to find something for everyone to do because every time you announced something you ended up with so many children you didn't know what the heck to do with them.

These kids attended the Henry School, and because we were all teachers and the kids knew it, they were always coming around to get advice on schoolwork, so we set up regular tutorial sessions. They came because they wanted to know something. The greatest feeling in the world is to be dealing with children who come in an orderly manner and come because they want to learn something. We started off with an hour, and we ended up having to expand that thing to three hours. This would be after school and at night. They would have a homework assignment that they had not understood, and they'd come to us. The teacher had explained it, but they didn't quite get it. Fortunately, we had a girl who was a high school math teacher, and

she was extremely good. Kids would come in there not knowing a doggone thing and they'd walk out knowing everything. I think that was one of the most enjoyable periods of my whole life.

I've kept up with some of those children that we used to have down there. They loved living down there because it was just like an intact city to them. But Cochran wasn't well maintained. They didn't screen their people well. Bertha Gilkey was one of the kids down there at the time. I didn't know her but I'm told, "You should have known her, she was always around there running her mouth just like she is now!"

SEPARATE BUT EQUAL

In 1954, at the time of *Brown v. Topeka*, our school board initially fought integration. They went to court to keep it from occurring, and it was a number of years before they finally threw in the towel and crossed sides. At first they were the defendant and then they became the plaintiff.

I was a route salesman selling for Royal Crown soda then. About a year later, I went back to school and finally graduated from Harris Teachers College in 1961, and I was assigned to the Mason School on the south side at Southwest and Watson. It was an all-white school with all-white teachers. They selected me, Stan Jordan, Doris Harrington and Nadine Hart. We were all graduates of Harris, and we were good friends. We had one thing in common. We were all older people who had been married and had held other jobs before. We found out later that they had purposely selected us because of our supposed maturity. I was anxious to go and begin working. It was my first teaching job.

We bused the children from in front of the Dozier School at Maple and Goodfellow to Mason School. I don't think there was any question that we were pioneers in the process of integration in that there had never been a black teacher or a black child at that school. But we taught only our black children in four self-contained *black* classrooms. *That was supposed to be integration!*

We originally had different recess periods. Our children were in the yard at one period, and everyone else in the building was in the yard at another period. We also had different lunch periods. Margaret Flavin was the principal at Mason School, and I loved her. She didn't like that arrangement, and she got permission from her district superintendent to put all the children together for recess and lunch, and she did just that!

She was a great gal. She told the white parents, "These people are teachers. They are going to do what you find other teachers doing," and she told us that when we're in the yard, "You discipline the white children like you discipline anyone else." That's the way it was.

We were fortunate to have a principal who was straightforward and honest and who would take the position that we and the children we brought would be treated exactly as all the other children in the school. It was a good situation primarily because of the principal. She was determined that it was going to work out well both for us and the children.

Prior to opening up Mason School to black students, there were black teachers who were assigned to all-white schools on the north side like Walnut Park and Walbridge with the same kind of self-contained classrooms as Mason. I heard all kinds of horror stories from the black teachers who taught over there about how they were treated mostly by the other teachers in the building. They did not have nearly as good a situation as we did.

During this time, the NAACP was protesting this artificial integration, the fact that pupils were being bused as a unit and kept as a unit once they arrived at their destination. They also wanted integration of the faculty. One morning, the NAACP blocked the buses. They just stood in front of them and wouldn't allow the buses to leave the Dozier School, and the school board didn't make any attempt to send the buses to Mason. They just left them at Dozier, and that's where we stayed all day. I know it happened one day, and it might have happened twice. I believe it was on TV and in the newspapers, but there were no immediate results from it.

I felt good about what the NAACP had done, because something needed to be done. I thought, "How stupid does the administration think we are that they think we would believe this is integration when we know it isn't? And who in the hell do they think they're fooling?"

The Black Children of Mason School

I don't remember the children we took to Mason School ever wondering or asking why they were in a segregated black classroom in a white school. No, I don't ever recall that ever coming up. I'm sure they knew because it was all over the news. I'm sure their parents had discussed it with them, but I never entered into any formal discussion or anything of that nature, although they

would point out some inequities that they felt existed when they were in the lunchroom or on the playground.

These children were some very bright and inquisitive students, one of the best classes I ever had in the first couple of years I worked. I don't know what effect this experience had on them. I'm not sure if it had much effect one way or the other. Once they graduated from the elementary school, they would have gone to Soldan High School. I think Soldan was integrated, although there weren't that many whites, I think, who still lived in that area at that time. I think they'd all run by then.

REFLECTIONS ON MASON SCHOOL

We were at Mason in the early '60s when they'd started marching all over the South, and there was all this tension between blacks and whites. We ate lunch with the white teachers, and usually the topic of the day would come up, and the topic of the day was black and white issues. We had some disagreements with the white teachers. Those were pretty turbulent times.

The white teachers and the principal got along fine. They called each other by their first names, which I found to be unusual at that time because in most all-black schools people called one another by their last names, Mr. and Mrs., but they didn't do that.

I worked at Mason for three years, and then I requested a transfer to Enright Middle School, one of only two middle schools in the area. I wanted to teach the older children and I wanted to go to an all-black school. It wasn't that I disliked Mason; I felt I wanted to work in a situation where you were not under the scrutiny that we were under at Mason. There was a regular parade of people who came to school to see what we were or were not doing. There were probably as many white parents in the building—strolling the halls to see what was going on—than had been at that school in the last five years. It became a joke among us for a time to see how many people in the neighborhood would walk through—people who, incidentally, had gone to that school themselves when they were children.

All in all, I would call the Mason School experience a partially integrated opportunity, and under the guidance of the principal, we felt that we did a very good job there. And although we had some discussions with some of the teachers which were not always pleasant, we still managed to get along with all of them and managed to work well with them and the children.

DIFFERENCES

Most blacks and whites who have an education are really two different people in that they are one person around blacks and another person around whites. No matter how close you are with whites, and I am close with a number of them—I count some as being my very best friends—they are still different.

I've heard teachers say, "Just give me a child, I can teach any child," but they're wrong. Black children and white children are different, and if you don't recognize that you're going to be in an awful lot of trouble trying to teach them. They're different because of what they bring to schools. They're different because of the way they talk and the way they act, the way they're taught to act at home and the way they are disciplined. Most blacks vote Democratic and they're very liberal, but in their personal lives, they're very conservative at home concerning disciplining their children. Another notable difference I think is if a black child gets into an altercation at school and goes home and tells his parents about it, they will tell him, "Look, you've got to fight; that's the only way to keep this person from bothering you." I don't think white parents tell their children that. Most of the white parents I've discussed it with say they tell their children to avoid a fight.

There's a lot of what they call corporal punishment in black homes. If you do something wrong, you're going to get cracked. I know they say that leads to child abuse, but to tell you the truth, I'm not so sure. I'm sure you will see children who were raised that way raise their children the same way.

The last thing they needed to do was to stop using corporal punishment in the public schools with black children. Because they had been raised all of their lives by black parents who used corporal punishment in the home, it was extremely difficult to control them in school without it. Now the children realize there isn't much you can do to them; they know the corporal punishment policy as well as you do.

There was an article in a magazine relating to sports teams about the way blacks argue with each other, boast or what blacks call signifying or woofing when they play against one another. There was a lot of that in the film *White Men Can't Jump*. It's not exactly a conversation with one another. They try to put you down not only in their play but in the way they talk. They're in each other's face as they say it, they're going chin to chin and they're calling each other everything except the son of God. Generally, black teachers recognize that they're not going to fight and that it's going to dissipate right away, and I think they recognize that from their own upbringing. In some innate way, black teachers can tell *when* they are going to fight and they'll step in and

quickly separate them. The white teachers have never been around black children, and they can't recognize the difference.

When I was working with the teachers' union and then with the board of education at the time when they integrated teachers, there was a genuine fear among white teachers not wanting to work in black schools, and many of them quit when they ended up being transferred to the north side. Ninety-five percent of the school principals on the north side at that time were black because that's the way they had it set up. And those black principals felt that the black teachers were better disciplinarians for the older children and felt the white teachers could handle the younger ones better. The younger children, kindergarten through fourth, were usually on the first floor with white teachers, and the upper grades were on the upper floor with black teachers.

When you got over on the south side, you found the white principals felt the same way, and they too assigned all the black teachers to the upper grades.

INTEGRATION AT FARRAGUT SCHOOL

When they supposedly integrated the schools in 1954, we were living in the 3900 block of Labadie, and my son was still walking all the way up to the Simmons School, 4318 St. Louis Avenue. Then they integrated the all-white Farragut School, which was around the corner from our house. Since most of the whites had already run, it became mostly a black school with white teachers. So my son began Farragut School, and it turned out to be the worst thing that could have happened to him in that all the teachers were white.

It was *terribly* overcrowded. Rooms of forty-five or fifty were not unusual, and they put one black assistant principal there to try to maintain some kind of order. I can remember going to visit the teacher at his school, and when I stepped into the door, it sounded like a riot was going on in that *damn* room. She was *screaming* at them, and no one was paying any attention to her.

I looked for my son. He was sitting over in the corner. He'd just withdrawn from it, looking out the window, tapping his pencil on the desk, wondering what was going on. He was withdrawing from the chaos in that darn room. I'm not sure if he ever recovered from that although he ended up going to college and did extremely well. We even got some therapy for him because he had reached the point where he'd learned to just withdraw and let the world go by.

A lot of black children were killed, what I call *killed educationally* during that period. There were other black schools where they had that same kind of chaotic situation and it was not good at all—*just wasn't good at all*. Since the white teachers couldn't handle the children, very little education was going on. The white teachers were at their wits' end.

You see, about that same time, the exodus had begun. Because of the demise of the Mill Creek area, blacks began to move north and west. This population movement caused a great influx of black pupils into those areas, causing the overcrowded classrooms. To correct this situation, they had begun building additional free-standing buildings all over the north area to reduce the class size, and you could tell the difference in the students that came along after my son.

O'FALLON TECHNICAL SCHOOL

I don't recall any specific conversations I had with my son about racism, although I'm sure we probably had some. The only one that I really remember was when he was in high school. He wanted to go to O'Fallon Technical School and take auto mechanics, so we allowed him to do so. All the shop teachers—they were called technical and industrial teachers—99 percent of them were white, because they were put in there by the various labor organizations.

My son was having an awful lot of difficulty with a particular shop teacher, and I went over to talk to the counselor about him. He was going to take me down to the shop teacher, and I said, "Don't tell him that I'm a teacher. I don't want him to know that." And so we went down to talk to him, and you've never heard such ridiculous nonsense. The shop teacher talked about how students learned and how my son was having difficulty, and it mostly related to race except that he didn't say that. He inferred it. As a matter of fact, after I finished talking with him, the counselor was apologizing for the teacher's ineptitude and his ignorance.

My son was not with me at that time, but we talked afterward and I pointed out to him what kind of fool he had for a teacher. He said, "I've been trying to tell you that all along." I said, "Yes, but I didn't believe it until I talked to him." My son had sensed that the teacher was prejudiced. Until I had a chance to talk to the teacher, I thought my son was just making excuses for not doing well in that class.

I told him, "There's no one else teaching this course. You've *got* to take it." So we worked out some strategies to survive in that particular classroom. And then we discussed race and not only race but what you had to do with any teacher—you had to learn what that teacher expects and then learn how to deliver. It's a game. You have to learn to play it. And I told him, "You're going to have to do that when you leave here and get a job."

INTEGRATING TEACHERS AND SCHOOLS

In administration, I worked at the process of integrating schools from both ends. I worked at it from the union angle, trying to look out for what we call "teachers' rights." And when I went downtown, I did the same thing at the other end, at the board of education. And, *oh God*, there were numerous cases that we handled where a white teacher had been assigned to a north side school and would come down to us almost *hysterical* about reporting to that school—really in fear for their lives. I did have to sit down with them and very carefully explain that nothing was going to happen to them. And when I did get them to report, I often wondered how much learning went on. They were in such great fear when they went. I just can't imagine them being effective teachers. There were some that I recommended that the board not send them—send them somewhere else. But we had rigid guidelines that you had to follow, so we had to figure some way to get around them, and in some cases we did.

As I said before, some teachers quit because of their fear of going to the north side, and some went to the county, but there weren't a lot of them who did that because they were giving up an awful lot. Tenure in the county took five years, and it took only three years in the city. And once you had reached certain spots on the higher levels of salary schedule, you'd find it very difficult to match your salary unless you went into a very high specialty like science or teaching algebra or calculus. If you were just teaching as an English teacher, you'd have a very difficult time trying to match your salary anywhere.

There were workshops for teachers to learn how to get along with one another, but I'm not sure how much good it did. They thought it was good at the time, but even now you can go into schools at lunchtime, and you see the white teachers have their place to eat and the black teachers have their place to eat lunch, and rarely will you see them together. Occasionally, yes. Now

that isn't to say they don't get along. They get along well with one another, and generally there's no resentment—none that you can see—but when it comes to socializing, they will usually back off, both of them.

I'm not sure that if the teachers did sit together the children would follow their example. It's the same with the kids. It's not that they dislike each other; they just feel more comfortable being around people that they've known all their lives.

NEIGHBORHOOD SCHOOLS

The problem with the schools today is that there is no sense of community, there are no neighborhood schools. That's what has really undermined the parents' ability to interact with the child's school. You don't have any allegiance to the school you're going to or to the people who live in the neighborhood.

When I went to Sumner, *everyone* lived in the Sumner neighborhood and that was their school. They owned it. And Sumner still has that because it's one of the schools that is not integrated. I don't think there are any buses that bus into Sumner. In my day, either you walked or you somehow got there on your own, and it's still like that. Roosevelt High School, on the other hand, where two-thirds of the children are bused in, is just a transient home for most students, and they have absolutely no allegiance to Roosevelt whatsoever.

When I was at school the teachers at Sumner were institutions. If you had older brothers and sisters, you could trace the history of those teachers all the way back by looking at the annuals. I graduated in June '43 from Sumner, and I met people in my neighborhood who had the school annuals back to when I was born in 1924, and some of those teachers were in it. And as I said, they were "stars" and you talked about them, and right now you could get a group of those people together and they will still talk about those teachers.

BUSING AND PRINCIPALS

I don't think busing has done what it was intended to do. They felt that if you integrated pupils, it would raise the general level of academics for

everyone. I don't think it did that. It might have done that in the early stages, but it's certainly not doing it now. And a lot of blacks don't think that this hour of busing and then having to take the abuse that children have to take when they get to these schools is worthwhile or is doing them any good. Most of the black children who transferred to the county schools are those that are highly motivated, hardworking pupils anyway and would do just as well if they stayed in all-black schools.

Personally, I thought that the segregated schools did extremely well. They had some bang-up good teachers in them, and while I used to call the principals "kings" and the schools their "kingdoms," they did run some very good schools, and you don't find that kind of thing existing now.

Today, it doesn't seem that the principal has that much control or will exert that much control. Now there are a few of them who do. I have a brother-in-law who is relatively young, about mid-forties, and he's extremely interested. He's constantly walking the halls, talking to teachers and talking to pupils. If there's a problem in the classroom, he's out talking to that teacher and trying to help that teacher improve. But there are some who just sit on their hands if they know the teacher's not doing well, and instead of trying to help that teacher improve, they direct their efforts to get rid of the teacher. As long as they're somewhere else where they don't have to worry about them, they don't care.

My brother-in-law is at Clark School now. But there are others like him too, other good young principals. More and more, there's been a great turnover of principals in the last three or four years. When I left, the principals had the highest average age of any group in the system and had begun to retire.

IF I HAD THE POWER TO CHANGE THINGS

Racial attitudes? Oh God, they've changed some and they're still changing, I think. They are in a state of flux right now. We went from the strict segregation in the 1940s to a period where, for a while, we were going to match up every black and white in the world, and then we gradually came to a period where people were saying, "There's no segregation. Blacks have every opportunity everybody else has so they don't need anything special done for them." Of course, blacks say they need one thing done for them: change their color, which is what we can't do. The one thing that separates us from everyone else is the color.

That is not to say I want to change my color. A lot of blacks don't want to change—they simply say, "That is the difference." If I had the power to change things, well, I'd make everyone one color—but I wouldn't make blacks white, I'd make all whites black.

GABRIELLE WILSON

Gabrielle Jacquet Wilson was born in People's Hospital on Locust Street in 1944. Her grandfather was Dr. Oliver Wendell Holmes Tyler. She is a member of the African American Historical and Genealogical Society. She worked for the director of minority affairs at Washington University's Medical School.

GROWING UP

When I was born, my mother lived here in St. Louis at the home of my maternal grandparents. We had a large extended family—at that time this was very common. My father was in the service and was still overseas. When he came home, my parents found an apartment and later bought the house next door. My grandparents were two blocks away, and they were there all of my life. There was a path worn on the sidewalk between our house and my grandmother's because we were there that often. In those days, you just didn't move far from home.

My maternal grandparents were as much a part of my life as if they lived with us. They were interested in everything we did. We were the smartest kids that ever breathed. When school reports came, you called and told them what you got on your report card, or they called you, whichever happened first. It would never occur to me not to tell them something that was important to me.

I saw my grandpa every Sunday morning when he and Grandma would come to pick us up in the car to go to the eight-fifteen Mass at St. Anne's

Shrine. He let us know he was thrilled to death to see us because he had a grin on his face from ear to ear when he saw us. If you didn't feel welcome anyplace else, you knew you were welcome on Sunday mornings. After church, we would go back to their house for a big breakfast. We stayed all day, played music and visited while grandma cooked a big southern dinner. We didn't go home until eight o'clock, and Sundays were special days for all of us.

I grew up on Enright. My grandfather's house was in the 4100 block, and I lived in the 4300 block. Back then it was a fashionable neighborhood— pretty much like where I live now: well-kept homes, well-manicured lawns, very quiet and peaceful. Neighbors knew everyone on the block; whether they were friends or not is a different story. It was integrated when I was born, but as I grew older—no!

My father's parents were from Louisiana, and they moved to St. Louis when I was five. They sold everything to move here and they lived with us. My father was an only child, and they wanted to be with him.

My parents met in the army. Mom was a lieutenant, a nurse, and my father was a master sergeant. My mother graduated from Sumner High

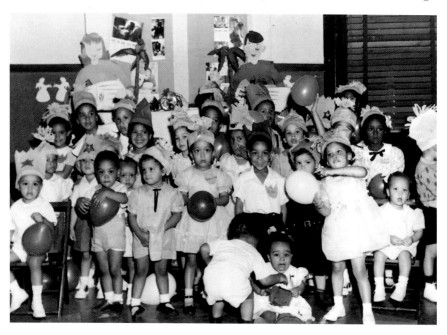

Gabrielle Jacquet's fourth birthday party at the Floretta Howard School of Expression, 4406 Garfield Avenue. Gabrielle is in the front row, center, with a balloon, 1948. *Courtesy of Gabrielle Wilson.*

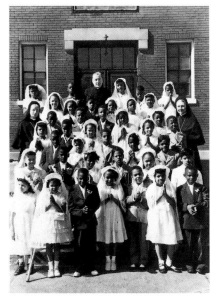

School and from Howard University in Washington, D.C., and went to nursing school at Freedman's Hospital, also in Washington, D.C. She finished here at Homer G. Phillips Hospital and took cases at Barnes, Incarnate Word, Homer G. Phillips and did private duty in people's homes. Mother continued nursing as I grew up. My father was a cartographer for the Army Records Center.

Grandpa's sister, Aunt Bea, taught kindergarten at Riddick Elementary School. All of the children and grandchildren went there, at least to kindergarten, so I began my schooling at Riddick and went to Cathedral School in the third grade. I was one of a few Negro children there at that time, and though I had heard some scary stories—none were true. My principal, Sister Elizabeth Joseph, would never have allowed any

Top: Gabrielle Jacquet, age five, with Lena Horne at the Floretta Howard School of Expression, 1949. *Courtesy of Gabrielle Wilson.*

Middle: First Communion class of St. Anne's Shrine in front of St. Joseph High School, 4132 Page, formerly the Negro and Indian School, before 1950. Gabrielle Jacquet, six years old, is in the second row, second from right. Mother Flora is at left, and Father Bresnahan is in the back row, 1950. *Courtesy of Gabrielle Wilson.*

Bottom: The Jacquet children, *left to right*: Gabrielle, age seven; Julienne Rose, age four; Duane Pierre, age three, 1951. *Courtesy of Gabrielle Wilson.*

problems at that grade school, and if something did happen, I never knew about it. And I never spoke to another child who mentioned that there had been a problem, that there had been a slur or anything like that. We were just not aware of it. Never!

I didn't go to the white children's houses to play, but I think the reason for that was not because I would not have been welcome but I didn't live in the neighborhood. We weren't members of the Cathedral Parish. We belonged to St. Anne's Parish, and I walked about eight blocks from my house to school. Everyone else lived much closer to school—so that was the difference.

My Grandpa—Dr. Oliver Wendell Holmes Tyler

My grandfather was born in Cadiz, Kentucky, in 1888. Both of his parents and his sisters taught school. His grandfather was a Jewish merchant; his mother was born the first year after slavery ended. His family migrated to St. Louis when he was very young. He graduated from Sumner High School in 1908 and entered medical school at Howard University in Washington, D.C. He graduated in 1912 and returned to St. Louis.

He opened an office, and his primary interests were respiratory ailments and heart disease. Through the early years, he was not happy with the way he was received at the hospitals here. People's Hospital and Hospital #2, which later became Homer G. Phillips Hospital, were the only hospitals he could walk into without any problems.

There were other hospitals that were open then, but he was refused there. Though he could see patients at Barnes Hospital, he had to see them in the basement. They were not allowed rooms on the regular floors. There were only so many rooms assigned in the basement to black patients, and if you ran out of rooms, they were on stretchers or beds in the hallways. All of these conditions disturbed my grandfather.

In 1929, around the Depression, his office was destroyed during a tornado. There was no money. There was no place to go. He began looking for a spot to open an office, but remember, he had lost everything he had in this tornado. I don't think he came out with anything at all. I kind of remember them talking about that, my grandparents and my aunts.

He began looking to become associated with another doctor—and those that were established had no need for a partner at that time; I mean, it was

hard to make ends meet, so he took the first opportunity that he could find, which was the job in St. Charles. He went out the one time, spoke with two brothers, Negro physicians, I think their names were Johnson or Jackson, and he liked them very much. They liked him and that was it; they took him right away. He knew he was going to have to drive that far out there every day. I think he said it was twenty-two miles each way, and he did that from about 1929 until he died at age eighty-five in 1974—over forty years! He didn't get home until at least 10:00 or 10:30 at night, and I asked him why he went so far away to work. And his reasoning was, "I couldn't stand working under such conditions." So he went to St. Charles, where perhaps he could practice more comfortably.

Grandpa married Nora Hall in 1915. They had three children, and my mother, Mary Gwendlyn, was the oldest. Grandpa said that you couldn't tell by looking at a photograph of his wife and family what they were; that his children could go anywhere, and his son could even go to white barbershops, and that his children went to the best schools. Once his son said, "Dad, come on, let's go in the movie theater." And he told me once when I was grown, "It hurt me in my heart that I couldn't take him in there because I was a Negro. People didn't think I was a Negro. They thought I was everything else but a Negro."

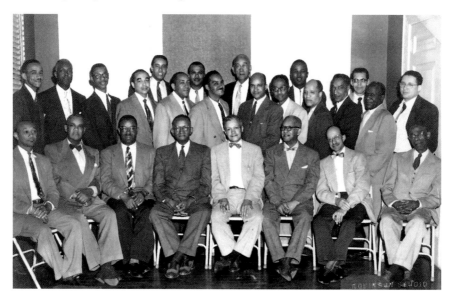

An African American medical fraternity, Chi Delta Mu, at the Vagabond House, 64 North Vandeventer. Dr. Oliver Wendell Holmes Tyler is in the front row, second from right, 1955. *Courtesy of Gabrielle Wilson.*

I believe he was afraid to take his children where they were not wanted. He didn't want to make a scene and have his children be witnesses, so he just never tried. But my grandmother took them just about everywhere they wanted to go.

When my grandfather first went to St. Charles, his patients didn't know he was a Negro. He was white in St. Charles and Negro when he came back to St. Louis. He was *passing*. He lived in two worlds. I don't remember him saying anything; of course there were probably things that we were shielded from. Wouldn't you think you'd hear something once in a while? There are other family stories you got as a child coming up, and you would hear one or two words and you know something is going on, but there was *nothing* relating to my grandpa passing as a white doctor in St. Charles.

We went out to see him periodically, and he was pleased with that. We could have been patients, but of course, we called him "Grandpa" and he greeted us with open arms.

A patient came in to see him one day and wanted to know if he were there alone.

And he said, "No, my nurse is here. Why do you ask?"

"Well, I heard a rumor there's a nigger doctor here, and I want to make certain he doesn't touch my wife."

Grandpa told him, "There's no problem there, I can assure you. I'm the only one here who's going to touch your wife."

"That's fine, doc, as long as it's you."

Grandpa said, "Oh no, it's just me."

Of course, I didn't know there was a problem, but maybe by the time I remember going there, maybe by 1950, things had changed and other people knew. I don't know when people decided that he was okay to be him.

My grandpa had a slow and deliberate way of speaking, and he was very straight. I imagine he was the most honest person alive, and if he told you something, you better believe it was the truth. He was very easy to get along with but very determined about many issues and could not be wavered. He had six grandchildren, and he told all of us, "There is nothing you can't accomplish. If you want it bad enough—nothing will hold you back." I've always remembered that. There have been times when I felt that I couldn't do something, but then I can hear his voice— saying, "You can do it!"

Gabrielle Wilson

The Fox Theater and Chain of Rocks Park

My grandmother took me to the movies before they were integrated. When she took me to the Fox, I remember being told to wait in the car, and she went and bought the tickets. She came back to the car, took my hand and we walked right in; I mean, *she* was holding the tickets, obviously it was okay for us to go in.

We were never made aware of problems at home growing up. No one ever told us to expect a problem when we left the house. I had no reason to ever think I couldn't go anywhere.

But *sometimes*, just sometimes, I was aware that something was different. Whether it would be white people or Negroes that would see *me* going in someplace with my grandma that they knew Negroes were not allowed and they would stare at me like, "Well, I wonder where *she* came from." No one ever said anything, but you just wondered, "*What's* going on? What had happened?" I *never* knew. It just was never discussed.

I was aware at those moments that *something* was different, and I would think, "I don't know what's wrong or why it's different. What did *I* do to cause it to be different?" *But it was different*, and my motto always was, "Well, just be quiet; let's see what happens next." I was always with adults I felt comfortable with, so I never really worried that something could happen.

I remember sometimes people asked me if I was Spanish or Italian or whatever. I was confused. First of all, I didn't know what they meant, and then when I figured out what they did mean, I didn't know how to answer because I didn't know what the repercussions would be.

I didn't know that Negroes, at that time, could not go into the Fox Theater. I don't remember hearing anything like that on the radio—newspapers were available, I don't ever remember seeing anything about that. Maybe I was sheltered, but I remember when I first heard it was okay for Negroes to go everywhere, *then* it clicked. *Well, that's why they were staring at me.*

When I would tell a friend at school, "I went to the Fox," no one believed me. *No one* believed me.

"How'd you get there?"

"I went with grandma" or "I went with my aunt."

"No you didn't, no you didn't. You passed by—but you *didn't go in*."

"Oh yes, I did. What did *you* do this weekend?"

"I played baseball."

"Well, *I* went to a movie at the *Fox*."

"No you didn't."

"Well, yeah I did, my grandma took me." They never pushed it, so it was just kind of teasing back and forth.

"Well, I don't believe you went there."

"Well, I don't believe you went on vacation."

"So what."

"Let's play."

And that was it. But they thought I really hadn't gone, because they knew it was impossible.

When I look back on it now, I wonder why I never asked questions, but there was no reason to—I went everywhere I wanted to go until about the fifth or sixth grade. And then I vividly remember the incident—our school picnic at the Chain of Rocks Park. I was about eleven. And I know the priests and nuns never would have done this to us if they had known what was going to happen.

We went to the park, and everybody's riding on the rides and everything is fine until some of the kids wanted to go swimming, and they were told at the gate that they couldn't go. Now, I didn't swim, so that was not a problem for me, but I remember them turning one little boy away. He couldn't understand why. He wanted to go swimming.

And they said, "Well, you know you can't come in here."

He said, "Why not? I can swim."

"We don't care if you can swim or not. *You cannot come in here.*"

"Why not?" And it was kind of bantering back and forth. And he said, "Well, you let my brother in." And sure enough, his brother was swimming. They didn't know he was a Negro. I overheard all of this. And then they got his brother out of the pool, and neither of them was allowed to swim.

My mother was livid that the priests and nuns put us in that position. And of course she went to school with us the next day and complained about it, and they were bending over backward—"*We did not know.*" She understood that they didn't know—but she had to yell at somebody. The school never went back, but I'll *never* forget seeing that happen. I remember my parents talking about it maybe once afterward, and that was it.

This wasn't something that happened to us on a daily basis. We were told that these were ignorant people who ran this particular spot, and if they don't want us there, then we won't go back. And so we never did.

You Didn't Know My Grandma!

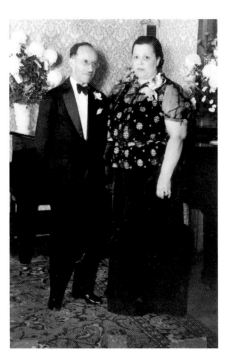

1915 1940

Dr. and Mrs. Wendell Holmes Tyler
request the pleasure of your company
at a reception in honor of their
Silver Wedding Anniversary
on Sunday evening,
the twenty-seventh of October
from seven until nine o'clock
Forty-one Forty-two Enright Avenue
Saint Louis

Nora Hall Dr. W. H. Tyler

There was a dime store downtown on Sixth and Washington, and the lunch counter was in back of the store, right on St. Charles. Though I was only five, I could read, and I remember a sign on the wall that said "Colored." It was near the entrance to the kitchen right by a cash register. And on that counter there was like a metal guard of some kind that differentiated like six spaces only. And the counter undulated so there was like six stools on one side of one counter only where you could sit. There was also a standing counter, but I don't remember that as well. I'm guessing this would be 1948 or 1949.

I knew immediately what it meant, and you *know* you can't ask *why*. Had I asked I would have been told, "*Shh*, I'll tell you later."

That's the way those things were handled then, and I mean any kind of thing that went on in public that was out of the ordinary.

Top: The invitation sent to friends for a reception in honor of the silver wedding anniversary of Dr. and Mrs. Oliver Wendell Holmes Tyler, 1940. *Courtesy of Gabrielle Wilson.*

Bottom: Dr. and Mrs. Oliver Wendell Holmes Tyler, 4142 Enright Avenue, at their silver wedding anniversary celebration, 1940. *Courtesy of Gabrielle Wilson.*

How did I know I wasn't supposed to ask? *You just knew!*

My grandma went in the dime store to pick up a hairnet, or whatever, but she would *never—sit at a counter—in a dime store*! You didn't know my grandma! It just wasn't done. *It just wasn't done.* I mean, she would have starved to death before she would have been at that counter at McCrory's. Grandma and I ate at Stix, at the counter—on the first floor!

When we went downtown, Grandma never drove, and we never rode the bus. There were service cars, a line of cars—I guess they were old limos that people used—that ran up Easton Avenue across Aubert and down Enright all the way downtown, and this made a complete circle. It was much better transportation than Bi-State could ever offer, because they ran about every fifteen minutes, and they stopped at every corner. And when I was a little girl it cost fifteen cents to ride. We would leave my grandmother's house and walk a half block down to her corner, and we rode in the service car with everybody else who was black, and we'd get down to Stix and we'd go inside Stix and we would eat at the white lunch counter. That's how you did things. It wasn't a big deal to do any of the things I did. I was with my grandma. She went everywhere and did everything she wanted to do. There was never a problem. I can't imagine anyone saying anything to her. She had a presence!

IT WASN'T US

When the civil rights demonstrations were going on in the 1960s, I saw it on the television and I read about it in the newspapers, and this is going to sound horrible, but *this didn't happen to me.* This was for people who had no rights, and *I knew I did.*

It was almost like reading about a civil war in another country. This was happening in Georgia or Alabama or Mississippi—but it wasn't happening here, because we don't have things like that.

Shopping downtown—I know *now* that Negros couldn't legitimately eat at the lunch counters. I remember going to the lunch counter on the first floor at Stix when I was so little that Grandma would have to lift me up on the stool because I was too little to climb up on my own. I would sit on the stool swinging my legs and eat my lunch. I was with my grandma and I thought she was all-powerful. I always went with my grandma, and I went *everywhere.*

I never experienced a salesperson not waiting on me, not even when I was older. If something like that happened—well, first of all, I went to Catholic school, and in Catholic school you were taught to wait your turn. So, many times when people may have felt slighted because they weren't handled right away, I would have assumed that it wasn't my turn. I stood there like an idiot and waited. I don't ever remember that happening to me when I was younger. There have been occasions *now*—and I'm not looking for it, I don't carry this with me when I leave the house—there are times when it slaps you in the face and you know what's going on, and I just stand there and wait my turn. *I'm not going to go away.*

I have never ever been turned away from anyplace I wanted to go. The incident I told you about at the Chain of Rocks Park swimming pool was the first time I was aware that things like that happened. Then I really knew that there was a basis for the word "prejudice," because I heard and saw it happen, but it didn't mean anything *to me*. And I knew things like that happened—somewhere away. They didn't happen here—and then I found out that they did. But *it wasn't us*. It was somebody else. It was *always* somebody else.

I knew that I was a Negro, and now I know that Negroes weren't supposed to be certain places, but *some people* could go, and it was okay and obviously it was okay for me. And the fact that because I was fair-skinned and that's why I was able to go places—don't know when I realized that. It's one of those things—you think you've always known something—one day it's there, okay, *that's what it is*! I know it now.

Maybe I grew up in a land of make believe. Just plain stupid is more like it, because I didn't know what was going on around me. It's probably hard for you to understand, but *I didn't see the segregation! I just didn't see it.*

You see, we're mainly talking about where I went with my grandmother. We didn't *pass* as an entire family, and I didn't live with those grandparents. I went with my grandmother on occasion, and the places we went it seemed we were certainly welcome to go.

My father and his parents were darker and couldn't have passed. But he never questioned or complained when I went with my grandma. It wasn't discussed. If I *had* asked my parents to take me to the Fox, the first thing they would have said is, "Why do you want to go? Is there something going on there?"

Timing would have been a problem. For one thing, my father worked two jobs, so he had no time. If it were during the daytime, my mother, as a nurse, usually worked nights, so she slept during the day. She wouldn't have been able to take us. These were all legitimate excuses.

BEING LIGHT-SKINNED IN THE BLACK COMMUNITY

You want to know what it was like for someone to grow up in the black community who is fair or light-skinned? I guess it all depends on where you grew up and what people say to you.

I always felt—and I still do—that dark-skinned people felt like we didn't belong. It wasn't just my skin color, remember I was Catholic too! When I would attend public school dances, some people would remark, "Oh, you think you're cute," or even "Yellow bitch," like you were *trying not to be black*. I love that expression now, "*She's trying to be*," because I can't *be* any more than I already am.

It was a detriment to be light-skinned, like you have control over it—I have to laugh—I'm sorry, blame my parents! They're responsible for this. I never wanted to be any more or less than I was. My likes and dislikes are not programmed because somebody wanted me to be different. If I happened to like chocolate ice cream, then I just do. I'm not a big strawberry ice cream fan—makes no difference where I come from. It's just the way I am.

So you learn, at an early age, to keep some of your preferences to yourself. Music, for instance; had I told anyone when I was a child that I was into country and western music, I would have been laughed off the block, because country and western music was "white music."

We were exposed to all types of music as children. Everyone in our family played a musical instrument. We had everything from opera down to rhythm and blues, and anything in between, and you learned to appreciate all of it. It should be the same way with people—appreciate them all.

THE WAY OF THE WORLD

We were told that girls who graduated from Rosati-Kain High School, when I graduated in 1961, had the equivalent of a partial college education and would have no trouble getting jobs *anywhere we wanted to go*. Though they wanted us to have a college education, they said if you went anywhere to apply for a job and they saw Rosati on your application, usually you were hired. And it was the honest to God truth!

I remember my sophomore year of high school we were planning classes for the next year. We were asked to list what we were interested in, and then we were told what classes were available. We were asked what type of position we would look for if we took this subject and got wonderful grades.

I signed up for office, and I clearly remember sitting down and talking with one of the nuns about why I chose office.

She asked me, "What do you want to take?"

"Well, I guess I'll take typing and shorthand," and she took a deep breath. I didn't know *what* was wrong. "What's the matter? Isn't there any space left?"

"Well, yes, honey, but why are you wasting your time with this?"

I said, thinking ahead, "Well, I'll need to know how to type when I get to college, and I might as well take it now."

"Yes, you're right. I'm just grateful you're not looking for a job *in* an office."

"Why not?"

"Well, honey, *they* don't hire colored girls to work in offices."

I said, "Oh, I didn't know that."

My counselor said, "If you want Typing I, fine, but I wouldn't take Advanced Typing and Office Procedure because we're just not ready for that yet. You'll be wasting your time."

Knowing the nun that spoke, I didn't take it as something *she* felt—it was just the *way of the world*, and she said, "It's just *not going to be*. You take what you can use. What *you* need to think about is nursing or teaching because they can always use good colored nurses and teachers."

And I said, "Yes, Sister," because that's what you said back then.

I can see her in her habit, as clearly as I'm looking at you right now. She took a deep breath, because she did not *want* to hurt my feelings, and I realize now she was telling me the truth. There probably weren't any jobs in offices in St. Louis for colored girls in 1957 or 1958. And as a fourteen- or fifteen-year-old kid, how would I know who had or had not been hired in offices *anywhere*? I had not looked at the newspapers to see if there were any jobs listed. I didn't need to do that yet. Let me finish high school first, and then I'll decide what I'm going to do.

As it turned out, I took the typing class. I wasn't crazy about it, but I took it. And then for most of my adult life, I worked in offices!

St. Anne's Shrine

When I went to Mass on Sunday mornings with my grandparents, they liked to sit four or five pews from the back of the church. As our congregation began to dwindle, the priest urged everyone to move closer to the altar, and

after a while, he said he would fix it so everyone had to. The next Sunday, we saw that the priest had ribboned off the back section of the church pews so everyone was forced to sit in the front.

My grandfather stopped the priest after Mass and told him, "You can't do this. If this is the way it's going to be, I'm not coming back."

And the priest was horrified. He said, "What do you mean, Dr. Tyler, why won't you come back?"

Grandpa said, "I grew up in a time when I was *told where I had to sit*. We're supposed to be able to come to church and pray, and I should be able to kneel or sit wherever I please."

The priest just apologized all over the place. And the next thing you knew, those ribbons were down!

FIVE MINUTES

Back in the middle '60s, I had a party and I invited a lot of people I knew from work and school; they were from all over St. Louis. Parties back then were very quiet. There was usually music in the background and some drinking. And a few days before the party, while talking on the phone with my grandfather, I mentioned to him that I was going to have some people come by Friday night. Just off the top of my head, I said, "Grandpa, why don't you come by on your way from work?" I hadn't planned this, and maybe I really didn't expect him, but he came. He stayed maybe five minutes, but afterward, he talked about that evening over and over again. He said that was the first time he had seen that many people in one room that were different; diverse—different cultural backgrounds; everyone sitting around talking, laughing, having a good time. He said it made him feel so good just to see how far things had come.

GENEALOGICAL RESEARCH

I did not realize when I was a child, even in high school and college, that some of my family lived through times of persecution. When I read the textbooks, the dates never meshed with me. Though I knew my maternal grandfather had come to St. Louis from Kentucky for more opportunity, I

had no idea that there were slaves on that side of the family. And we're not talking that many generations back.

I did not learn all of this until I started my own genealogical research last year. I went to the public library and went through the regular channels, looked through the census books and microfilm, and my family wasn't there. I thought, "This is crazy. I know they were there." I went to the librarian: "I'm looking for these people and they're not in the book. Why not?"

The librarian said, "Well, honey, maybe the census people missed them."

I replied, "How could they? They'd been there for ages." And I'm picturing this huge house—not that anybody told me they had one, but in the back of my mind, surely they had a large house. She suggested other avenues to try, but I had already done those and assured her the names were not there. And she just went chalk white and said, "Did it ever occur to you that possibly they weren't free?"

I said, "Excuse me?"

"Well, judging by the dates you gave me maybe they were *slaves*."

I had a case of the vapors. I couldn't even answer her. She asked me if I was all right.

"I think so."

She said, "I'm sorry."

I told her I just didn't know.

She replied, "Obviously."

I had no idea. It was *never* discussed.

It gives you the chills. It just gives you the chills. I cried. I'm sitting in the public library crying like an idiot. Then I got angry. I was *angry* that it happened—I was *angry* that we weren't told!

I wonder *why* no one ever told us. I guess they thought we were smart enough to figure it out on our own, but I think it would have helped just in the discussion of education alone. My grandfather placed such a high value on education, and of course when I realized more about our past, I understood that education had been denied to us for so long. Had we just realized where Grandpa was coming from, maybe some of us would have tried harder. But it just never occurred to me.

What upset me was finding out that it was so close and I didn't know it. If it had been three or four generations away from my grandfather, I would have said, "Ah huh, that's the way it goes."

This kind of discussion doesn't come after "Pass the salt, incidentally, your great-grandfather was a slave," but it was never mentioned. And I have talked with other people who have said the same thing: "It's just understood,

and you don't talk about unpleasant things." But I just felt like somewhere—and I was a nosey kid—somewhere, I should have caught on. Somebody must have said *something*, but I realized after talking with you, *never!* I would have picked up something. Honest to God, I would have.

THE WAY THINGS *SHOULD* BE

No one ever told me, "You are black, you are colored, you can or cannot do thus and so, *never, never, ever.*" And when people on television tell you, "Black people do this, black people should do that," I'm just amazed. I'm just truly amazed. Or when they talk about a "white point of view" or "a black point of view," I just want to scream at the TV set because I don't know what a black point of view is supposed to be.

We were allowed to be ourselves. We weren't taught that people are different. Certainly we knew some people looked different, but we weren't taught we should treat them differently or expect to be treated differently by them.

I was taught—I was given permission to dislike someone who did something to *me*, but *not* a whole neighborhood, *not* the rest of their family, *not* their religion. *It just wasn't tolerated*, and I've tried to impart that to my children. I truly believe *that's the way things should be.*

CHARLES POINER

Charles Poiner was born in the old St. Mary's Hospital in 1928. He was awarded a ring for forty years of safe driving for Bi-State, the public service company. For twenty-five years he coached teams at the Matthews Dickey Boys' Club and the Lou Brock Boys' Club.

COMIN' UP

My parents migrated to St. Louis from different parts of Mississippi, my father in 1916 and my mother in 1920. For years my mother worked on that WPA. They cleaned up the auditorium and different city buildings, and she did some domestic work in people's homes. My father worked for General Motors over on Natural Bridge and Union. I don't really know what he did there. First we stayed on Papin Street. Then we moved to Eighteenth, right off Cass, and when I was eight years old, we moved to Dayton Street, 2903, and I stayed there 'til 1954.

My grandmother mostly raised me and my sister, and that was good. We called her Mama. I was raised up in the church, True Light Baptist Church. Had to go to church. See, the church was down on Eighteenth Street—well, then they bought a church right there on Glasgow and Dixon, it's called Cool Papa Bell now. The church was right across from my house, so I had to go to church with my grandmother, had to go to church. We played a whole lot of ballgames on Sunday, so I had to go to Sunday school 11:00 and Saturday school—get out of these running to go to the ballpark.

Charles Poiner, 1994. *Courtesy of Charles Poiner Jr.*

I had jobs when I was comin' up. My friends and I delivered papers for the *Post*, the *Globe* and the *Star*. One guy in the neighborhood had the routes, and he would give us part of them. We delivered them on foot, and I set pins at Burton's Bowling Alley next to the ice skating rink on DeBaliviere, called it the Winter Garden. After I got out of high school, I worked for the city recreation department at Gamble Community Center right there on Glasgow at Gamble. I was a recreational leader. I helped to oversee the building and taught kids how to play basketball in the winter and, in the summer, softball. Kids were much different then. You didn't have all of this shooting. In fact, it was nice. At that time we only had two community centers, that was Gamble and Tandy out in the Ville. Later on we got Vashon Center and later Buder, south over on Compton Hill. I played football and basketball, and Vashon usually beat Sumner out in the Ville.

I used to go there quite often. Some of my people stayed in the Ville. My first cousin, we were close in the same age, we used to be together all the time because we played baseball at Tandy Park. That was the only place to play baseball at that time. It was just regular league baseball. Us kids were raised up by a policeman named Thomas Brooks from the Tenth District and another named Billingsly, from the Ninth District, and Sharp from the Fourth District. They were all juvenile officers, and what they did, they organized teams from the different areas and we played there at Tandy. I played third base. They knew us from Gamble Community Center. Tom Brooks used to stay right up the street from me on Dayton, so he practically raised me comin' up, taught me how to play ball and this type of thing. He was a special ballplayer during his day like Quincy Troupe, Satchel Paige. I seen 'em all 'cause my grandfather used to carry me to see them when the All-Stars Park was over there on Market Street. That's where they played, and we used to go see them. There were teams like the Kansas City

Monarchs, the Birmingham Black Barons and the Indianapolis Clowns. I was a little one then. I could sit up and watch 'em.

I been knowin' a long time that there were people whose skin was different than mine. Never did pay it no mind though 'cause comin' up on Dayton we had a Jewish synagogue right at the end of the block up at Garrison and Dayton. Then the confectionary was owned by people named Hyman, and they stayed in the rear of the store; used to play corkball with Frank, Morris and Abe. The people were nice, real nice. I remember my grandmother got along just like they were kin people, so we never had no problems like that, not back then. Never run into it actually until I got in the army.

EUCLID PLACE

There was a difference between the people who lived in the Ville and the people who lived downtown. You know for a long time downtown was just people barely makin' it. In the Ville, some of those people were affluent. You had doctors and nurses, all of them stayed mostly out there.

You had another neighborhood that was much better than the Ville. It was right off Aubert and Euclid Terrace and Fountain in the West End, might have been called Euclid Place—can't remember—had big gates and it was an affluent neighborhood in the 1940s and 1950s. Those were large houses, some of them mansion like. As the whites moved out, the blacks from downtown moved in, and those large homes became rooming houses. I used to go over there just looking around, that's about all.

THE DEUCE FOUR

I missed the Second World War, I had a broken leg. I got drafted in 1949, went to the Korean War. Lucky I didn't go south when I was drafted. My father had told me so much about the violence in the South I was kind of skeptical of goin' south. We were all concerned about gettin' down there and gettin' into trouble. You'd be in your army uniform, you go into a restaurant and you'd have to order stuff to take out—this type of thing. You couldn't sit down no place. If you'd been in civilian clothes, you'd probably be treated worse.

Once I was drafted, I went to Fort Custer, Michigan, and then to Fort Riley, Kansas. From there I came home on leave, went to Seattle, Washington, and was shipped out to Japan. You want to know did I feel like fighting even though I was black? No, I never felt like fighting for any reason. I was put into this. Once I got there I was going to try and stay alive. I was only nineteen, twenty years old. So this is the way it was.

I was with an all-black outfit which we called the Deuce Four, but it was the Twenty-fourth Infantry Regiment of the Twenty-fifth Division. I guess they started integrating, mixing the outfits in '51. They brought in Puerto Ricans and whites. I didn't pay too much mind to it because we were in a line company, we were fighting. See, we needed a body next to us, didn't pay too much attention to who the next fellow was as long as you know he was an American soldier.

DRIVIN' A BUS

The transit company started allowing blacks to drive buses in 1953. The first black bus driver went out on the fifteenth of April. I wasn't in the first bus. I came later. I started September 3, 1953, and drove for almost forty years.

When I got out of the army from Korea, I was going back to my old job at Gamble Community Center, but the city didn't pay but twice a month. I was near twenty-six years old, and my wife was getting ready to have a baby. I got my job driving a bus through the Urban League. I went over to the transit company, took a test and they hired me. After six weeks training you take a written test, you had to learn to drive a bus and once you passed those tests, what they called finals, you were a bus driver. You went out on the streets by yourself. It didn't pay that good, but only thing you got your money every week. I made a dollar and fifty cents an hour when I started, a dollar fifty, and when I left in January of '93 we were makin' $13.65.

It's not hard drivin' a bus. They're easy. Now most of them are not power steering, especially the old ones. The new ones are all power steering. I didn't do too much driving on the new ones, but the old ones I drove and they're easily turned goin' around corners. Judgment is the main thing about drivin' the bus. Like you get in your car and you're used to your car—you just got to get used to the bus. I loved drivin' a bus, and later on when I got about fifteen or sixteen years, because I could almost always get the runs I liked, it was easy then. But it was rough at first. I remember I was workin' on

Delmar and you pulled to the stop there at Kingsland at the Loop—all the white people would step back, they wouldn't get on the bus. I didn't know no different then, I'd go on. Later they found out that we could drive a bus just as good as anybody out there and they started riding. My first five to six months they would back up, wouldn't get on your bus, and working over here on Lindell, Lord, no! White people would complain and say you were doing things that never happened, like you passed them up or you didn't wait on them or something. See, it's always been a policy, you pull up to the bus stop, stop and get anybody at the bus stop. You don't stop the bus out of the bus stop because if you did and somebody run into the back of the bus, that's your problem. So this was about the size of it. It was bad at first. Then you knew you were goin' to have some people get on there and call you different names and things. At that time I'd just overlook it and keep goin'. Didn't make no difference.

Later on it got better. They turned out to be fine. It got so you know people, and they speak every mornin', didn't have no problems, but before that it was terrible. It was hard to bear. You had to control yourself to a certain extent. When you think back about it, it's funny. How could this have happened? How could I have did this, control myself with somebody gettin' on my bus and callin' me names and why didn't I get up and punch him? I needed my job, for one thing. I had a growin' family at the time. My wife was workin', she was at Kmart, but she didn't make, what you call, no money. We just needed those jobs to raise our family. I had bought an old house there on Goodfellow and Ridge in 1954, and we stayed there until I bought this house I have now in Ferguson twenty years ago. So I had to hold myself in because at that time they'd fire you in a hurry for punchin' people, but in some cases I thought I should have done it. I surely wanted to.

One of Those Danky Restaurants

St. Louis didn't have no integration. I spent all my time in the black neighborhood. Never knew anything about integration or thought about it.

The only time you got into the Fox Theater was like they had a class or somethin' from grade school goin' there or the firemen had somethin' there on Saturdays and they'd give you tickets to somethin' goin' on then, but as far as goin' to the Fox to look at a movie, no! no! I think I've been in the Fox Theater one time in my life. I'd go to the black movie theaters, the Criterion, the

Roosevelt, the Regal, the Comet, the Douglass—see, the Comet and Douglass was on the west end; the Regal and Criterion was on the east end. Then you had the Star on the south side. We had enough shows to go to. I wasn't never a big thing goin' to shows no way; spent a whole lot of time in Forest Park.

I never went into restaurants no more than Crowns until I had been workin' for the public service company. See, we had a problem down there on DeBaliviere and Delmar. At the time they had a restaurant right on the property. We couldn't go in there and sit down and eat. They had like a loop there you'd come around, the Goodfellow bus or whatever it was called then, it would stop right in front of the restaurant. We couldn't go in there. We couldn't go into the restaurant. So what we had to do was one of us would take our car and we would go all the way down to Jefferson and Market or someplace and get somethin' to eat and come back to work. Sometimes you didn't have but a couple of hours of split in the run. It was crazy. It was terrible. I got into it with one guy, but some of them were sympathetic—real nice—and some of them just didn't want you around.

Mel Green, president of the union at that time, went out of his way for us. He's the cause of that restaurant gettin' put off the property. He went to the company, to one of the big wheels, told 'em if we were going to work there everybody would be served in the restaurant, so they finally started doin' it. But it was one of those danky restaurants, didn't seem to be too clean in there, and I didn't care too much for the food and stuff so I hardly ever bought anything out of there, maybe coffee, otherwise it was all right.

STOOD UP TO IT ONCE

In '57, me and another operator went down right on DeBaliviere to a Plymouth dealer and bought brand-new cars. We had days off on Thursdays and Fridays, and I stopped at the garage to pick up my check. So I run my car right up alongside the road where the powerhouse is at now, right up alongside the wall, got out, went inside and got my check. And when I came out, some old guy had backed into it, pushed a whole door in. But he wasn't bad; he told me, "Well look, I got insurance, let me turn my money in and we'll take it up here and see about gettin' it taken care of."

I said, "Okay, that's all right," and when we got back to the steps there was a bunch of guys on the steps and another big old white guy, Walter—never will forget his name, weighed about 340 pounds—said, "Well, I wouldn't pay

him nothin', he was parked wrong." I didn't say nothin' to him at first, but he said, "I wouldn't pay him nothin', that nigger was parked wrong." And I turned and exploded on him with my fists.

The superintendent suspended me. He suspended *me*! He said I cut him with something. I told him, "I didn't have nothin' in my hand." But then I had three or four whites come up and say, "No, he hit him with his fist."

The superintendent said, "Well, I'm suspending you." Told him, "I don't care; suspend me and you better be careful if you mess around 'cause you're the cause of that restaurant over there being like it is, people not being able to go in there." He got mad at me, so he suspended me. Mel Green came in, the union officer at the time, and he told the superintendent, "No, you're not going to suspend him!" And then Mel Green went and made a call on the telephone, and after that here come the superintendent, "Well, we're just going to forget about what happened out here today."

I said, "No. I'll never forget it." He said, "Well, let's just have no more trouble, partner."

I said, "Well, I didn't start the trouble problem in the first place. So tell people like big ol' Walter there and others just like him to just let people alone. If they don't want to work here, let them quit." Told him "I wasn't worried about your firin' me' no way. I can get another job."

There was another guy that was the boss at that time named Jimmy Lord. I found out later that's who Mel called, and then Jimmy Lord called the superintendent back and told him he better not suspend me. So that ended it. Since then I never had no more trouble around there. Never had no more trouble.

You know, most of the time I walked away from that stuff, but that just went all through me. I didn't think he had anything to do with the man backin' into my car, but those were his words and I just hit him. That was the only time I didn't walk away from it. Had to take all that stuff too long; stood up to it once.

IF YOU GOT MONEY

I spent all my life in black neighborhoods. St. Louis didn't have no integration when I was comin' up. Never did go to the south side that much. Never had no reason to go west of Skinker. Wasn't nothin' across Skinker for me. As far west as I got was the Ville and around Sarah and Finney up in there.

Now I feel comfortable goin' anywhere in St. Louis 'cause I found out one thing. If you got money, you can go anyplace in St. Louis that you want to. People used to turn their back on you even if you had money. A person was scared of killin' his business if he let black people come in there so they just didn't do it. Money seems to be the goin' thing now. You got money, you can go anyplace you want to go in St. Louis.

REFLECTIONS

I guess it all came out all right. I was able to raise a family. I have five children, and they all doin' all right now, so I don't even worry about 'em no more. You just have to take care of your family, that's all I can say—and teach your kids to stay out of trouble like takin' somethin' from somebody. I never could stand that. Breakin' into people's houses and this type of thing. I never been one to do somethin' like that, so I just passed that on to them like my grandma told me.

It's important to me that my family do well, my grandkids are well and that my wife and I can do well. That's all. Other than that, I don't have nothin' else.

Chapter 8

ERNESTINE NEWMAN

Ernestine Newman was born in 1928. She graduated from Harris-Stowe Teachers College and subsequently taught at the Lexington Elementary School from 1964 to 1990. She married Chris Newman, Tuskegee Airman, in 1948.

GROWING UP

I grew up in, I guess you would call it Depression times. Families kind of grouped together. We stayed with relations or we had a room in somebody else's house like when we lived on Gamble Street, 2600 block. It was east of Grand Avenue and west of Jefferson. We never realized we lived in Mill Creek; we always said "downtown." Our neighborhood was full of old ragged houses. People put linoleum on the floor, wallpapered the walls, added a coat of paint—tried to do the best you could. As a child you learned how to set rat traps and deal with the roaches. It was beyond our control because in those days we had ash pits where the garbage was burned. In the winter, we kept the water running overnight so the pipes wouldn't freeze and we put our milk outside the window to keep it fresh. My mother used to tell us "to chink up the windows," and my brother, Frank, and I would fold the newspapers in between the window and the sill to keep out the cold.

We lived on the third floor of a house, and two families lived on the first floor and two on the second floor. We never had to lock the front door, but you locked the other door inside. It was like a little extended family there.

Everyone took responsibility for cleaning the front steps and cleaning the bathroom on the second floor.

We didn't have much grass to amount to anything, so you swept the dirt; that was your responsibility. Sometimes we'd make patterns in the dirt.

You were never alone. We were all what you called latchkey children, I guess; our parents worked and we had a key to the house. You'd come in after school, change your clothes—you had chores to do, and if you needed help you could always go to one of the neighbors in the building or on the block. Everyone was concerned about each other and each other's children. If your mother said, "Play out on the front," that's what she meant. You played right on the front steps. You did not leave the front of the house. We played jacks, "rock school," made up all kinds of games, and your friends played on their front or maybe you could go next door, but not too far.

We were poor, but so was everyone else, but you knew all the people in your neighborhood and say—two or three blocks on each side, so it was just closeness that developed that I guess you more or less took for granted. People were kind, and they shared what they had.

On Gamble Street, we only had two rooms with a curtain in between. There was no inside plumbing for bathing facilities. You bathed in what they called a number two tub. And when one person had to bathe, everyone moved to the next room. We never saw our parents unclothed. You respected each person's privacy.

And it was just wonderful the way our parents shared. I remember we had an old icebox—everybody had an old icebox that you put a big cake of ice in—and to have ice cream was a treat because you couldn't save it. I was always the sleepyhead, and when my father brought home a surprise they would go through all kinds of things to get me to wake up so that I could share in this pint box of ice cream divided in four ways. But they insisted until I got my part of the ice cream. They could have very easily eaten the ice cream and thrown the box into the fire; I would never have known the difference, but this is the kind of loving atmosphere we grew up with.

When I think about those days, when I reflect on those times, they were just happy days; they were some of the best days of my life, because we had close friends, we had church support and community support from the Y and we had good families that loved us and were concerned about us.

Ernestine Newman

My Parents

My mother did day work in white people's homes. She did the washing and ironing. She didn't make very much money; sometimes she would make maybe a dollar and a half or two dollars a day. They gave her carfare and maybe lunch, but that was about it. But that supplemented the seven dollars a week that my father made. Rent was like eight dollars a month. We struggled. That's why people used to live together—to try and share common things. People used to give what they call house rent parties, and they would sell sandwiches, soda and beer, and they'd have music. People and neighbors would come and buy the sandwiches and soda and beer, and that's the way they raised the rent money.

My father worked at the Green Foundry, but when he was out of work, he sold coal, wood, candy—he did *any* kind of odd job. At that time they had the WPA, but he refused to accept that kind of help. He said as long as he could work—if he had to work three, four or five jobs—that we would never go on any type of relief. So this is how we made it.

My dad was a tiny little man, almost bony, but very strong and very vocal. He was known for being a snappy man, feisty, and he didn't bite his tongue with anybody. It kind of frightened us in a way, and my mother would tell him, "You know, you're lucky," because he always spoke up to his bosses and we were afraid he was going to get fired. But he set high standards for himself; they knew when they asked him to do something he would do a good job. He was a good worker, and they respected him.

At one time he had a job on the railroad. He said he was a cook, but I think he was a cook's assistant; he washed pots and things. His runs were usually twelve to fourteen hours, and they would ask you to double back. You get off the train and then you get right back on the train again and go out for another run. He would do this for a long stretch of time—he needed the money badly—but there were periods when he was very tired and his boss would ask him, well, tell him, that he had to go back on out. He would just say, "I'm not going to do it." He said, "Iron wears out, and I'm going home to my family." He was tired. He was not made of iron. But they kept him anyway!

We were proud of him. He was a strong person; very loving person; real clean, squeaky clean, kept *everything* clean. He washed the windows, and since he didn't have a lawnmower, at one time he took out the big scissors, got on his knees and trimmed what little grass we had with the scissors!

My mother was almost the opposite; not messy, but she wasn't argumentative. She was just a happy, jolly, real pleasant and loving person to be around, so I guess they complemented each other.

We moved away from Gamble Street in the late 1930s when my father got a job out in University City taking care of three apartment buildings. We lived in one of them, but we had to take the streetcar back down to go to school and the movies. The board of education furnished the streetcar tokens to my brothers and I to go to school. The rest of the time we spent in University City. We played with the white children that lived in the building. That was very nice, but I don't know if this would have continued if we had lived there when we were older.

When my father got his job back at the Green Foundry, we moved back downtown on 2708 Locust, and that's where I spent the rest of my growing up time. I got a job working part time at the Velvet Freeze on Jefferson and Franklin. I worked there three and a half years while attending Vashon High School, and I kept my studies up. The little money I made really was a big help at home.

THAT WAS THE WAY IT WAS

We were very poor as far as money was concerned, but we were never poor in the things that mattered the most—the things that have sustained me through my life—the values that were instilled in me as I was growing up. The love and concern that I received from my parents, my friends and my community, those were the things that made me strong and that I feel made me a good person.

I grew up in a loving atmosphere. In fact, when I think about my parents, that is how I remember them: loving parents, but very strict, no nonsense. They didn't tolerate any foolishness, even though I can almost count the spankings I got on one hand. They set high standards for themselves and for my brother and I. It was understood from your family and your teachers that you gave your best in everything, and they were constantly feeding you, in words, "to do the best job you can." If they gave you a task to do and you didn't do it as well as they expected you to do, you had to do it again. Your friends had the same standards, and if someone acted unruly in school or was disrespectful to the teacher, well, that just brought us to tears.

Ernestine Newman

In the way I grew up, color was never stressed; in fact, the white race was never really directly addressed other than your parents were constantly telling you, "You are as good as anyone else; you can do anything that you want to do; be the best that you can be." They never discussed blacks and whites. We knew—it was unspoken—but we *knew* there were certain things that we couldn't do. We *knew* that it didn't take a lot of smarts to realize that you couldn't go to the Fox Theater or any of the movies on Grand Avenue. And we *knew* that when we went to Forest Park, we couldn't go to the Forest Park Highlands. We *knew* that when we went downtown that we couldn't go into the restaurants and eat, and that if we went to a lunch counter in one of the dime stores, we had to stand up and eat because there was no place for Negroes to sit down. *We knew these were the facts of our lives!*

But your parents had built such a foundation early in your life that you felt secure; prejudice was not a problem with you; *you didn't allow it to be a problem.* Let me say that, because you were so strong with your community that you were strong enough to deal with those things—they were only a problem when you went outside your own community—so they weren't overwhelming in your life. Your parents, and that was everyone, were constantly boosting you up, building up your self-esteem, and so you always felt good about yourself. When you would encounter these situations, well, you knew that was the way it was, and you didn't dwell on it; no one dwelled on it.

A lot of people feel, "Why didn't you grow up bitter? Why weren't you resentful that you couldn't do this or you couldn't do that?" I remember my father would tell Frank and I, "You're as good as anybody and better than most." Making us feel good about ourselves was one of the ways our parents tried to protect us.

Another way was when we took the train or bus to go to a little place in New Madrid where my relatives were. Since we couldn't eat in the restaurants, our parents just automatically packed all of us boxed lunches, a shoe box lunch. When the bus stopped at the rest stop, you couldn't go to the restroom; you had to go behind a curtain and use what they called a slop jar.

Every facet of your life was geared to racial things. If your parents dwelled on it, golly, that would be too much for a youngster to grow up under. It was just more or less understood that you couldn't do this, you couldn't sit here, you couldn't go to a nice restaurant. We didn't have the money for that anyway, so they stressed the love and concern and "you're a good person," I guess, to shield you from all of these things, because it would just be overwhelming. So they didn't dwell on those things.

We all knew—we all knew that we couldn't go because of race. It didn't make sense. We didn't question a lot of things, but we knew *that!*

When did I find out there were people whose skin was a different color from mine? I think I always knew. As I said before, it was never spoken of, but I think children who grow up in that type of environment grow up pretty fast. I guess we were mature for our age.

And *no*, we *never* asked our parents why we couldn't go to certain movies or eat in restaurants when we went downtown. We didn't ask because we didn't want to. *We knew they knew*, and *they knew that we knew*, and we didn't want to embarrass them. What could they say?! We knew why we couldn't go; that blacks could not go to certain places. Now, just *when* I found that out I couldn't pinpoint it, but it was just something I knew was always there. I guess it was a way of life. Maybe it was a survival technique; we were just so caught up in doing—living in our community, doing our daily thing—that that was not a big problem for us, because basically, all your activities were in your own community.

I don't know if you saw it, there was a program on television not long ago about Kenneth Clark, a black psychologist who in the late 1930s did an experiment with sixteen black children about six to nine years old. He had a black doll and a white doll, and he asked the children to pick the "prettiest doll," and I believe most all of the children picked the white doll. There was a feeling in the black community—they perceived white as being richer, better and prettier—so if you had straight hair, that was always "good hair."

I have a friend that was raised in Arkansas; she lived on a farm. She had seen the pretty white dolls with the pretty curls at the store in town, and she would always notice when the white families drove in the truck, you know, past their farm, the white girls' hair would always blow in the breeze. She said, quite innocently one day in front of her mother, that she wished she was white. And she really didn't mean she wished she was the white color; she wanted her hair to blow in the breeze.

And her mother really set her down that day and talked to her long and hard. Parents couldn't change things for their children, so they just kept on reinforcing that "what *you* have is *good*."

Chris and I talk about how the color black denotes bad—mean. You know, like the cowboys, the bad guys would always wear the black hats and ride the black horses. All of this can do a lot of damage to children, and as I look back, I think parents were pretty wise and pretty smart that they were able to come up with so many unique answers that children could accept and understand and live with—and come away feeling good about themselves.

WALKING WEST OF GRAND

I have so many friends from my childhood that I still maintain a connection with; we sit around and reminisce about those days. We laugh at the holes in our shoes and not having any money.

We also talk about how our lives were like a circle—just a continuous network of home, school, church and also the Y because that was our recreational outlet. We all basically went to the Metropolitan AME Church on Garrison and Lucas; we sang in the choir; we went to football and basketball games. We walked everyplace we went and did everything together.

Most of my life was spent east of Grand Avenue, but every Sunday my friends and I would walk to Forest Park. I thought I was really going someplace because that was west of Grand—and a very long walk from Locust Street.

You didn't have telephones then, so on Sunday morning, after church, you would go to your friend's home, stand out in front and call or signal to them; we each had our own special sound or signal. Then, a group of us neighborhood children, boys and girls, would gather on the corner and we'd start walking west to Forest Park.

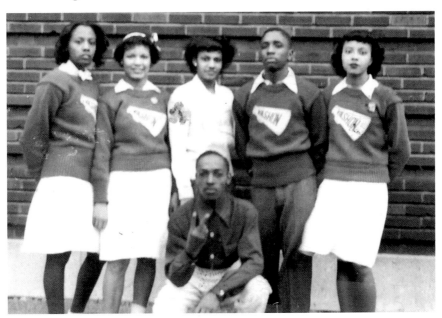

Cheerleaders at Vashon High School, fall 1945. *Left to right*: Helen Beeks, June Griffin, Johnetta Turner, Finley Martin, Ernestine Perry, Johnnie Smith (kneeling). *Courtesy of Ernestine Newman.*

We'd spend the day visiting the zoo, the Flowerbox and the art museum. We knew where everything was in the museum, and we would visit all the rooms—we especially liked the mummy. Then we would move over to Muny Opera in time to get a ticket for the free seat section. We knew all the songs to *Oklahoma!* and all of the operas; that was the fun of it—meeting and walking with our friends and seeing the shows. We felt perfectly safe walking home. There were no problems; those were just good times.

DIAMONDS IN THE WOODS

All my activities in church and school, up through the Teachers College in 1946, were in predominantly all-black situations with just every now and then a little exposure to whites when we went downtown.

But one summer, for a week, I was part of a group that went to camp, a regular camp in the woods, with white girls. They opened up their camp to us—I think—to expose their children to some black children.

We were about twelve years old. And it was *wonderful!* We enjoyed ourselves and were amused at the girls. They rubbed us; they rubbed our skin; they rubbed our hair. They were fascinated with us. We kind of chuckled to ourselves that they would be so intrigued. Maybe they thought it was going to rub off. Probably we were the first black girls—we were called colored at the time—first colored girls that these little girls had spent any time with. Through all of this, we were just a secure group of kids. I believe we were probably handpicked to spend this weekend with them. I can't really remember, but I guess we felt their hair too. We were probably just as curious about them. We had seen white kids before, because many of the businesses on Easton Avenue—the poultry, fish, clothing, furniture and hardware stores—were owned by whites; they lived above the stores, and as little kids, we played with their children. And some of the black women in the neighborhood that worked for private families would bring the white children home with them, and they would stay right in our neighborhood either overnight or for the whole weekend until the maid went back to work, and we would play with them too.

We all lived in a big dorm with beds on each side. We all started out in our own little section, and by the end of the week, we were all over each other. We asked each other questions just like any group of girls would do. I know these girls were from wealthy families, because here they were, out in the

woods with their little sweaters and these little diamond club pins. But it was a fun week. *That's* the way I remember it.

It only happened one time.

Moving to 4869 Margaretta

In the 1960s, Chris and I wanted to buy a house. We had the money to pay down, and of course you try and get the best value for your money. It's all dictated according to the realtors and where they take you to look at homes. There were *no* homes available west; everybody had moved about as far west as they could go, so that area was saturated. The south part of the city was a no-no! It was understood you could not buy property in south St. Louis. A lot of things are gentleman's agreement; legally, they can't come out and openly do these things. It's structured so that if you want to buy a house, there are only certain areas that you can afford to buy into, and I guess the north St. Louis area was open for blacks.

So we found a house in north St. Louis that we could afford the mortgage on, in a nice neighborhood, a partially integrated neighborhood, where we could raise our family. It was a two-story house with six rooms; had three bedrooms and a two-car garage.

Chris and I were very excited. It was a thrill to own our own property. We love each other very much, and we have the same type values and we'd worked very hard to try and save to make a down payment. The house only cost $12,000, which, in those days, was a lot of money for us. So in September 1957, we moved to 4869 Margaretta, and we lived there for thirty-five years.

It was just a matter of time before the white families began to move out of the neighborhood. You can't imagine how fast they cleared out. When *you* start moving *in, the whites move out.* Within a short period of time, you look around—there had been maybe four black families on a block—now you have an all-black community with just a sprinkling of whites that tried to stay. So, in no time at all, you're back to the same situation as before—an all-black neighborhood.

They didn't wait to see what kind of neighbors you were. They didn't know Chris was a veteran of World War II, a Tuskegee Airman, or that I was a schoolteacher. They don't care—they see *color* and that's it! People don't wait to get to know you.

We hadn't really thought about any prejudice—the first indication was when we enrolled our kids at the Scullin School. Scullin, at that time, had classrooms galore; in fact, they had empty classrooms. They had two gyms and two libraries. The class size was about ten to fifteen kids; there were hardly any kids at all in this school. The yard was lined with trees and grass—just beautiful.

But as blacks entered the school, they cut down the trees, they paved over the grass. All of a sudden, there were thirty to forty students in a classroom. We could just see a lot of changes that weren't for the best.

Scullin School—My Daughters

My life, I would say, was more or less sheltered from racism, but where I really felt the pain was when I had my children and they had to face racial prejudice. I don't know if I prepared them well enough. It was more open when they came along than when I came up, so they are the ones who really got the jolt entering school.

As I told you, when we moved to 4869 Margaretta, the neighborhood was partially integrated and so was Scullin School. The first week after my children transferred from Washington School, this teacher wanted to put my oldest girl back a grade. That teacher didn't even *know* my child, hadn't tested her or anything, just that she came from a black school. She just automatically said she was behind the other students.

My second girl had a little buddy named Judy that she dearly loved. I think they were in the first grade together, and everything was "Judy, Judy, Judy." And then all of a sudden, Christy came home and asked what a niggero was.

And I said, "*What!?*"

Christy said, "Judy's mom said she couldn't play with me anymore because I was a niggero."

She was young and couldn't even pronounce it. She had never heard this term before, and that's when I really began to be uncomfortable, because now it was my turn, as a parent, to try and shield my family and children from the prejudice. That was the unpleasant time; trying to help them to grow up, to feel strong and secure as my parents had helped me to be. Chris and I had a lot of discussions about how to work with these situations without hurting them, without dwelling on things. But you had to deal with it, because—as I said—prejudice was more open. The children were hitting it head on, and *they didn't understand!*

Ernestine Newman

SCULLIN SCHOOL—MOTHERS' CLUB

I went to my first Mothers' Club meeting with a few other black women. We were definitely the minority in a mixed neighborhood. I remember one Christmas party in particular. We went with open minds because, at that point, we felt they had really opened up to us and we felt truly involved in the community. There were about twenty black women at this particular party. It was a good group, and we were having the best time!

All of a sudden, the principal came up and gave us all some kind of token Christmas gifts, maybe fifty cents or a dollar at the most, and then *they closed the Mothers' Club.* "This will be the last official meeting of the Mothers' Club. We know that you mothers will start your own club and you'll do a very good job." We just sat down. We were *stunned.* They took all the trophies out of the trophy case; they dispersed the coffee maker and all of the coffee service, and the white mothers just carted all this stuff off—left the room bare. *This* is the way they closed it down, as if to say, "Let the blacks who come in now start their own club."

As an adult, you've been around this stuff for a long time and still you're shocked. As a woman and a mother, you're surprised and hurt that it took place; in fact, we could hardly believe it took place, but obviously it had been planned ahead of time. I was here. Did this really happen to us and *why?!* The trophies belonged to the school, and since these things were part of the Mothers' Club, they should have been passed on to the next Mothers' Club. That was one thing I never did understand. But that was a clear picture to me as to the attitude of not only the Mothers' Club but also the school as a whole and the principal.

These things are the hurting things you face with your children. We knew we had a battle on our hands to protect them. You see, if you're not careful, these are the things that can make you very bitter.

After we discussed it, we became angry, but then we became *determined.* "Okay, we'll start our own Mothers' Club, and we'll do all the things that had been done before so that our children would reap the benefits of the support they needed from the school." Here again, you draw from past history and the things that happen to you. You are determined that it's not going to get the better of you. You rise above it and do what you have to do! I went home and discussed it with Chris—in privacy where the children couldn't hear us.

They changed the principal at Scullin School. The new principal was much more open-minded and agreeable, I guess, with all the factions, and more concerned with how the school was run and how well the students

were doing. We were pleased with the school, but you could see that the physical environment had changed. Without the grass and trees, it was a dreary-looking place. They started busing kids into the school, and they built a portable on the outside to contain the kids in the neighborhood, so the school was overcrowded. The school system allowed that to happen. We fought many battles over there.

What do we do with our anger? Well, I don't know if our conditioning from when we were little up to an adult conditioned you to deal with it until you more or less don't *allow* yourself to get to the boiling point.

I think now, the young people really don't know what to do with their anger, and so they just explode and act out. Racial prejudice has a way of—it's just with you all the time. We've grown up with it; we've learned how to deal with it on just little small, day-to-day things until—sometimes I get angrier now than I did when I was younger because you keep waiting for things to get better, and you see that it goes on and on and on and on.

TEACHING

I started teaching at Lexington Elementary School, a small school at Lexington and Kingshighway—I taught there from 1964 to 1990. As a teacher, my personal feeling about school busing is that it could have been a very positive thing as far as education is concerned, but the first thing they did—they drained the schools of the best students, some of the best teachers, some of the best equipment. If you had movie projectors, slide projectors, any good equipment and you sent it in for repairs, they didn't send you your own equipment back; they sent you some old beat-up stuff. So we were almost afraid to send our good equipment out.

They asked me to transfer to one of the schools in south St. Louis. They felt I was doing a very good job and I would be doing the board of education a favor if I would volunteer to be one of the first black teachers in an all-white school. And I told them no. If they felt I was doing a good job, then I needed to stay where I was because these children needed some strong teachers.

I think it really hurt our black kids. I think it's one of the worst things. Over a period of time, they have really just drained the city schools of the best students and the best teachers; not all, but the teachers that are left are really struggling.

We really had a feeling that some of the white teachers that came in didn't *want* to be there. We also felt that they didn't have the best interest of the black students either—the ones that I encountered didn't have high expectations for the children. They didn't make demands of them that they could do the best work that they could. They made excuses: "What do you expect?"

We didn't accept any excuses because the child came from an abused home or whatever. Home was home, and school was a place where they could be nurtured and you showed concern and you helped that child to develop some skills; the same things that made me strong I was trying to pass on to the children I encountered. And we didn't find that to be happening with some of the white teachers.

A lot of teachers came in with a lot of gimmicks, a lot of showy things, a lot of art projects—we called it busy work. This was not good for the kids. I had a white assistant teacher; she grew up on the far south side—she played with the kids; now here again, the rubbing; these black children just rubbing her and her hair and all. They loved her to death, but she didn't get about the business of educating those kids. She got into their personal family life to find out what was going on at home. I have a friend who is a supervisor now, and she goes into integrated schools and she hears a lot of "little niggers this and that" from the white teachers' discussions in the teachers' lounge.

The kids today that are bused don't have that closeness as far as community is concerned, because if you go to school outside your community, you don't have common school ties. Some kids are going here—and some kids are going there. The parents are not able to go to the PTAs and the kids are not able to participate in all the club activities because they have to get on a bus to get to and from school.

OUR VASHON

We're having our fiftieth Vashon High School reunion soon, and we've been talking about our memories. Back then, Vashon was the newest high school for Negroes. It was a brand-new beautiful building, and the school was just spotless. Most of our teachers had their PhDs at that time, and they were highly qualified. The whole atmosphere of the school was very professional, very quiet—you knew you were there for learning. It was a privilege to go there.

Everyone was trying to make the honor society, trying to make the best grades. You took pride in good grades, and unless your grades were up to par, you could not participate in all the extracurricular activities such as the choir, glee club and cheerleading. Academics came first. Discipline was not a problem; all the teacher had to do was just call your parents and your parents supported the school. They might not agree with what was being said, but you never knew it.

We were proud of our school, proud of our teachers and proud to be there. It was a terrible blow when they moved Harris-Stowe from Enright and Union to "our Vashon" and Vashon was moved to the old Hadley Technical School on Grand Avenue—it looks like a warehouse. They not only took the building, but they took the pride and the memories that went with it.

I feel sorry for the children who are at Vashon now. How can you expect kids who live in rundown neighborhoods to take pride in a rundown school? Have you been inside? It's a disgrace. We're trying to help see if we can't get a new school. My husband, as a Tuskegee Airman, does a lot of inspirational speaking in high schools all over St. Louis, and I understand they've built a lot of new schools out in the county.

GEORGE ELLIOTT JR.

George Elliott Jr. was born at home on Newstead Avenue in 1920. He became an administrator at Webster Groves High School, retiring in 1986. He was honored as Man of the Year by the Metropolitan YMCA for his service.

CAMP RIVER CLIFF

My involvement with the YMCA began in 1929 when I was nine years old. Mr. Milton Carter came to my house on Newstead and Cottage Avenues and invited me to go to Camp River Cliff. He was the assistant to Mr. James E. Cook, the director of the camp. I remember they paid for it, 'cause it didn't cost us too much, maybe five or ten dollars. The money for running that camp was raised by the Y Circus that they had every year at the Kiel Auditorium.

They got trucks from Mr. Hartung's hauling business that would bring pigs and other animals from Bourbon, Missouri, to St. Louis. They would clean up those trucks, put benches in the back and we'd ride sixty-five miles down to camp on Highway 66. Camp River Cliff had twelve cabins, and about 120 youngsters would go down every ten days. There were some all-season campers, but that was a lot of money for some of those parents to try and pay.

They taught us a lot about values, how to treat people, how to take care of ourselves and to keep clean. That's where I learned to set tables

in the dining room. And every morning they had inspection. There would be a prize given at lunch to the best and cleanest cabin, and that's where I learned to make up a bed. We followed our peers. We had our own standards to make and our awards to win. We developed our skills and became capable of lifesaving in our swimming hole on the Meramec River. We learned self-esteem and a way to relate with people in the world. We had services every morning in a beautiful little chapel on the side of a hill, and we learned a lot there. Camp was a great experience. I grew up there, and Mr. Cook helped raise me.

As we got older, my friends and I became leaders and counselors, and then we were the role models. Eventually, I became a member of the upper staff and helped run the camp, and I handed stories and traditions to the next generation. Even now, we all still have those binding relationships with each other.

There is a deep appreciation of those strong influences from our camp experiences. It meant so much in our lives, and I have never been able to find anything like it since then. It's something you can't get in most other places.

NICKNAMES

Every kid that came to camp got a nickname, and it followed them through their life. When I was a counselor and would introduce myself to the new campers the first night, they needed to know somebody and have a name that will strike 'em. So I go on to tell them how smart I was, and from then on they all called me "The Fox." Today, I meet them in the stores—clerks— and they smile and say, "Hello, Mr. Fox. How's Mrs. Fox?" Yes indeed!

THEY TURNED IT AROUND

I think the original campground in Bourbon, Missouri, was owned by the Metropolitan YMCA, and they let us buy it from them, but the *community didn't want us.* They never thought of *blacks* coming in there. They probably never seen blacks before. They burned a cross on the other side of the creek, and I still have one or two friends who were there when that was done. There are eighty-five-year-olds who remember that. But we just

stayed on—wouldn't get up and leave and run. They let us stay, and we finally had an experience that made them *totally* our friends.

The people in the community knew we had lifeguards, and we got a call one day that a youngster had just drowned in a man-made lake about fifteen miles away from us. They asked, "Could we come, quick?" Our director, Mr. Cook, put three of us in the camp truck, and we went over there to try and help them. They thought they could save the child—thirty minutes under water. We took a boat out and took turns diving. Then I went down, and it was deep. We didn't have anything but just us, nothin' on your mouth, no oxygen, no nothin'—we never heard of that stuff. When you get down past ten feet, the water temperature changes to really cold, and you just feel like you're swimming in coffee—you can't see anything. But I found the kid and brought him up, and then we took him over to the shore. They tried to do artificial resuscitation. It was useless really, but that was something for their benefit. Boy, were they our friends from then on. Then we got other calls, "Come over here, come over there." It was a dangerous game, because the

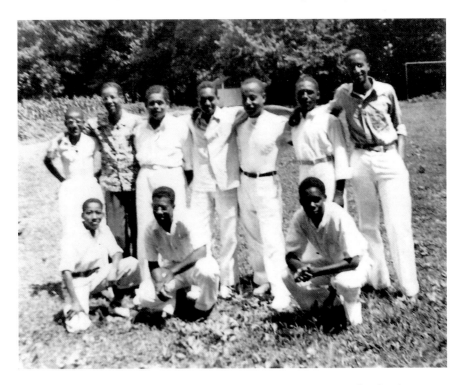

Camp River Cliff counselors dressed in white to host visiting parents on Sundays in Bourbon, Missouri, summer 1930s. *Courtesy of George Elliott Jr.*

Left: Camp River Cliff campers on the steps of their cabin, circa 1941. *Courtesy of George Elliott Jr.*

Below: Camp River Cliff. John D. Buckner is third from left; Andrew "Papa Jack" Jackson, director of the camp, is fourth from left with his wife, Mae. George Elliott Jr. is at the far right, with his daughter Linda in the front row, standing, early 1950s. *Courtesy of George Elliott Jr.*

Meramec is known for having trees that have fallen over and you can get tangled up in that stuff, but we went. That really got us the best kind of relationship, and of course, we bought our food all up in Bourbon, Missouri, and we went over to the cave at Sullivan—I think that's where it is. And so we spent a lot of money in that community.

They began to come over and play us in sports on Sunday afternoons when all the parents would come out from St. Louis to visit their kids. We had a lot of fun, picnic lunches and all that sort of thing. They turned it around, became our friends.

INTEGRATION

Life changed when integration came. The kids today can't get what we got, because they are not in a concentrated group. Now the black kids attend the large YMCA camp at Potosi, Missouri, which used to be only for white children. When I was on staff at River Cliff, we'd take our campers over the mountains by truck to spend the day with the white campers in Potosi. Those white youngsters had never had any contact with black youngsters. We'd play games, talk and swim. Basically, everybody got to know each other, same principle as when they integrated the schools. It was a great experience, but we didn't do it too often, maybe three times a summer.

WALKING TO THE PINE STREET Y

I've spent a lot of time in my life with the YMCA. When I was a little boy, they had an outreach program, the Elleardsville Y—in the heart of Elleardsville—on the corner of St. Ferdinand and Pendleton, across the street from the Poro College building. It was a storefront, one room, and Mr. Cook was the outreach director. We would meet there every day after school and go over to Tandy Field and play our games. We were grouped by age. All the guys who were ten and under were called Friendly Indians, twelve and under were called Pioneers and so on. You accomplished certain skills and moved up in rank.

The Pine Street Y was on Pine and Ewing, below Grand Avenue, and it served all the black youngsters in St. Louis. We had a whole year-round

program, walking down there every week, taking physical exercises and learning to swim better. We were all involved with it, the whole community was concerned with the boys at the Pine Street Y and the girls at the Phyllis Wheatley YWCA.

As a youngster about twelve, thirteen and fourteen years, I had a group of running buddies. Wendell Pruitt was part of that group, and on Saturdays we were scheduled to be at the Pine Street Y. We would walk all the way down there from Elleardsville. We could have taken a streetcar if we had carfare, but we never thought about it because we had so much fun talking, laughing and dealing with the things we saw. Some of the guys were adventurous enough to hop on trucks as they came down Easton and hang onto the back of them. You could fall off those things, but they never did. It would take us two hours to walk down and two hours to walk home. We enjoyed having our time at the Y.

The Pine Street Y was situated in the middle of a tremendous black community around Jefferson and Market, a heavily populated area, larger than Elleardsville. This area was crawling with low-level economic folk;

Pine Street YMCA's swimming pool, spring 1943. George Elliott Jr. is in the center with his class. Tom Brooks, juvenile officer of the St. Louis Police Department, is kneeling by the pool. *Courtesy of George Elliott Jr.*

George Elliott Jr.

Pine Street YMCA pool, summer 1944. George Elliott Jr. is teaching a lifesaving class. *Courtesy of George Elliott Jr.*

Volunteer interns from Homer G. Phillips Hospital giving free annual physical exams to children at the Pine Street YMCA, 1943. *Courtesy of George Elliott Jr.*

people, people, people living in low economic homes. It extended from Grand down Twentieth Street, and south over Papin to Compton Hill, and north on Jefferson to the other side of Easton Avenue where there was another set of people who stayed within their city limits.

There were groups of boys, young men in these areas that clashed with one another. Gangs are nothing new. They talk about gangs now. There were gangs then, the Sharks from Easton Avenue and the Compton Hill Boys. They were known for carrying knives, and we knew the police stories of how they had to run them off street corners. We really didn't see them, but we knew they were around. So my buddies and I, when we reached that area, would tip through the streets. That's another way of saying we were very careful that we didn't get caught by one group or another, because we were the guys from the other end of town.

They never bothered us. They weren't even thinking about us. Mostly they had their own cross-town fights—but we were ready to run at any time.

THE Y CIRCUS

The Y Circus was really a show, but we called it a circus because that's the way we started—from scratch, in the gym at the Pine Street Y around 1924.

I remember when I was a kid in it. We had clowns dancing around, a "hanging-on" apparatus for acrobats, sawdust on the floor, and we, as kids, would come out and do our part. But then, it was a very small-scale kind of thing. The physical education department worked up a program for the parents to come and see. They had it every year, and it kept growing, so about five years later they had to go over to Vashon High School so it could accommodate more people. I think they had it over there about two or three years—that would put it around 1932—and then it got too big for Vashon, so they said, "We're going to Kiel Auditorium," and that's what they did. They went pro—they became professional.

The main purpose of the Y Circus was to benefit Camp River Cliff. That's the way we got the money to pay for the kids to go to camp. The kids didn't have any money; their parents didn't have any money—maybe we got five dollars for two weeks—so the Y Circus subsidized the rest.

From 1942 to 1945, one of my responsibilities as a staff member at Camp River Cliff and the Pine Street Y was to plan the first thirty minutes of the program for the Y Circus. It was held in April, and I spent the summer

The Y Circus at Kiel Auditorium, 1940s. *Courtesy of George Elliott Jr.*

before dreaming up the theme for exactly what our part of the show was going to be.

I usually had about 150 youngsters, and I divided them into five groups, each group doing a different act. I planned their routines: the acrobats, the gymnasts, the dancers, the music and the costumes. They were really dressed up. We had a well-known local band that backed all of this up. When I came back to St. Louis after camp, I trained those youngsters from September to April.

The boys had a ball doing their part of the show, and then the two high schools, Sumner and Vashon, sent girls' dance groups and other amateur acts, and they would all perform. Then came the halftime intermission, and after that, it was time for the pros. It was great! Through the years we brought in Duke Ellington, Ella Fitzgerald and Lionel Hampton. Another year we'd bring in the Nat King Cole Trio, and one year we had Count Basie, and there was the guy who played the xylophones so well, still does. I can't think of his name. We just had the *best* in the country. Now you're talking about an audience out

there in front of them—for five nights. When you fill Kiel Auditorium Opera House, it's about five thousand people. So that was the time when twenty-five thousand black folk saw their great musicians and bands perform *in person*. The *only* place they would be coming to entertain in St. Louis was the Kiel Auditorium, and the people filled up that place *every* time. I believe they were paying six or seven dollars. That was a lot of money in those days.

All of this stopped about the mid-1940s. The big bands were becoming well known all over the country, and they became too expensive and we couldn't afford it. We were doing all the work and they were taking all the money. The economics changed and you had integration, you had television to come in, and people saw them there. They didn't have to come to a Y Circus, and it just changed the nature.

CHANGES

The Monsanto Y is not the same as the Pine Street Y used to be. The Pine Street Y, on Pine and Ewing, was the focus and the only place that black youngsters could go, and that's also where all the town meetings for adults were held. The Monsanto facility doesn't offer that much because there are so many other facilities now: Matthews Dickey Boys' Club, Carver House and several others, so this is not the only one. What you get is a thinning out of relationships. Everybody is not coming to the same place, and everybody in town doesn't necessarily know each other like we did back in Pine Street.

We are not able to have the same influence on children that we had when I was coming up and working as boys' director, at least not in the wintertime, because we don't have the concentration of youngsters, same ones coming every week, so our opportunity to influence and to shape up their character and their way of thinking and their way of living with one another is not as strong as it was.

Also, we don't have Camp River Cliff. That's where for two weeks we could do tremendous amounts to mold their characters and way of life, help them to set goals. We did a lot there because we had them all day from seven o'clock in the morning until ten o'clock at night. You were constantly influencing and getting these principles over to the boys.

The boys I worked with at camp and at the Pine Street Y are now grown. Many have completed their careers and retired. Sometimes a guy will walk up to me, remind me that he was at River Cliff and say, "Boy, we had a good

George Elliott Jr.

Business meeting at the Pine Street YMCA, circa 1930s–1940s. *Courtesy of George Elliott Jr.*

time." I still play golf with one or two of them that were in this Y Circus. We all still relate to one another.

It all revolved around the opening up of the residential problem. For one thing, in my time, we couldn't live outside the black community, couldn't move to the county. When I got ready to buy a house, I didn't go across St. Louis. I did get up to Kingshighway, but we were still tied, still limited. After that, blacks began to move to University City in large numbers and to Black Jack, out there in that area. Neighborhoods opened up, and it changed the whole picture of where their kids could go. They don't come—it's too far— to Monsanto. It's not the same today as when I was a youngster. Kids today don't get that kind of closeness. It added a dimension to *our* lives. We'll *never* see those days again.

THE MISSOURI PICTURE

There were three high schools for blacks in the city: Sumner, Vashon and Washington Technical School. There were no high schools for blacks in the county. It's amazing, the story of the black students who came in on streetcars every day to the high schools in the city from places like Webster

Classmates on a Sunday afternoon at Lincoln University, Jefferson City, Missouri, 1941.
Courtesy of George Elliott Jr.

and Kirkwood, Richmond Heights, Clayton and other enclaves. They all came to Sumner, maybe a few went to Vashon. I even know one man, he's retired now, that came from St. Charles. We sometimes talk about that now in awe. We didn't think about it when we were kids. We knew that they were doing that, but back then, we just took it for granted. We didn't have any antagonism about it because we were busy just *making* it, just like they were. "I've got a goal, I got to get an education and this is where I got to go to do it, and that's what I'll do." And that's what *they* did.

We dealt with the same thing with the University of Missouri. They didn't want us. They'd pay our way to go to any other university that we chose. I wasn't aware of this at the time I went to Lincoln, so I went there for two years on a football scholarship. I worked all the time I was there. I was also on the basketball team and traveled. I had never been anywhere except to camp—went to all those colleges to play ball, like Wilberforce up in Ohio, traveled to West Virginia and down in Oklahoma.

Lincoln was a great experience. Had tremendous classmates and joined Kappa Alpha Psi, a social fraternity, a highly serviceable organization, now deeply involved with youth programs. Its major point of pressure is achievement. Kappa Alpha Psi has always been a strong influence in my life, and I still relate with my friends all over the world. Last summer I attended a National Conclave along with two thousand men in Philadelphia.

Later on I went to the University of Iowa—at the expense of the University of Missouri— for two or three months every summer for three years to complete my master's degree in physical education. I lived with a black family who took in three or four of us. We went to school in the morning, came home for lunch, went back to school and came home for dinner and prepared our studies for the next day. If they had dormitories at that school, *we never saw them.*

Many of our young people went up to Ohio, Kansas and Illinois. *That* was the *Missouri* picture. That just wasn't the picture of St. Louis or Elleardsville.

SUMMER JOBS

My degree was in education with a major in physical education and sociology. My first job after graduating from Lincoln was back in the city of St. Louis in the City Recreation Department. That was 1943. I worked for one year as a director of the Compton Community Center down on Market. I had inroads there since I had been working as a lifeguard at their community centers during the summer while I was at Lincoln, so I knew the recreational director. My first summer was at the Vashon High School pool, another was at the Adams Center on Jefferson close to Market. It was designed so the public could come there to bathe if they wanted to, and it had a swimming pool complex for children. I also worked at the Tandy Center, 4000 Kennerly. That was an indoor pool and was a nice cool place to work in the summertime. It's still there. I enjoyed those summers. Sometimes the kids who came to those pools stop me now and talk about how they enjoyed that relationship.

THEY DID IT ANYWAY

In 1950, I began teaching at the Vernon Elementary School on Maple Road. I was placed in a room with three grades of about thirty-five youngsters. I had two rows of sixth graders, two rows of seventh graders and two rows of eighth graders with different books for each grade. After I dealt with one grade on a given subject matter, I would move on to the next level and work with them. You didn't have a lot of time to answer questions; we had to move

along pretty quickly, and those youngsters learned as best they could. There was some cross-flow of information as a result of the youngsters hearing what was being taught to the other classes.

Schools were not integrated yet, and there was no busing. These children were all within walking distance from the school and brought their lunches. There was some physical education. I don't believe we were supervised there. The school board just let us go over there and do what we could. There were three or four teachers there, each with the same kind of setup I had, and each room was like a one-room schoolhouse.

I'm one who feels that even though youngsters didn't have the greatest or latest textbooks, whatever the circumstances, the teachers were able to make it functional and make it worthwhile. That's the way it was all through *our* educational system then. And what we didn't have never stopped people from doing great things. *They did it anyway!*

MY MOTHER AND FATHER

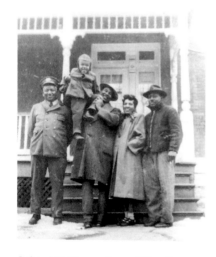

Left to right: George James Elliott Sr., George Jr. holding son Ronald James, Sara Elliott and Joseph Murphy in front of Mr. Elliott Sr.'s home, 4338 Ashland Avenue, north St. Louis, 1946. *Courtesy of George Elliott Jr.*

I had a very bright mother who knew how to inspire me and my sister to live life, to go to school and to think about preparing for college. I think I was very lucky because my mother had *insights*. She was just one of those kinds of people. My father wasn't bad, but he just worked all the time and he didn't try to see that we got places. Mother saw that we went out to the Municipal Opera when we were ten or twelve years of age. We would get out in those free seats on Monday nights and we would see all the shows.

We went to Forest Park for picnicking, and she saw to it that we got what we needed to go away to the Y camps in the summer. Mom liked those kind of things, and she wanted us to have those experiences.

Left: Ronald James Elliott, Cub Scout, circa 1951. *Courtesy of George Elliott Jr.*

Below: Kappa Alpha Psi Fraternity annual dance. The second couple from the left is Sara and George Elliott Jr. *Courtesy of George Elliott Jr.*

My mom didn't talk with me about my choice of life's work. She didn't have that much to go with. I don't know if she ever finished high school. She just knew that you went over there to the junior college and you got what you could get. Then you went to Jefferson City, and whatever they got, you got. But as far as choices, she never talked about that because we didn't have a lot of choices. When I went away to college, I really didn't know what I was going for. I just went to get a degree. It was kind of like the mountain was there. Mom had instilled that in us. You want to go all the way.

My father was kind of looked up to. "That's Mr. Elliott. He works at the post office as a mailman." He was one of the elite in our community. That gave him status. I didn't know anyone else whose father worked for the federal government. He had a better job than most folks around. Most of the other fathers were waiters or worked at Scullin Steel or didn't have a job.

Mom never worked. Dad saw that the money was there. It wasn't a lot of money, and Mom would have liked to have had more. I recall she was very sad because of that.

My mother was a Baptist mother, and church was a big part of our lives. We attended the Antioch Baptist Church regularly and went to Sunday school. When I grew up, I taught Sunday school, and later I was superintendent. My wife, Sara, and I both sang in the church choir, and we kept our kids in Sunday school.

I don't recall my parents discussing people who were racially different from us. They probably talked with each other and their friends among themselves, but they didn't pass on to us any attitudes. Theirs was just a question of wanting us to be out there making it, learning what we got to do in church and staying in the community. *That's* what they passed on to us.

YOU'RE TALKING TO AN OPTIMIST

As a youngster, there wasn't anything we went out of Elleardsville for except to go downtown shopping and to the Pine Street YMCA and sometimes to Forest Park. But when my sister June and I would go downtown shopping with our parents, we knew there were certain things we couldn't do. We would pass food on the counters and just didn't confront it, didn't attempt to use it, didn't think you needed to. It just wasn't part of your desires to get to a counter to eat. That's about the only thing that was denied, the eating per se. There weren't separate toilets or drinking fountains for colored. It

George Elliott Jr.

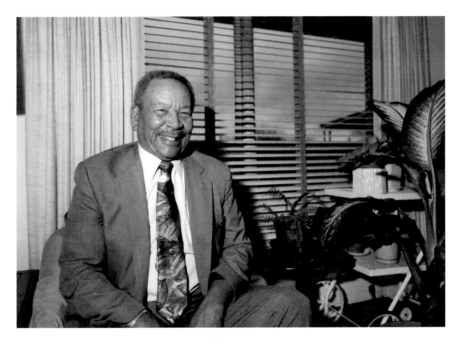

George Elliott Jr., 1994. *Courtesy of George Elliott Jr.*

was common knowledge, standard procedure that you didn't eat the food at places downtown. There were no signs.

We didn't spend a lot of time downtown. Everything you needed was mostly—in our case—in Elleardsville. Our lives were out in Elleardsville. We went downtown, got what we needed and mother would take us past those counters and we would get on a bus and come home. We didn't ask our parents why we couldn't do certain things. I don't think the parents would have had much of an explanation except, "We just don't, it's not available to us." We took all this for granted and didn't think about it much. I was too busy with the regular life. I wasn't distressed about it. That was just a fact. We had our own life to live and we were busy doing that, so we didn't worry about it, but *we knew it existed*. It didn't have any effect or impact on me. You're talking to an *optimist* and a person who has had a good life.

Chapter 10

EUGENE Z. LEWIS

Eugene Z. Lewis, born in 1902, lived in downtown St. Louis. As a child, he sold newspapers in a way others did not. He worked for the streetcar company for forty-eight years.

WHAT AM I?

You want to know where I was born? I do know this much about it, I was born on Arsenal Street in a hospital called the Female Hospital. It was right across the street from what we called the "Bug House." That's where I was born.

You want to know my father's name? Well now, that's history. I don't know what you'd call him, a father, but I'll give you this history. I'm not ashamed of it. My father was white and my mother wasn't, and that's the way I come up in them days, so what Inez [Mr. Lewis's caretaker] and I was talkin' about the other day was this: why did God make the black man? And then I'll go back to me as an individual human being; *what am I?* I'm not a white man; I'm not a black man. What is my nationality by my mother havin' to give birth to me? And that's been a mystery to me all the time. What would they call me? They couldn't call me a white man; they couldn't call me a black man; that ain't my color. What nationality am I by nature?

I come up in St. Louis. I was a good citizen as a boy. I never graduated from college and I went three years to Sumner High, but I didn't get to

do that 'til I was a man. I learned a lot of things in them three years that I went to school. I always have been a student. I got books on everything. I'm practically a self-educated—whatever you want to call it, a learned man. I like knowledge, but I always wondered, what part did God play in me for being born like I was?

Now my father wasn't a bad man. He was a good man, he was educated and everything else. The relationship they had, I know nothin' about it, but I was just wonderin' what I am.

You say, "a good man"? Well, I'd say, "a human bein'." So that's the way I look at it, but I never let it bother me.

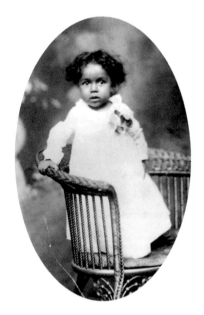

Eugene Z. Lewis, St. Louis, Missouri, 1903. *Courtesy of Eugene Z. Lewis.*

COMIN' UP

Life for me as a child was hard. It's difficult to discuss that here. Pleasure, when it comes to pleasure, *nothin'*! Now this playground park over here was all white. I'm talkin' about recreation, all the things, the nice things of a child comin' up, the black boy didn't have it. He didn't have no playground; he was denied this, all kinds of things. Oh my early life was hard.

And I had to get out early, and I'll give you this history of me. I didn't have a pleasant life. Let me see, I think it was when the *Titanic* sunk, it was around 1910 or 1912, I think. Now as a boy I lived at Ninth and Market, I never will forget it, I cherish what I'm goin' to tell you now.

A little boy like me was no kind of nothin'. I had two cents in my pocket. Let's see, I started sellin' papers when I was about ten years old, twelve years old, and the idea struck me what to do with the two pennies. I took the two pennies and went down to the *Post-Dispatch* sales and bought me some papers. At that time, the little boys would sell papers on the street. And I got four papers for two cents. And before I got back to my corner I sold 'em and I had four cents. I had the wisdom to

take the four cents and go back to the *Post* and got eight papers. I doubled everything that I had, and I was gone all day and my mother didn't know what happened to me. When I come home I think I had about a dollar, or a dollar two I had made from the two cents. By the Grace of God I took that money and got the paper for people in the neighborhood. I had my corner, was Ninth and Market, and I delivered papers to the people of that neighborhood.

I made more money sellin' papers than I would have done doin' hard work. I sold papers 'til I was fifteen. They thought it was a boy's job. It was a man's job; they didn't know it 'til a lot of years later when a lot of 'em seen the boy sellin' papers made as much as they did workin' for somebody, and that's what I done, and from that time on I always have been a mathematician, a businessman as I got older.

I took care of my mother when I was practically nothin' but a boy. My biggest responsibility was to keep my mother at home. I got my mother from the washboard. She didn't wash clothes for the Sprosses and nobody else. I put food on the table. I bought my graduation suit and helped my mother raise me. We were very close. I took care of her 'til she died.

KARL SPROSS

Now my bringin' up was this: what I remember of my childhood days was Ninth and Market. We lived next door to a restaurant and bakery owned by a German family named Spross, and my mother worked for them as a domestic and in the bakery. They had a son named Karl, and I never will forget we was just two days difference in our ages. He was a little German boy. I played at his house. I practically lived there. We was raised up together. We played cowboys and Indians, see who conquered the leader. We had a good association, but I didn't have the pleasures that he had. I couldn't go to the school or the places that Karl went, and Karl knew it, but that didn't hurt us one bit at all. My biggest recreation was to be with Karl. We were sidekicks, kinfolk, the same as brothers. When you seen Karl, you seen me. That's the way it was. He didn't have no other playmates. I took on the mannerisms of these people, and it was like that until Karl died of influenza when he was eighteen years old. I couldn't go to his funeral 'cause they were German American and the place they went didn't have any blacks. My father took me to see Karl's grave afterward.

Lᴇssᴏɴs ꜰʀᴏᴍ Mʏ Mᴏᴛʜᴇʀ ᴀɴᴅ Mʏ Pʀᴇᴀᴄʜᴇʀ

My mother was a good mother. She did the best she could under adverse circumstances, but the point about it, she didn't push me to get an education or nothin' like that, and I don't condemn her. It's just one of those things. My mother was a servant, a domestic servant; wash, iron, clean houses, that's most what she did. Domestic servants at that time, especially black women, they paid them whatever they pleased. They didn't have no unions, nobody to speak for them—the pay was bad, awful bad. I couldn't pinpoint how much an hour was, but for the work they done it wasn't good.

I learned from my mother about bein' honest, the basic part of raisin' a child, bein' honest and havin' integrity; hold your head up high and all like that; don't let nothin' get you down, and I was that way when I got to be a man workin'. I had the same thing, they used to try to put me down. So I'll tell you this. There was this one little man, a little dark fella, he didn't like me. I never will forget it, we were all eatin' in the same streetcar at work together and he says, "You don't know who your father is. If he was to come in here you'd call him 'mister.'"

I said, "Maybe I would, now who is your father? Who'd you call him?" So this is one thing I knew how to do.

How'd I get my strength? I don't know. I think I had people on my mother's side that were very religious. I got it mostly from my mother and her teachin' me the scriptures as a child and I seen that it worked. It wasn't nothin' gettin' in a fight, carryin' on and all like that, beatin' each other up and shootin' one another. I always turned my back to it. I never will forget the preacher who said in his sermon, "If trouble's goin' to meet you comin' 'head on' on the street, go to the other side of the sidewalk. And if trouble's goin' to meet you goin' to the next block, go to the *next* block. Avoid it!" And that's it, if you avoid a thing you ain't gonna get into it.

I like to say, "I was a person that can take it," and they used to criticize me. They'd say, "Gene, you sure know how to take it. I wouldn't have done this and done that."

I told 'em, "*That's you!*" I never got in no trouble. I've come in contact with some awful southern people, but I always smoothed it over. Now how I got that way, don't ask me 'cause I couldn't tell you to save my life.

Eugene Z. Lewis

Lessons from My Father

I knew my father. He was a good man; he used to come and pick me up and take me different places and all like that. Yes, I knew him. One time he took me to Spanish Lake and we went fishin', and he'd take me where he wanted to go and nobody do nothin' about it. He was a hardheaded German; you couldn't cross him too much. He'd cuss you out like he told a policeman one time *it was none of his business who this boy is.* He told him!

My father recognized me. He used to take me a lot of them places with him. I felt good about that. Yes, I did. He was nice to me. He adored me. His people used to live right over here on Fairgrounds, in this neighborhood. They were rich Germans, and that's where he was born and raised in this vicinity, my father was.

I got to see his brother, and one time his brother come and visit me and his family wanted to adopt me. They just done everything in the world; he come back there to where we was livin' and I remember that, and he said his mother and father and his brothers and sisters wanted to see me. He did what he could. The mission was to come and get me and raise me. So I had that knowledge from my father that the family wanted me, and for a while he taught me the German language, but I forgot a lot of the words now.

How old was I when this was happenin'? Well, I knew him all my life. I tell the truth, as a baby as far as I can tell, he didn't live with us. He stayed with his family and he helped put up the World's Fair. He was a carpenter. He was foreman of all that carpentry work. He made good money, but he throwed it away. He liked to gamble, he liked to drink and that was his shortcomins' more than anything else. My father did not work for me. If he had been stabilized, not alcoholic—I guess I put it that way—so that didn't give me anything to go on, but he always was nice to me. I never knew a time when he ever laid his hands on me. I do have good feelins' for him because the blood was there, and I was just a kind of a boy that always avoided fightin'. I stayed to myself. I'm isolated now. I was brought up that way. I don't care about a whole lot of people comin' here. If they never come I wouldn't miss 'em. I don't like nothin' like that. I don't like people comin' here, drinkin' and actin' the fool and this and that, boomity-boom-boom. I don't do that. Inez can tell you that. Sometimes nobody comes here in a week unless it's the mailman and he's outside. My daddy taught me, "Believe nothin' you hear and half of what you see." I'm that way today. I haven't changed.

SCHOOL

When I was a boy we could go to a black elementary school and go clean on through to the black high school. We didn't have no college in St. Louis for the blacks to go to. They had to leave St. Louis and go north to college for their education on different things.

I went to Dumas Elementary School on Fifteenth and Walnut. City hall was right at Twelfth Street. We had moved to Eleventh Street, and I used to go from my house across the street and make a shortcut and go through the city hall to school to Fifteenth Street. It wasn't no distance from the school.

I done good in school, I had friends. I didn't have no trouble. But you had to take a whole year for one grade. You had to go to school about five or six or seven years in grade school, and in those days there was no thing as skippin' classes. If you didn't pass, you stayed where you was 'til you got it right. I had a principal, and he was very strict. The girls sat on one side and the boys on the other, but when he had examinations he had a blackboard; he put a boy here and a girl here, and that way they couldn't cheat. I liked it that way. I always was a child that was tryin' to get something right.

We had a depression in 1921, and they were layin' off people. I had a job, paid good, and went to school at night; three years at Sumner High School. I got bumped off my job and I couldn't go back to school. I had to work. I had the same job but different hours, and that kept me from goin' to school, so then I never did go back no more. It was just one of them things.

I don't condemn the black schools. They done the best they could under the circumstances. We didn't have up-to-date books, but I done all right at school. To tell you the truth, I didn't see any difference 'til I got older. The basics wasn't any different than the other schools. The main thing I see in the school was learnin' your ABCs, and after you learn the ABCs then it made no difference what school you went to.

I had good teachers. I adored my teachers. I liked them and I liked school. You see a lot of books there on my bookshelf? I always was a great reader. My best book is the Bible. Oh my God, I'd go to school today if they'd take me; if it were feasible. I'm crazy about learnin'.

Eugene Z. Lewis

A Lone Boy

The neighborhood that I lived in had every nationality on the globe. It wasn't a racial district. Everybody lived in it. You take the Jewish people, they lived over the stores, and there were Germans and Irish. And on account of me bein' a boy right at Chinatown, I had a lot of friends that were Chinamen. They all knew me. My early associations were with whites. I had as many white friends as I had black. We all lived on the same street. We didn't have no trouble. I come up in what they called a so-called slum. It's a mighty good people that come out of the slum. One of the boys I used to play with, named O'Hara, and they used to call him a shanty Irishman. He sold papers on Seventh and Olive Street. Now O'Hara was a boy, same age as me, and he used to come and be with me and Karl. Now here's what happened. As he grew up he got to be a politician in the neighborhood, and when Roosevelt got elected president of the United States, O'Hara was named as one of those secretaries on Roosevelt's cabinet. *He was!* He was a poor Irish boy just like I was poor, and he rose up to be a big man and he always recognized me, but I couldn't associate with O'Hara on account of him being a national thinker.

I had people I looked up to, my teachers and the businessmen in my neighborhood. They liked me and they used to steer me on certain things and I liked it. I learned more about business bein' at Karl's home than I did in school, and I never will forget a man, Mr. Carnette, he was a tailor and one of my customers. He took the paper and seen I like to read, and he taught me how to read a newspaper. He said, "Don't just read the news. Turn the pages over. You have to read the editorial." I always liked to learn. Newspapers is the best thing that you can have; like today if you don't read certain things in the editorials, you ain't gettin' nothin' out of your newspaper. Now, that's my version; you had to read the editorials. I liked the *Star Times*, the *Globe*, the *Washington Post* and the *Republican*; the *Argus* was strictly a black newspaper with black news. The *Globe-Democrat* was my main paper. I sold more of them than I did the *Post*. I always liked the *Globe*. I was sorry when they went down.

When I come up, blacks weren't even called colored. They were called niggers. Even the black man called himself a nigger. That used to burn me up when they put themself down. The black people didn't like me. They called me everything but Eugene Lewis. They said I was different. Well, here's what it was. My ways was different than average for a black person that come up in them days. I was almost a lone boy. That's the

reason why I say, "What am I?" Now I got more discrimination and indignity passed on me by the blacks more than I did the whites. A lot of 'em would say that I thought I was a white man, and that used to puzzle me. I *was* different. I was *very* different. I read newspapers, books and magazines, Bibles and everything where they'd be out shootin' craps and all that kind of stuff. *That's* the reason I was different. I didn't have time to do that foolishness. Never did like it. So that's what they were; they were jealous of me, you see, because I had more knowledge than they did. They said I thought I was white and they thought I was tryin' to be better. I had that told to me too many times even after I got to be a man, and bein' lighter skinned was part of it. But then my speech was different. I didn't use "dis, dat and t'other." I was raised and educated by the white people around me, the business people in the neighborhood, and naturally I took on their language as the English language. I used to have a good command of the English language when I was younger, but now I got older, I kind of get mixed up.

My mother had that knowledge about what was happenin' to me. She was on my side. She realized that it was difficult, so that's the whole thing about it. That's the way it was.

EAST ST. LOUIS, 1917

In 1917, there was a riot across the river in East St. Louis. They had labor trouble. Here's what happened. They had packin' houses in different places over in East St. Louis; foundries were on a strike, and to break that strike they went south and get the black man to work. The black man didn't know the situation, and he come up and all he knew was that these people went south to offer him a job. Without the black man's knowledge, the whites used the black man as strike breakers. All he knew was he was gettin' better money than he did in the South. And that's what caused it. They lost their homes and everything else. They sent the National Guard in there; they had to send them in there. It took a long time to stop the violence, the killin'. It was a massacre. A lot of whites got killed too.

I'd sit on the waterfront with a friend of mine and see them flames shootin' up in East St. Louis. And we could see the black people comin' across the bridge; some of them were barefooted tryin' to get away from all that violence.

The police was tryin' to keep St. Louis cool, which it did. They wouldn't let no groups of people, white or black, over three people standin' and talkin'; they'd break it up. They didn't beat 'em up, they just didn't allow too much of a gatherin'.

Did you ever hear of Aloe Optical Company? Aloe was assistant mayor of St. Louis; the mayor of St. Louis was out of town when this happened. Well, Aloe had charge of the city, and these people were comin' in droves and they had to put 'em somewhere and they put 'em in all the vacant houses so they'd have a roof over their head. And Aloe made plans so they could have food and stay in these houses; they didn't have any money. That's the way they solved that thing. They had a lot of blacks who took 'em in their homes. Of course the whites didn't take 'em in their homes, but they made it possible that they could have food and clothing. And the churches were very much involved in helpin' out.

I wasn't afraid. That's one thing about me; I don't fear too easy. I'm not a fool. Lots of times fools rush in where angels fear to tread. No, I wasn't afraid, but I was very much concerned.

We had a lot of good white people in St. Louis. I have to give 'em credit for what they done. They didn't try to incite nothin'. All they done was try to help those people that needed it. That's what happened in 1917.

CHURCH

I was always religious by nature, but I didn't join the church until I was in my twenties or thirties. I seen so much wickedness in high places in the churches, I didn't care too much about goin' to church. What I seen when I went to church, like people of the world does, the people in the church doin' the same thing, and it didn't encourage me one bit. I'd just seen so much wickedness. Like the Bible say, "Wickedness in high places." I'd seen it. But I *did* join the church, and I was president of a club for twenty-five years. I done everything but preach. I taught Sunday school; did a bit of singin'; I helped pallbearer for the dead; I done everything. I've been a member of the Lane Tabernacle CME Church for over fifty years. I'm still a member although I can't do what I used to do.

HAULIN' CATTLE

I went to work for the streetcar company in 1921, and I worked there forty-eight years. The streetcar company wasn't too much—what you call it—integrated. Here's what they done. They had separate toilets, and when I came they didn't have blacks to be a mechanic, so I couldn't be a mechanic even if I wanted to be one. They used to ask me about it when they did open up for blacks to be mechanics. I wasn't never one. You have to get underneath the cars and buses, grease runnin' down your face. It was too dirty, and I never did like dirty work. No I didn't.

I was a maintenance man. I used to take care of things that needed to be done on a car to keep 'em runnin'. Then after that, when they eliminated streetcars, I went with buses. That was my main job. I had no trainin'; you learned most of it by trial and error. The only ones that went to school was the operators. They had to go to school on account of they had to deal with the public. They had to make change and to make schedules. We didn't have to make no change or no schedules. That's the way they done it in the maintenance department.

I done quite a few things there. One thing was I took cars that needed to be repaired off the street. I'd take one car out of the shed they was operatin' on and go to the end of the line and change it and give the operator the good car, and I brought the other car in to see what was wrong with it, and then when I brought it back I got in touch with the mechanic and tell him about how the car was actin' and what had to be done. They had to come to me because that way the mechanic knew where to start.

When they started to puttin' blacks operatin' the cars, I could have got on as a operator, but I didn't want to deal with the public. Runnin' the streetcars and buses, there was too much stress dealin' with people. There was a lot of abuse for black operators at first. I didn't want it. I wasn't thinkin' about gettin' on them cars and dealin' with the public. I told 'em I'd rather get me a rig haulin' cattle.

LIKE IF A FLY WOULD GET ON YOU

St. Louis wasn't too bad in my estimation. You couldn't eat in none of the stores, so many districts that you couldn't go in, so many things that I see now. I'm not bitter. I have been in Stix, Baer and Fuller and Famous Barr

and be *first* to get waited on, but I had this to happen to me at the Busy Bee Bakery on Washington Avenue and Seventh. I never will forget, the whites would come in and the clerks would pass me up and wait on 'em and left me standin'. And that was one of my bitterest pills to swallow, and I blowed up down there one day and I got recognition. I told 'em, "Is my money any good? I'm only comin' in here to buy your products and I got to be waited on." But it was a whole lot of little naggin' things like if you were eatin' and a fly would get on you. It was naggin', but I never have been bitter and I don't know why. I wish I could tell you why.

I wasn't a bully or anything else, nothin' like that. I don't hold nothin' in me too long. I've made friends out of enemies on account of my attitude of not bein' bitter. I wasn't that type, and I'm that way today. See, my mother was born in 1876 under black people that were slaves. They had reason to be bitter, but I wasn't 'cause I didn't have the experience that this other black man had. So, St. Louis wasn't too bad. They didn't do the things they done down in the Deep South like beatin' 'em and lynchin' 'em, but it was all them little naggin' things.

THE BEST TIME IN MY LIFE

I sold newspapers 'til I was fifteen years old, made good money on it too. Then I worked at the tannery on the riverfront. I was a tanner by trade. They told me as I learned the trade how much money they would pay me and make me foreman of the business. They didn't do it. The pay was forty cents an hour—doesn't seem possible, does it? No benefits of no kind and no overtime, just straight pay. We didn't have no Medicare. You could work a day and before the day was out they tell you they didn't need you no more. *No* notification, *no* benefits or *nothin*,' just like gettin' rid of garbage; that's the way they done it. They didn't only do blacks that way, they done the whites that way. We had unions, but everything wasn't organized. You couldn't do nothin' about it. They said you didn't have no job—you didn't have no job! And that's the reason why I left there and went to the streetcar company was they broke a rulin' on me. They didn't pay me more like they said they was goin' to do. And to tell you the truth about it, my main thing was tryin' to make money. I had nothin' given to me. I had people be nice, but I saved my money. I learned how to manipulate a dollar, so that was a plus on my side.

I moved here to this house from West Belle and Newstead. That wasn't a bad neighborhood. The black people was highly respected in that vicinity, but I told my wife I was goin' further west as I possibly could, and only north St. Louis was beginning to open up to us. We knew we couldn't go to south St. Louis. We knew we couldn't go to University City. So that's the way that was.

The best time in my life is when I moved right here on Lexington, best time in my life. I had clean streets, nice environment. The whites went somewhere else and left us housing to live in. Otherwise I wouldn't be here. Don't care how much money you had before, you couldn't buy a house out here. When I come here, there wasn't but two white families, and I didn't have no trouble with 'em at all. The only thing is they just put their houses up for sale and moved out without any fanfare, and the blacks moved in and bought 'em. Now the people I bought the house from, I seen 'em and talked to 'em. They wasn't bad people, but they just didn't want to—you can't make a person do something that he don't want to do. See, St. Louis is a good city to live in all the way around. It's not perfect and never will be perfect. I don't know any city that is. Most all of this down here now is owned by blacks. People are better citizens when they own a home, you know that. You become conscious of the city that you live in.

I didn't marry 'til I was pretty close to forty. I didn't like married life. I seen too much on the negative side and it had an effect on me; it wasn't no harmony among most of the people that I knew, man and wife. But I did get married and I had good marriages. I had good wives, otherwise I wouldn't have what I got now. I was married eighteen years to Sadie. She was a music teacher; that was her piano. She made a studio in the back room there and taught music. After she died I moved the piano up here. I stayed single for a year, then I met my second wife, Rose, and we was married eighteen years. She died in her sleep in that back room.

I've accumulated more things since I been here than I ever had in my life, and honestly, everything you see in this house is paid for. My first wife, her and I worked together. Everything you see was through us two. I was at the transit company and she was a music teacher. My second wife—my house was already paid for except for a few things she brought in with her.

I've owned two cars, and I enjoyed them. I got a '65 Buick, bought brand-new, and I got it from Castle Wilson. Did you know them? Second one, I got another Buick, and I got it now.

It's almost impossible for a man to make a home even if he don't have no children 'cause there's things that a woman go into a store and get, a man

Eugene Z. Lewis

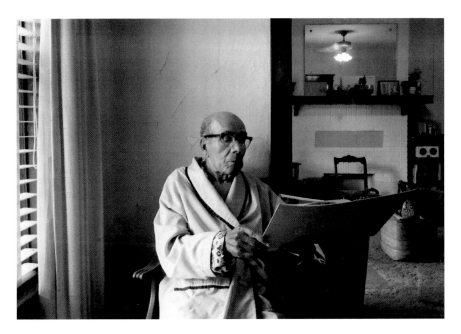

Eugene Z. Lewis. *Courtesy of Eugene Z. Lewis.*

don't even think about it, like detergent, napkins, towels, just name it. As a rule a man cannot shop like a woman. He don't see why you have to buy this and why you have to buy that. You need knives, forks, spoons, dishes and things. Something like that a man ain't thinkin' about. That plant there was given to my wife by her female children. A man wouldn't be no way in the world that I would pick that out. A man needs a woman. That's what the Bible say: "It wasn't good for man to be alone and He made woman as a helpmate."

REFLECTIONS

I've lived a good life, personally. I feel good about myself. I've treated my fellow man right, and the main thing, I've treated Eugene Lewis right too. I didn't drink; I didn't smoke; I didn't carouse or actin' the fool and all like that, and I never did down myself. That's the way I did it. I say there's nobody can take care of Eugene Lewis any better than Eugene Lewis. I never dreamed of anything bein' impossible for me to learn if I wanted to.

Chapter 11

SALIMAH JONES

Salimah Jones was born in 1941 at Homer G. Phillips Hospital. She worked as an investigator for the Civil Rights Enforcement Agency.

EARLY LIFE

My parents were strict. We always had to come directly home from school even when I was in high school. I never belonged to any after-school activities. If you got out at three-fifteen, you were expected home no later than four o'clock. That was the rule. You didn't question the rule.

Things are a lot different today. You can say "Why," but you didn't say that then. You knew they would just say, "Because I said so." You knew not to go beyond that.

My father worked in a hat factory, in the shipping department, packing hats and purses to be mailed out to different places. Shortly after we moved west to St. Louis Avenue, he went to work for the state hospital as a janitor. Then the city called him to go on the trash trucks and he worked there until he was called to the post office as a mail handler, and that's where he retired from. In between, my father always had extra jobs, even when we lived in Carr Square Village.

My father always brought his paycheck home to my mother to sign, and it was turned over to her until the later years of their marriage. My father was making thirty-five dollars a week in 1952 when we moved to St. Louis Avenue.

It was amazing how my mother ran a household on so little. My father wanted meat and dessert with every meal. She worked wonders to move into a house with thirty-five dollars a week and four children in school. We always had to work, and whatever you made, you had to contribute half to the house. My parents provided us with what we needed.

When I look at the talk shows now and read the newspapers, I say, "Thank God for my folks."

WE DIDN'T KNOW WE LIVED IN A PROJECT

We moved into Carr Square Village soon after I was born. It was a nice community to grow up in—a wonderful place to live. It was the first time that many blacks were exposed to a living room, dining room and separate bedrooms. You planted flowers in the spring, and they had awards for the best yards in the summertime and the best-decorated house.

There was a community center, a playground and a swimming pool. You weren't considered poor because you lived in Carr Square Village. That was like the best place to be. We didn't know we lived in a project.

Cole Street was the beginning of Carr Square Village, and we lived at 1617 Cole Street in a three-unit apartment. We had a three-bedroom unit on the second and third floors. There were cold-water flats across from us and a grocery store on the corner. Nearby there was a cleaners and a confectionery store that also sold sandwiches. Everything you needed was right there. It was like a little town.

Further up on Cole Street was a junkyard and a place we called the "trouble station"—I never realized we didn't know the name of it. Whenever streetcars broke down, they would go out with their big trucks to work on the streetcars.

I went to Carr School, and it was the most beautiful school in the world. The floors were always shined, and they had a little balcony in the kindergarten. It went from kindergarten through fourth grade. I had good teachers there, and they knew my parents. If you were really bad in school, they followed you home.

Everybody raised you. You wouldn't do anything wrong in front of an adult because they knew your parents and they would immediately come over and tell on you or they would chastise you or even spank you. And our parents didn't get offended by that. There was no talking back to adults. That was the way it was.

Salimah Jones

Moving West

The Knights of Columbus had a raffle every year. I think it was in 1951 when my father won the raffle, and he won a Ford. My parents took the cash instead of the car. It was like $3,500. So we were *rich*. From then on it was, "We're going to buy a house!"

We were going to have our own house at last. And in 1952, we moved from Carr Square Village to 4947 St. Louis Avenue. I was ten years old. I had never moved before, and at that time St. Louis Avenue was considered "out west." It was like you were going to California. Moving west was exciting.

Only my mother and father had seen the house prior to moving there. We moved late at night so there was nothing for me to see, but in the morning my cousin and I first explored the house, which seemed huge at that time, and then we went outside. Once we got outside we were afraid to go very far, so we just looked up and down the street. We didn't want to get lost.

It was a couple of days before we saw any of our neighbors, and everybody was white. We said, "There's all *white* people out here." We had never lived around white people. The only time I can really remember whites was insurance men coming into the neighborhood, the people who owned the corner grocery store and the people downtown. But being that close, living that close, I had never experienced anything like that and hadn't really thought too much about it until then. We knew white people lived "out west." The blacks were just beginning to move out there, but I guess we weren't really prepared for having whites as neighbors, having to have conversations with them or even possibly playing with the kids.

We hadn't anticipated that. We were just moving to a house. We did have a neighbor next door to us that was black. I think we were like the third black family in the block.

I had seen white people as a child, but not to actually interact, to be that close to them. I would go with my father to work sometimes, and everybody there was white. All the ladies who worked in the hat factory were white, and they would call me over and set me on their lap and talk to me.

But it was different than running into kids or real people—the people who worked with my father, I didn't consider them real people, and my mother dressed us up to go to the hat factory—so living among them, this was something really strange. As far as the adults or older people in the block—they talked, they were nice.

They talked and introduced themselves to my parents. In time, I started going to the store for them and running errands and things like that. There

were white kids across the street from us that was in my age group—eventually we got to the point of playing with each other.

We would play some, but it was—they were very curious about where I came from, and they wanted to touch my hair and touch my skin. And I never will forget one day, they were doing the touching, so I decided to touch them and I touched their hair. I had never felt white hair.

My mother saw me and she had a fit. She told me to come home. She said, "I better not ever catch you doing that again. What are you doing? You're acting like you're admiring all that."

I was just curious. They were doing it to me, and I wanted to see what they felt like and everything else. I can still remember them touching me. I couldn't explain to my mother what was going on. I didn't, I didn't *admire* them. I didn't think they were beautiful. I thought they were different.

It was exploring. But my mother didn't see it as that. When she saw me touch the hair, she thought that I was admiring the hair, the length of it and everything else.

I had short hair compared to white hair. Mine came about at the end of my neck. That was a thing with my mother, and I guess it's something that passed on to me, because as a kid, you were considered having good hair or bad hair.

In the black community, good hair was hair that was similar to white hair that didn't need pressing or all the things—grease and everything black people use. And that was considered good hair. My mother always hated that phrase, and she said, "Why does anything good have to be related to white?" She said, "*Your* hair is *good*."

That is what she would always tell us, our hair was good. It was a little bit confusing to me because it's how you describe somebody. You know, if you wanted to describe a friend, well what did she look like? Well, she has long hair and thick braids, or she has long, pretty hair—and pretty hair meant it was straight or naturally curly. That was the only way that you could really describe someone: they have short hair.

When a kid was born, the first thing everybody wanted to know was what kind of hair did the kid have. Well, all babies have the same kind of hair until they start getting up to three or four months, and then the hair starts changing. But it was, "What kind of hair does the kid have?" That was always very important to black people. Hair was the most important thing, I think, and skin color was next. There was light, candlelight, brown skin and dark. You could always tell what color a baby was going to be by looking at the top of the ears and tips of the fingers around the

cuticle area. And if they were dark, then you knew the child would grow up to be dark. And if they weren't then the child would be light.

I'm Getting a Hot Dog

When I was real young, whenever my mother took me downtown, it was always a blur. She had a special mission. She didn't wander and shop. She had something to get, and we got it and that was it.

At that time, I really didn't have any interaction with the people in the downtown stores because my mother primarily shopped for us on Franklin Avenue. These were the clothing stores and shoe stores owned by whites, and the people knew my mother and me. When we would shop for school or Easter they would say, "Oh, let's see, you've grown a little bit," and they called me by my name.

But what I really remember about downtown—I guess when I was about five or six, my aunt would go downtown every Saturday, and my cousin June, who is eight years older than me, would go with her and carry me. My aunt and June would split up paying bills. June would have to go to the electric company and the gas company, and my aunt would go to Union May Stern to pay the furniture bill.

We always ended up at Thomas Market where, at that time, you couldn't sit down and eat. My aunt always had to have this hot dog. I don't remember having anything to wash it down with, but we had the hot dog and we would have to go over in like a dark corner to eat it. Well, as a kid, I'm getting a hot dog. I'm getting something the other kids are not getting. That's all I cared about. So that's how it was.

We Can Sit Every Place in St. Louis

I remember when we went to Jackson, Tennessee, to visit my mother's hometown. We had to go to the balcony in the movie. And I told everyone, "You all have to come up to the balcony to sit and watch a movie? In St. Louis we can just walk in the door and sit everyplace. How can you *stand* the South? You ought to come up to the city." I can remember as a little kid really showing off. And it wasn't until I was grown that I realized that we could walk in the show and sit anyplace—but it was a *black* show.

I was fourteen when they integrated the movie theaters in St. Louis. I begged my mother to go. "Oh, *I want to go*, I want to see what *their* movies look like." She gave me some money and I went to see *Not As a Stranger* at the Loews State with my sister-in-law. It was just grand inside. I said, "I will never go to the Marquette or the Criterion again."

JEOPARDY! AND THE LIBRARY

I don't want to brag, but my mother and father were very smart. Before my mother died, her favorite TV show was *Jeopardy!* Her specialty was geography. We would say, "How do you know that, how do you know that?" And she would say, "You *read*, you *read* and you *read*."

My mother took Latin and learned about black history in a one-room schoolhouse in Jackson, Tennessee. Both of my parents were avid readers. They knew more about black history than I probably will ever know. That's how they raised us.

My mother didn't finish high school, and my father only finished eighth grade. I can remember her saying she had a teacher once that she just loved who had traveled all over and would tell about Chicago and New York. The teacher's husband worked for the railroad. My mother always wanted to travel, and later on she got a chance to take some trips. She knew a lot of history. She knew a lot of everything.

My mother was the one who kind of stood over our schoolwork and wanted to make sure it was done and done correctly, but it was my father who believed in the library. He saw that we got a library card as soon as we were big enough to read or write. And just as we got a social security card as soon as we were like fourteen, it was just mandatory you got a library card.

The downtown library stayed open late on Monday, so when he got off work, we would all walk down to the library. Everybody had to get a book, and it couldn't be junky. You had to read the book and be able to tell him something about it. The library was huge, and to a five-year-old, Monday nights were an adventure.

WISHES

When I was a little girl, I wanted to be a movie star—not just an actress. I wanted to be a star, and everybody always said, "You're not fat enough to

be a Hattie McDaniel and you're not light enough to be Lena Horne." As I got older, I wanted to be an airline hostess. I wanted to be a fashion model. I wanted to be all the things society decided I couldn't be. These were the things I aspired to.

When I was a teenager, I thought being an airline stewardess was the most glamorous job in the world. I sent off for and received the information, and my teacher said, "They don't have blacks doing that." I didn't become disturbed. I didn't want to change the world. I went on to something else. But as I got older and really understood what that was all about, I knew that I shouldn't have had to change to something else.

I remember when the weather was bad and they would give out school closings on the radio, we would sit every morning waiting for Carr School or Patrick Henry School to be closed. White schools were closing their public schools, but our schools never closed. I remember saying, "I wish I went to a white school so I wouldn't have to go to school." My mother would say, "You know they're not going to close your school, so get up and start getting ready."

But we would sit there and just hope that one time they would call our school and say, "No school today"—but it never happened.

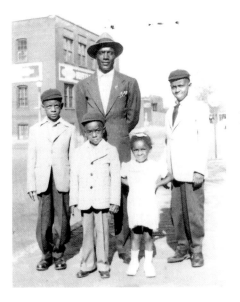

Salimah with her father, H. Habib Ballentine, and brothers (left to right) Krim, Kemar and Richard on the 2700 block of Dayton Street, in front of the pickle factory. Easter Sunday 1945. *Courtesy of Salimah Jones.*

THE PICKLE FACTORY

My father was one of the few black people who had a camera, and he was always taking pictures and having us pose, and I always loved it. See, I've got my hands on my hips. I told you I always wanted to be a movie star.

It was Easter Sunday, about 1945, and I was four years old. There was a pickle factory in the 2700 block of Dayton Street. It was all white, didn't even have a black janitor.

And since I've been grown, we'd drive through that neighborhood and we'd point out the places and

we'd say, "There were all those factories here in our neighborhood—we had a bread company, we had Coca-Cola, a shoe factory—we had all those companies right in the neighborhood and there was never a black who had a job at one of them."

PRINCESS OF THE NILE

My father was very important to me growing up. He taught me about black history and about being black. He would say, "You are beautiful."

I never considered myself ugly, I just never did. But when I was coming up, I was dark, I had short hair, I was skinny, I was a crybaby. I guess my father needed to reassure me all the time. He used to call me "the Princess of the Nile." He would say, "When somebody says, 'Where are you from?' tell them you were born in Egypt along the banks of the Nile." That's what I've always said to people.

I've had cousins on his side of the family tell me much later on, "You know, you really were an ugly kid, but your Dad thought you were so beautiful he just insisted that everyone else think so too." My cousin said, "You know, we used to say, 'Yes, she really is a pretty kid,' but you really weren't a pretty kid."

You see, beautiful kids were considered light-skinned kids, with the long hair. I didn't have any of that, so if he hadn't told me that, I would not have grown up thinking I was beautiful.

DOLLS

When I was little, my mother was the first person I knew to have black dolls. She saw them in some magazine and sent off for them someplace in New York. She had the hardest time trying to sell them to people in Carr Square Village.

A lot of people would say, "Oh, my daughter would not like a black doll." My mother said, "Why? It looks like her"

But she had the hardest time, I mean she got in arguments with people. She was able to sell some, but not like she wanted to.

When I was little, the ladies at the hat factory where my father worked gave me a little doll. All it had was a white face, and the rest of it was like a

cloth outfit or something. I got it for Christmas, and when I opened it up, I said, "Oh, Ma, she's *white*." My mother took the doll, and with the crayons that I had gotten for Christmas, she started painting the face every color.

I took the doll with me when I went back to the factory to visit, and the ladies said, "What happened to the doll's face?" And my daddy said, "She can't have a white doll because a doll represents a baby, and I'm not raising a child to have a white baby or to babysit for white babies." So they never gave me another doll. They always gave me some other toy. I understood what my father said. It made sense to me. And I couldn't understand when a lot of people wouldn't buy the black dolls. Some used the excuse that it cost more. But a lot of them said, "My daughter wants what is in the store, and not that."

I couldn't understand why anyone would want a white doll over a black doll. This is the way your baby is supposed to be, reflective of you. And I didn't have any problems with that. It was something that I grasped right away. I had problems with other people not understanding that.

My Father on Whites

Even though my father worked around a lot of white people, he didn't talk about his true feelings until he got home. Then he would tell what he felt about whites and what he had experienced.

Now today my father says he can't remember anything of that, but at that time he would say, "Whites are *bad* and they have held us down."

He said, "You have to be smarter than anybody else. You have to be better to make it." He also said, "White people don't tell you the truth about what blacks contributed." You grew up thinking that all we had to do with was the peanut and not anything else.

It wasn't a lecture on a regular basis, but what my brothers and I knew then, about whites, is primarily what we learned from him. I can remember once that one of the ladies at the hat factory wanted my mother to clean her house. My father went into a rage at work and at home. He told them, "My wife only cleans my house. My wife will never go out and clean white people's houses." And he was very proud of that. But sometimes when my aunt was sick and she wanted to "hold her days," she would ask my mother to work in her place. My father would just raise holy hell until the whole thing was over with.

When I was older and going to Soldan, this Cook family that lived in the West End, they had a daughter, who was in the Veiled Prophet. When she got married, they asked my father if I could babysit. My father told them, "No! I didn't have a daughter for her to raise white kids. When she raises kids, they will be her own."

MY CLASS PICTURE

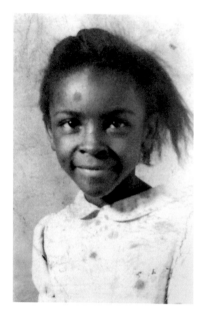

I wanted long hair. I think every black kid wanted long hair. My mother combed my hair every day. She would usually put it in three braids with a bow on the top. Since I was the only girl in our family, my mother put me in bows and ruffles.

We were having our first-grade class picture taken at Carr School. I decided to take my hair down so it would be like the white girls. I really didn't have enough hair to hang down. After rough playing in school all day, it was nothing unusual for my hair to be like that. It was only after my mother saw the picture that she knew that I had deliberately taken my hair down 'cause she knew the pictures were taken early in the morning. When I gave her the pictures, I knew what was coming. She had a fit! "What *is* this? I'm gonna *kill* you!" I kept thinking I should have tilted my head back and then my hair would have appeared even longer.

Carr School first-grade class picture. Salimah Jones is six years old, 1947. *Courtesy of Salimah Jones.*

I remember once in high school a white girl asked, "Why do you straighten your hair?" We explained it was because our hair is originally in tight curls, and we made a joke that first you get a pressing comb and you heat it up on this big fire, and when you take it off, there's all of this blue smoke. And that's how it really does look to the child, all this blue smoke is around the comb.

You wipe it with a cloth or something, to kind of cool it down, and then you oil the hair, and you take this hot comb—and that's what it was called,

a hot comb or a pressing comb—and straighten the hair, and the hair would come out *very* straight. That's when you go and get your hair "fixed." That was another term.

You know, combing hair like mine is hard. As a kid, you call kids "tender headed" who didn't like to have their hair combed, because the comb pulls through their hair and it hurts.

As a kid, I was one of those who went all the way down to the floor. My mother put me on the floor and wrapped her legs around me to hold me in place. That was the only way she could really do it. And if you squirm too much, they take the comb and they kind of hit you in the head with it, so you'd be still, and then they can part the hair and braid it or do whatever they want with it.

Sometimes people say you want to be white; I don't think it's wanting to be white, I think it's wanting what's easy, and good hair was easy hair. It required less care.

THINGS I LEARNED AT SCHOOL

I learned about the real race differences among blacks when I went to Cupples School, and that is when a lot of my feelings changed. That's when I began to hate teachers. They made me feel "lighter" was better.

The light-skinned kids with long good hair were usually children of doctors and lawyers. Blacks at that time who were light tended to marry other light-skinned blacks. They wanted to be as close to white as they could be and still be legal and accepted by blacks.

The light-skinned kids made a big difference at Cupples. They were put in the front rows, and the darker kids were put in the back. We were talked to differently. We were hit immediately, and the other kids were never touched. I was from downtown, so I was assumed to be dumb.

When I grew up, there weren't many people named Salimah. I was dark, I had short hair and my parents weren't professionals. At school, I was a natural scapegoat.

I had a friend and we were talking in class, and the teacher punished me. My friend was light and had straight hair. My parents believed the teacher. They didn't question her and didn't listen to me. I decided I would not do that to my child. I learned all of this from black teachers in a segregated school.

There was a certain metamorphosis that took place at this time. I began to speak out and challenge authority figures. I was angry and I began to question—"Why are you punishing me and not those other kids?"

But I guess my true rebirth came when I started working for the Civil Rights Enforcement Agency. I became an investigator and at age twenty-eight was still accepting a lot of things. I investigated discrimination complaints in employment, housing and public accommodations, and that's when things started coming full circle for me.

I realized what discrimination was all about and the impact it had on me. I was seeing those same things that had happened to me not only from the white community but from the black community. I knew these things had been unfair, but now I realized they were against the law.

I felt white people took care of white people and black people took care of white people. What I get from whites, I expect. When it happens from black people, the hurt is deeper. Sometimes a black person in charge becomes white. Black-on-black discrimination, I still have more trouble understanding that.

BEING DARK IN HIGH SCHOOL

When I was ready for high school, schools were integrated, and integration meant that we could go to a school that was close to us. Though I was in the district for Sumner, I didn't want to go there. It would have been too much of a challenge.

Everything at Sumner had to be extra. If you were dark, you had to be extra smart. If you were dark, you were on the back line of the dance group and you didn't get starring roles unless your parents were someone important. If you didn't have really sharp clothes, you were not considered "in." Even though I wore nice clothes, I didn't always wear what was really in. My mother didn't go for all that. I knew all of this, and I was afraid to go to Sumner.

I chose to go to Soldan, and I was comfortable there because I didn't have the same kind of competition. I didn't have the same pressure to fit in, and I was considered part of the well-dressed group. I was able to fit in with the blacks at Soldan but not necessarily with the whites. We went to the same school, but everything else was separate. I was accepted by blacks because I was black. I was accepted on those terms. If you went to Vashon, you could be dark and fit in too.

Salimah Jones

ACCEPTANCE AND DENIAL

When we moved on St. Louis Avenue, I couldn't go to the all-white Benton School on Kingshighway, and my father never said, "My daughter has a right to go to the school across the street." It was never a big issue.

Now I realize he should have been very disturbed. He just didn't look at it that way. When you start thinking in terms, "I didn't get this because I am *black*," it changes everything about you. You become hardened; you become a cynic. I think it's protection, so you just accept it. You really couldn't focus on racism then. I guess it was more of a denial. There is a difference in just thinking, "I can't get that job," but not thinking about the reason why.

I think that was the way it was with my father. He cleaned offices and he never thought about being owner of that company. He just thought of himself as an office cleaner, and he thought his job as a shipping clerk at the hat and purse factory had nothing to do with racism. That was his job, but he didn't think he was assigned that because of his race even though the only other job there for blacks was the janitor. Later he stated that he was sure he didn't make supervisor at the post office because he was a Muslim.

I HOPED FOR MONEY

I did not really know what racism meant until I was grown. Even though I had gone through the integration at Soldan High School and lived on 4900 St. Louis Avenue with whites, I accepted it and didn't question it was racism.

When I was little and went downtown, I would see restaurants and people sitting down eating. I knew that I was black and couldn't go in there, that it was forbidden, but most of all I knew that I could not afford to go in there.

That was more overpowering than the fact that I was black. I felt money would overcome everything else. Even if I were white we would not have the money to go in, sit down and eat in a restaurant with a tablecloth and a vase on the table. Money was the key to it. I hoped for money, not for integration.

He Gave Us Nickels and Dimes

My father had a regular job, and that money was exclusively for the house and my mother to do whatever she wanted to do with it. He was also like a handyman. He did odd jobs, like errands for the white people that he worked with on the job. He also cleaned up their yards and things like that.

And I remember the Cooks. They lived in the West End. When I was little, my brothers and I went out there with my father. After he had finished for the day, Mr. Cook came outside and told my father, "I want you to take down those screens and wash them all." My father said, "I can't do it today, I have something else to do."

And Mr. Cook said, "Boy, I told you what I wanted you to do, and either you do it today or don't come back."

My father said, "Yes sir," and he took down the screens.

I remember my brother sayin', "That damn Mr. Cook, I hate Mr. Cook."

You know, we had always loved Mr. Cook. My father loved Mr. Cook. Mr. Cook gave us nickels and dimes.

My brother said, "The way that he talked to Dad, I'll *never* let a white man talk to me like that when I get grown."

My parents didn't talk about the discrimination and the hurt. I think if you talked about it too much you became angry. If you just accepted it, if you didn't talk about it and went on with the flow, you were able to survive. Because anger, at that time, didn't get you anyplace at all. You know, anger would have lost the job for my father.

When I was coming along, you were told you couldn't do things because you were black, and that was it. You were not allowed to question or ask "why?"

Parents could never use those tactics today and get away with it. We accepted without questioning and without understanding. You took on a certain demeanor, I guess, just as they did.

I don't know if grown-ups were able to really understand the prejudice. I think back on some of that, that they didn't understand it. I guess our parents didn't really know how to explain it, so the answer was "Shut up."

Reflections

During the twenty years I was with the Civil Rights Enforcement Agency, my number of cases never decreased. People continued to be discriminated

against, and they continued to file charges. The way things are said, the way things are done has changed, but as far as the city being polarized, it is still the same.

I think racism will always exist. As long as there is a black and white, or black and yellow, or white and yellow, or *whatever*, you're still going to have that because you are going to have people with power and people without power.

As long as you realize that and still are able to get as much as you can and still live and not let it destroy you as a person, then we can move on. But a lot of people, both blacks and whites, think that one day racism will no longer be there. That's not true.

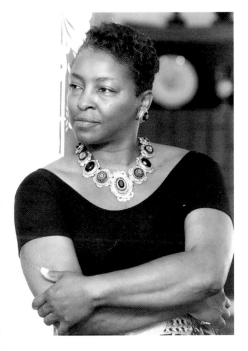

Salimah Jones at home, 1994. *Courtesy of Salimah Jones.*

Chapter 12

MELVIN HAMILTON

Melvin Hamilton, born in 1912, was a member of the first graduation class at Vashon High School. He has a letter from Sophie Tucker and one from Arthur Ashe, whom he taught at Sumner High School. He was a graduate of Ohio State University in 1935 and received a master's degree from Washington University in 1951.

FROM MADAGASCAR TO ST. LOUIS

My maternal grandparents were William Royster and Prisilla Mack. When my grandfather was twelve, he and his sister Bessie came to this country from Madagascar as slaves on the ship *Molly Gaspar*. He worked in the house of the Roysters in Tuscaloosa, Alabama. When my grandfather raised his own family, he stressed two things: getting an education and owning property.

My parents felt their children would get a better life and a better education by migrating up this way rather than remaining in Alabama. They stopped in East St. Louis, Illinois, where I was born. My father had a job at a packinghouse, and in 1917, on July 2, there was a terrible race riot in East St. Louis. We lived at 1236 Division Street. I was just five years old at the time, and I remember opening the front door and somebody was lying out in the street. My father took us up to the city hall so that we would be safe. I remember people were crying and there were soldiers there and they protected us. My father went back to our house and stayed there on the back porch with his gun, so they didn't bother any of our things. My cousin's

home was completely destroyed, and my mother said she wasn't rearing her children there. The next day, my mother insisted on leaving, and she moved us over here to St. Louis. We came across the Eads Bridge on the streetcar. She just left everything for my father to bring over.

I wasn't frightened. I guess I wasn't old enough to be too serious about it. Some say this happened because they had brought in some people that were working for lower wages, and most of them were African Americans, and the whites didn't like it.

MY PARENTS

My parents were William Picken Hamilton and Emma Jane Royster. Now my mother was born in 1880 and my father was born in 1876. Mother had finished the eighth grade; my father didn't have that much education. They were taught to use their hands, and that came in quite handy. My mother was wise. I cannot understand—see, my parents married when they were fourteen and eighteen—how she could have been so wise; she taught us how to do just about everything!

When I entered kindergarten, I knew how to write my name, I knew how to print my name, I knew my ABCs and I could read some. In those days, St. Louis was number one as a city, as far as schools were concerned. In fact, they had sewing for boys at Banneker, just like they had for girls. I knew how to cook, I knew how to sew, I knew how to wash, I knew how to iron. I knew how to do all of those things, even though I was a boy. My mother said a boy needs to know these things just as well as a girl. And it came in handy, because years later, I made extra money cooking every other Saturday at Fairmont Race Track. I made their pies over there when I was holding two other jobs: teaching school during the day at Sumner and working at the post office at night.

My parents were from the South, and they believed in cooking and sitting around the table having your breakfast and having your dinner. After my mother fixed our breakfast every morning, and before we left to go to school, we had to pass by her to see what we looked like before we got out of the house. It was just nice.

Everyone in the family played music. My sister was given piano lessons and dancing lessons, and I was given piano lessons and violin lessons. Later, I played the piano at Sumner High School on special occasions, and I played

the violin in the school orchestra. My oldest sister has been playing in the Baptist church since she was seventeen. Although I was reared in a Methodist church since I was six, I didn't join church until I became a member of All Saints Episcopal Church in 1936. My brother was Catholic, so that makes four different denominations in my family. My mother said, "As long as you are serving God, that is all that matters," and we could join the church of our choice.

Even though my mother worked, she still found time—see, my mother was a laundress, but she still found time to take us just about everywhere, and that's why we scored high on the intelligence test, because we were exposed to quite a bit.

My mother took us to the Muny Opera every Sunday in Forest Park. It was usually very hot, so most of the time we carried an umbrella, but we went there to see all the operas. We sat in the free seats, way up at the top. She wasn't the only mother that did that. Some of the whites sat up in the free seats too.

I guess because she married early, and she was young with us, we saw all the circuses, and we went to the show every Saturday at one o'clock at the Criterion. It's been closed for years. We went together until my sister reached twelve and wanted to go with her friends, and then when I was a Boy Scout at the Pine Street Y, I wanted to go with my friends. Mother let go. She always let go of us because we had to take care of ourselves.

Mother also took us to the Booker T. Washington Theater many years ago. We never thought about going anyplace we were not wanted, because she never took us anyplace where we were not wanted.

My parents were strict. I got whippings when I grew up, and it wasn't for things children do now. And I loved both of my parents. They didn't kill me, but I knew I had to be disciplined. There were certain things I could do, and there were certain things I could not do. So I had to adhere to those things or I caught it. My mother was really the disciplinarian. She weighed about 115 pounds, but she was the hardest-hitting little 115-pound lady you ever saw. She did not spare the rod.

My mother, she told us and taught us so much. You live by the Golden Rule and you don't give up easily. And if you want something, keep striving for it. And you're not going to get anything until God gets ready for you to have it. Those were some of her words, and then there were other things that she wouldn't get too morbid about, the things we were deprived of doing.

I didn't know what I couldn't do really. I knew that I couldn't go to shows, and there were certain places that didn't want me; they didn't want any of

us there, but that didn't bother me, because as far as I was concerned, my life was fine. I had too much fun growing up with my friends. I wasn't worried about those places I couldn't go. It didn't mean that much to me. That's just the way it was. I wasn't made to feel that I was inferior to anybody. I knew my color would make a difference, but other than that, I never felt inferior to anybody.

My father was an excellent provider, and his family meant a great deal to him. He didn't want anybody to touch us. I was the youngest and close to my father. He was a janitor, and as a boy, I'd go by and watch him pull out the clinker—it was the coal that burned down and formed a solid mass. He was a hard worker, and I don't remember my father ever being without a job. When he first came to St. Louis, he fixed the boilers for a big National Laundry on Channing and Laclede.

Each time he was offered more money, he went to a different job. His last job was a janitor in a large apartment house of middle-class whites at 6101 Etzel, where he had to fire the boilers and take care of the building especially in the winter to be sure everyone would be warm enough when they awakened. If he had to get up early in the morning—like four-thirty or five o'clock—to be out there to fire the boilers, then my mother would give me his breakfast to take to him on the streetcar. I could get off the streetcar and go into the place he worked and get back on the next streetcar, which would put me off right in front of Banneker where I attended school.

When it was too cold he would stay on Etzel, and he had a kitchen, bedroom and bath—everything at his disposal that any person would need in a home—and my mother would take me, being the youngest, and we'd spend the night out there. It was really nice, and my older sister took care of the youngest sister back in our house. I remember when my father went to and from work, he wore a suit, a shirt, a tie, good shoes and a good hat. He looked like a doctor or a lawyer!

BACK THEN

I would go downtown on the streetcar with friends or by myself when I was seven or eight years old. The streetcar cost three cents, and until you reached a certain age, you could ride it all day. I was so small that even when I reached the seventh grade, I was still paying three cents, until one day the conductor said, "Look, you got to be twelve years old, as long as you've been

riding the streetcar." We went all over St. Louis. On Sundays, we'd ride down to Broadway and you would get a transfer and use that same transfer to ride from one end of the city to another for that three cents. Just riding, seeing everything in St. Louis, looking out the windows—you'd ride to the end of the line this way, you'd ride to the end of the line the other way. We had fun.

My friends and I, we read all the time, and we would go to the library. We could take out two books until we were twelve; after twelve, you could take out as many books as you wanted. In the summer, we read just about a book a day. And we would roller skate, believe it or not, from Channing and Lucas down to Fourteenth and Olive. They didn't have as many automobiles then, and the sidewalks and some of the streets were nice. Then later on, when we got older, we rode our bicycles down to the library.

I became a member of the Pine Street Y when I was eight years old because of a teacher, Miss Arsenia Williams. She had a boys' club at Union Memorial Church. The Pine Street Y had a program seven days a week after school. On Sundays, I played the piano for the boys' group, the Life Builders Club, at four o'clock in the afternoon, and Monday there was Bible class. Tuesday was recreation; there were just so many programs and ballgames. People could rent rooms, and men could stay there. The swimming pool was downstairs under the gym, and there was an indoor track upstairs that we ran around. Now until you reached twelve years, you could only stay there until eight o'clock, but when you reached thirteen you could stay until nine, but there was a whistle that blew, over on Chouteau, a curfew. I think it began about ten minutes to nine, and by nine o'clock you had to be home, you had to be where your parents could call you and you'd answer.

I spent a lot of time at the Pine Street Y. They had a YMCA on Pendelton and St. Ferdinand out in the Ville, west of Grand. It was just a small building, and the boys there had to come all the way down to the Pine Street Y to swim on Saturday. Well, we were right in the area where everything was bloomin'! I'm going to be honest with you, I had just about *everything* that any little boy would ever want to have.

FROM SUMNER TO VASHON

Because of segregation, African Americans could not go to white schools, so Sumner was the only high school I could attend. I would walk or take

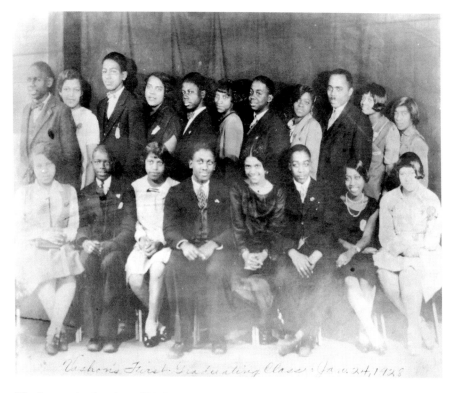

The first graduating class of Vashon High School, January 24, 1928. *Courtesy of Missouri History Museum Photographs and Prints Collections, School Groups Collection, n46463.*

the streetcar with my friends from the downtown area out to the Ville, west of Grand Avenue, where school was located. My mother gave us twenty-five cents a day for tokens, two for fifteen cents, and she always fixed our lunch and then gave us that extra dime for dessert. Well, sometimes I would walk—it took less than a half hour—and save that extra dime, and on the way back home, I'd buy broken cookies.

Sumner had become very overcrowded. There were sometimes forty children in a class, and in September of 1927, we were given a choice if we wanted to remain at Sumner to get our diploma or transfer to the new Vashon High School. It may sound a little ridiculous, but I decided to transfer to Vashon, because they had a wonderful swimming pool and swimming was always my favorite sport—and I lived closer to Vashon. Twenty of us left Sumner so that there would be a graduating class at Vashon in 1928.

Melvin Hamilton

To Become a Teacher—Part I

I knew I wanted to be a teacher when I was six years old. I had such wonderful teachers. They were so nice, not only to me but to the other students in the classroom, and I wanted to be just like them.

After my graduation from Vashon, I got a job as a page at the St. Louis Theater—now Powell Symphony Hall—so I could earn money for my college tuition. I later worked backstage running the elevator. The Depression was just beginning, and everyone was starting to feel the pinch. My salary was ten dollars a week, and I made extra tips by going to the performers' dressing rooms to see if they wanted any refreshments. I saw some of the very best of vaudeville and met some of the very best actors, and Miss Sophie Tucker was one of them. I knocked on her door every day for seven days and she never wanted anything, but one day she asked, "What do you plan to do with your life?" I said, "Well, I'm going to be a high school teacher, a mathematics teacher." When she got ready to leave, and I helped put her luggage in the cab, she gave me a five-dollar bill. I told her, "I don't have change," and she said, "No, that's for you."

In 1964, when she was performing at the Chase Park Plaza Hotel, I wrote her a letter. I wanted to let her know that I had accomplished just what I told her I was going to do. She wrote me back and sent me a picture. I have a lot of wonderful memories.

In 1929, if you were an African American male and wanted a college education, you had to get out of town. There was no school for African American males to attend in St. Louis, nor as a black was I allowed to go to the University of Missouri, and—I wanted to compete with whites. To be honest with you, I wanted to let them know that my brain was just as good as theirs, because they thought you were inferior if you were black.

I had made enough money at the St. Louis Theater to be able to go to Ohio State University in January of 1929. I was sixteen years old and I became a freshman, and during the

Melvin Hamilton's graduation from Vashon High School, 1928. *Courtesy of Melvin Hamilton.*

third quarter of my freshman year, I received a telegram telling me that my father passed suddenly of double pneumonia. I was heartbroken, but I had to continue to do the things I wanted to do, so after the funeral I returned to school and finished the year.

I had to drop out of school to make more money, and I went to St. Charles, Missouri, took the teacher's examination, passed it and began teaching in a little one-room school in Wentzville, Missouri. I was eighteen and made fifty dollars a month. After that I came home and worked curb service at Brugere's Candy Kitchen on Delmar and Kingshighway. I would sit out front, and when people would drive in, I would put a tray on their car window and take their order. That's how I met Robert Seebry, the manager of Glen Echo Country Club. He offered me a job as assistant bartender for sixty-five dollars a month. Now I had a chance to go back to school, and that's the way I made my last money to finish college.

To Become a Teacher—Part II

I graduated from Ohio State University in 1935 with a BS in mathematics, and I put my application in to the board of education for a job teaching in the St. Louis public school system. I was never called. I waited. I went back periodically, but I was never hired.

In 1936, I was working as a statistician for the United States Bureau of Labor Statistics making ninety-five dollars a month when I was called in for an interview with the board of education and told I needed more teaching experience before I could teach. So I left my ninety-five-dollar-a-month job and got a teaching job at Campbell College in Jackson, Mississippi, for sixty dollars a month. After two years, I returned to the board, showed them what I had done and the man in the personnel office that I had seen before said, "You don't have a master's degree, do you?" I had been away now for two years teaching, to get more experience, at sixty dollars a month, and now this same fella that told me to go back and get some teaching experience tells me I need a master's degree before I would be selected to be a permanent teacher in the St. Louis public school system. Then I did blow up. I said, "You *knew* I didn't have a master's degree when you told me to get some more teaching experience." *I was angry!*

I knew everyone didn't have a master's degree. I knew everyone didn't need one, that that was just their way of keeping me out of teaching because

Melvin Hamilton

Melvin Hamilton's graduation from Ohio State University, 1935. *Courtesy of Melvin Hamilton.*

I was *black*. I couldn't complain. I was insignificant. The people at the board of education didn't know anything about me except that I was black. Whatever I said wouldn't have done any good. I knew I was getting the runaround. Most of the people in St. Louis knew I was getting the runaround, but as I told you before, I was very naïve. I was taught you got your job on merit. I just had it rough. I'm not saying that everybody had it rough. Now some of the teachers got jobs down there because their mamas were doing housework in some of the houses of certain people, but I have never done that. I have never gotten any job through politics in my whole life. So that was the runaround I got for sixteen long years.

In 1942, I began working nights at the post office as a clerk for sixty-five cents an hour. I worked there for ten years, and I hated every second of it. *I wanted to be a teacher.* In 1945, the board of education called me to teach at Sumner as a permanent substitute, and during that same year, I started working on my master's at the University of Southern Illinois. In 1951, I graduated from Washington University with a master's degree in education and became a teacher on probation at Sumner High School.

I had never had the opportunity to say anything to the man in the personnel office at the board of education, but I did get a chance to express myself to one of the members of the board of education who I felt had been prejudiced against me. When I was a teacher on probation at Sumner High School, some of the board members were having a meeting in the Home Economics Department at Sumner. As the sponsor of the Student Council, I stood with my students in the hallway at the top of the stairs, waiting to greet the board members as they came up the steps. I would give one group of students their coats and give another student a chance to take them to the home economics room. As one of the men came up

the steps and got to where I was, he turned around, looked at me and told the men he was with, "I took this *boy* out of the post office." My students were listening to this, and here I am, a married man with children. And I walked over to him. I was *close*. I couldn't call him what I wanted to call him. I was close enough to his face to kiss him. If somebody touched the back of my head, I would have *kissed* him. I didn't say *one* word, *I just looked at him*. My eyes were about two inches from his. The other men were right behind him, and they must have told him, "You better leave that little man alone." They *must* have told him that. They must have said *something*, because I never had any more problems with him, or just maybe he figured it out for himself.

THE PRESIDENT OF THE UNITED STATES

I became a permanent member of Sumner's faculty in 1954. I taught mathematics at Sumner for twenty years and at Vashon for twelve years. And the students were just as nice to me at Vashon as they were at Sumner. I had certain rules and regulations in my classes, and they had to adhere to these. I had a dress code in my classroom. Students weren't allowed to wear blue jeans, and you didn't come to my class with a comb in your hair or your shirttail out. I said, "If the President of the United States walked into this classroom, he was going to see a model classroom." That's just the way my classrooms were.

The difference today is there is no discipline. They haven't been taught, and it has to be done in the home. The teachers cannot do all of it; it's impossible. I really enjoyed my years of teaching, and so many teachers now cannot say that. As my parents had taught me, my students knew there were things they could do and things they could not do, and if they did them, they knew what was going to happen. The students today don't care.

As sponsor of the Student Council, I wrote handbooks so the students would know how to act and know what was expected of high school students. These books sold for fifteen cents. The council met every Tuesday morning at seven o'clock and there was a representative from each class, sophomore to senior, and they went back to their classes and reported everything that was being done. My students did a lot of good things. We took part in the March of Dimes, and on Christmas morning, there wasn't a patient at Homer G. Phillips Hospital who didn't wake up with a Christmas card on his tray.

Melvin Hamilton at home, June 1994. *Courtesy of Melvin Hamilton.*

If I hadn't forgotten some of the things that happened to me I'd probably be in an insane asylum, the way I was treated. But I'm just not made that way. I wasn't reared to be a quitter. If you want something, you just keep at it—and I wanted to be a teacher!

Chapter 13

STELLA BOUIE

Stella Bouie, the oldest of fourteen children, was born at home in 1928. She began working at Stix, Baer and Fuller as an escalator girl in 1946. From 1956 until her retirement in 1987, she advanced from elevator girl to coordinator in the display department.

BACK THEN

I was the oldest of fourteen children. I had nine sisters and four brothers. I was always two years behind my class in school because in those days when women went to the hospital to have babies they kept them almost two weeks. I had to stay home and take care of the other children until Mom came home. My mother had babies every two years. They didn't have throwaway diapers at that time and the younger kids had not been potty trained, so it was real hard. I don't feel like I had a childhood.

I do remember a few things that happened when I was young that was fun. I remember very young years of playing at the public school playground during the summer. We would play ball, volleyball and baseball. I recall occasionally going to the movies with my aunt who was my dad's sister and was eight years older than me, but I didn't know teenage playing too much. I was not free of responsibility of babies and taking care of children. I got a little childhood in between my mother going to the hospital having babies, but I guess I knew I wasn't getting a normal childhood. It didn't seem to matter, because I didn't realize those things until I became an adult. I guess

maybe as I got older I resented it because it was an adult duty and I had to do it, but I don't think any of that hindered me. I always feel if there is anything that you want, and you know that you want it, you go after it. It gave me the opportunity to meet more friends, different people. I think you always learn even though you're not in school.

We lived south of the Jefferson Avenue Bridge in an all-black neighborhood, and there were blacks who lived north of the bridge. There were a few white merchants who had children, but we did not play with them. I think the people that lived on both sides of the bridge all lived the same way; we were all mostly poor. The differences in the blacks' areas were in the Ville and the West End where your educators lived, the teachers who taught you. Their finance was different. There are always people of different classes. When you have more finance you live differently.

I had a friend who lived in Webster Groves and went to Douglass High. We met through our social football season. You met people and became friends with them although you didn't have transportation to be with them. You didn't have a telephone, but occasionally you would drop them a card at holiday time, and you'd look forward to seeing them at football games.

I met my husband at Vashon High School. He was an end receiver on the football team. Well, that team, I remember them traveling to Memphis, Tennessee, to play the black high school in Memphis and how exciting it was for them to come and talk about that. Even the principal when we had a pep meeting in the auditorium, he talked about the boys traveling to Memphis to play and how great they were. It was a fun time to us; it was not a trying time. It was always wonderful for Vashon to win football and basketball games over Sumner High because we felt—the kids who were fortunate to live in the West End and the Ville, if their parents were not educators, their fathers had good jobs like postmen, firemen, policemen, doctors, lawyers, medical technicians and librarians, and they were looked up to.

COTTON IN KINDERGARTEN

In my day, black teachers saw that you got a good education. They taught you about your heritage, your culture, your customs, people who had gone on before you, like Paul Lawrence Dunbar. You learned a lot about different poets and artists, and Frederick Douglass, who was an

orator. And mostly your teachers were southern educators because your best schools, your black schools were in the South. I shall never forget in kindergarten, Mrs. Word was the kindergarten teacher and she reminded you of a grandmother, a beautiful woman, had a wonderful temperament, smile, small in stature. And when she would go south during the summer she would always bring cotton back from the fields, and that was my first seeing cotton. She would tell us stories of how the blacks worked in the fields without machinery and they didn't have any machinery at that time because they worked for poor white sharecroppers. She would tell us how they lived on the land and that some blacks even owned their own land. It was wonderful because we could feel the cotton as she talked to us about it, and she would not bring a lot, not a piece for each child, but it would be passed among us.

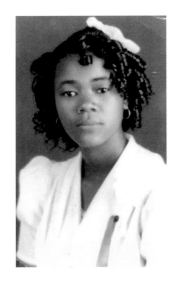

Stella Bouie in the eighth grade at L'Overture Elementary School, 1943. *Courtesy of Stella Bouie.*

SHIRLEY TEMPLE

I wanted to be Shirley Temple. See my curls? She was my idol. We were born in the same year—we grew up together. She was a child star and learned to dance with Bill Robinson. She's Shirley Black now. But oh yes, whenever I was naughty, and if there was one of her movies playing, Mama would tell me, "You will not see Shirley Temple!"

FOREST PARK

In the early '40s, my papa had an old Pontiac car, and in the hot summers he would put us in the car and take us to Forest Park after supper so that we could kind of cool down before we came home to go to bed. We did not have air conditioning in those days, I think one fan for the whole house. There were six or eight of us children then, and we would all sit on a blanket on the grass. My mother had made homebrew and root beer.

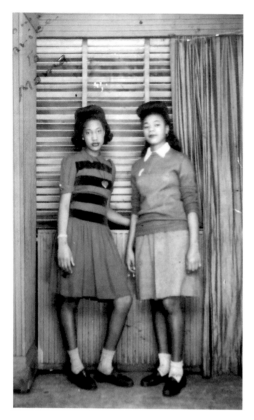

Left to right: Clarice and Stella Bouie in a photography studio close to North Jefferson and Market Street, 1944. *Courtesy of Stella Bouie.*

Maybe I shouldn't tell this story, but we'd be on the golf course when they'd be wetting it down at night. I remember walking through the cool grass and we could hear the sounds from the Muny Opera. We were curious, we didn't know what was going on, so we wanted to be closer, to hear more, to see more. Us older kids would kind of stroll while walking through this wet grass cooling our feet, leave mother and dad with the smaller children and walk across the parking lot to the back where we heard the sounds. We would stand very still and listen to the music and the voices. We knew it was something special.

You know, all your life you have brushes with society or better-class, better-thinking people. Somehow it either rubs off on you and you go with it or it never materializes to go any further but yet you remember these nice things that happen. When I go to the opera now, my sisters and I talk about "scurrying on the edge" of what was going on back then.

PRIDE

Homer G. Phillips Hospital was built in the Ville about 1938, before World War II, and when that hospital opened it was a wonderful time for blacks. It was a big brand-new pretty building. Before that, blacks had City Hospital #2, which was an old dilapidated building downtown below

Grand Avenue. The nurses, most of the employees were college-educated degree people, and for my mother to go there as a nurse attendant, it was a beautiful thing to happen to our family. She had put in so many hours to be taught like they do the practical nurses—and she passed!

The day that she got dressed to go to that job it was just wonderful in my home, because they had certain uniforms that they wore and my mother was a pretty woman, *very* pretty woman, tall. She was about five feet, nine inches, and she had this blue and white striped uniform which was long to the floor and she wore a white bib apron. To me, as a kid, it reminded me of the Dutch pictures I used to see. And she had this white nurse's cap on too and wore white oxfords and white stockings, and she was so pretty. It was her first professional job. My mother worked there between three of her children. As we girls got older, we would laugh about mama going to have a baby at the place where she worked.

My mother and father went to work together. My father also worked at Homer G. Phillips Hospital. Dad helped take care of the grounds around there, keeping them neat, yards cut and tending the flowers. He was like a nursery worker. Tandy Park, the recreational park in the Ville, was in the back of the hospital. There was a clay tennis court, and my dad had to be out there very early to get this clay hardened and ready for the doctors and nurses and the hospital administrators to play tennis before they went to work and on their days off. He used to get a joy out of coming home and telling us how he had to wet it down good and he hand-rolled it with the same type of roller they used in the streets before they had machine rollers. The doctors and nurses came from southern medical schools and from Howard University Medical School in Washington, D.C. My father enjoyed watching those young professional people play tennis. My parents were proud of their jobs, and we were proud of our parents and of the stories my dad would tell us—that it made him feel proud to see these young blacks have a place to come and do professional work. We enjoyed all that. That was a lovely time of our life.

"WORKED OUT IN FAMILY SERVICE"

My mother also did day work for white people, and we would run up the street to meet her when she got off the streetcar. We looked forward to carrying her bag home because sure enough there would always be some

food and some kind of clothing, *always!* And that was a joy to see because it was a constant struggle for our family to survive. There was always eight to ten children to feed, clothe and house—and only two people working in menial jobs—neither one of my parents were, would you say, skilled labor?

There were many blacks who worked for white families that were influential in the city. That did for blacks what television does for many people who were poor. You see something that other people have and you decide you'd like to have that too, you'd like to live that way, so you go after it. That's how some of the blacks were. At that time they called it "worked out in family service," and they learned an awful lot. The only way white people back then knew about blacks was through the communication of their maids, their chauffeurs, cooks or yard people.

I don't know if anyone has told you about the Butlers and Chauffeurs Club. Well, look at the knowledge they had, so they could bring that home to their families, and then they were more or less the families who were looked up to because they did things different from people who did not have the knowledge of how to have etiquette. You take the woman who worked and served the parties. You think she didn't have class when she came back into the neighborhood because the old saying is, "You practice what you preach," so whatever influence your job had on you, that's the way you lived when you came home. She learned to prepare different dishes from the way she cooked at home, to serve at a seated dinner, to set the table with a salad fork, a dessert fork and a soupspoon. That's a class thing for us. And she learned to approach people, say, opening the door for company and greeting them at the door. Whatever you learned on the job, it went home with you and you liked it. It looked good. Compliments were gotten at your employer's home, so you would get them at your house when you did some of the same things. And I'll tell you another person that was admired, at least we heard about them, was people who "lived on the place." Did you ever hear of that? They stayed out at the white families where they worked and would come home and visit their own families and friends on their days off. We've even seen men who drove their employer's car that he kept clean and looking good and polished. My rearing came at the end of an era, so I got a chance to see some of what my relatives spoke about.

When you had a brush with elegance or things that were better, I think you liked it and accepted it and continued to try and be around it—you would prefer being around it. I'd say both my parents had a touch of that, even my father. In his early twenties he drove a taxicab, and he recalls driving a lot of celebrities around, all the elite blacks. He did not drive any whites in those

days. So even as a taxi driver you have brushes with people who are living better, who have better incomes, who live differently, and when he watched young doctors and nurses play tennis at Homer G. Phillips Hospital, that made a great impression on him. Some parents wanted that elegance and that's what they carried home.

We've had our children tell us, "We were happy you were as strict as you were." Our daughters are refined. I feel the things you learn make you refined and make you a person with class, such as table manners. Etiquette was very important in my home—to do things right.

COLOR, RACE AND WHITES

I think the fair complexion is something the whites wanted. It comes from the slavery era when the lighter-skinned Negroes worked in the house or took care of the children and the darker-skinned Negroes worked out in the field. This way of doing things was passed down—I'll say it that simple, there are some white people who are still diehards, who don't want the change so they stay with what they feel comfortable with—and that's the way I felt about complexion even back in the '30s, '40s and '50s.

You know there are always classes in every race, and class does not always come from color. But it so happened that in the black race, color became an important factor. Since the lighter-skinned blacks were chosen by the whites to do certain things that passed down, like I said, to the blacks—they did the same thing. Blacks congregated because they were forced into a society of their own. They had to have their society because they were oustered from the better things so that caused the lighter-skinned to be educated, to be accepted in the social sororities, the social climbing groupings and certain types of

Paul and Stella Mae Mosby, Stella Bouie's parents, at their fiftieth wedding anniversary in St. Louis, 1976. *Courtesy of Stella Bouie.*

parties. Or if a white organization wanted blacks to be involved—or wanted to *permit* them to do certain things—to keep from being shamed or told "No" from other whites in their group, they would choose a lighter-skinned black.

You see what I'm saying, it's prejudice within, just like in any organization, there's always infighting even though it looks good when we see it. It's so sad. It's not because a person is clean or doing what is right. You know, when I was coming up my dad always told us, "It's never who is right, it's always what is right." But it's too bad that man cannot do what is right.

A LOOK OF CLASS

The jobs that blacks held at Stix, Baer and Fuller in the late 1950s were elevator operators, elevator starters, stock workers, housekeeping, which is janitorial services, cafeteria work, busboy, dishwashers and cooks.

I applied for a job as an elevator operator at Stix, Baer and Fuller in February 1956. I had worked there during holiday seasons, part time as an elevator girl, when I was in high school at Vashon, so I knew the lady personally who employed the girls. Her name was Celestine Chambers; we called her Tina. She was black and she was in charge of hiring only the black women. She employed a certain kind of look of a person to represent the store: clean-cut women who had the look of class, and of course, she could recognize that because she was a woman of class herself, someone you would want to be associated with, someone you would look up to and appreciate knowing. She had a view that things were different for us in the late '50s than when she was hired and that things would be better in the future.

Being an elevator operator was not so much a good job but a prestigious job; this was understood in the black neighborhoods—it looked good as far as the black community was concerned as well as the white community. It was just common knowledge at our two high schools and our vocational school. It was a clean job, so clean and so wonderful. You didn't get dirty. The only thing you could maybe get on your uniform was if you were carelessly eating.

When I went there to be employed in the late '50s, most of the women, particularly the women who were much older than I, who had been working at Stix for years, were of fair complexion and wore their hair in a fashionable bob. In the late '50s it didn't matter as much what complexion you were; my complexion is in between the very dark and the very light so I did not

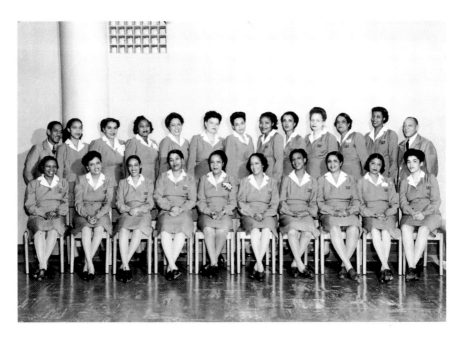

Above: Elevator operators and starters at Stix, Baer and Fuller, 1949. *Courtesy of Vivian Howard and Todd Studios, Inc., St Louis.*

Below: A retirement party in a private home celebrating the retirement of a starter who worked at Stix, Baer and Fuller, 1950. *Courtesy of Stella Bouie.*

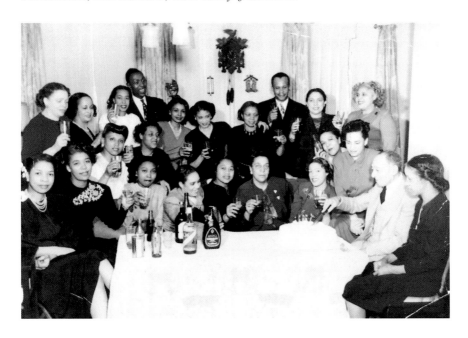

come in contact with that. During my time, Tina was more concerned with personality; etiquette and manners mattered more than color, your overall appearance, your smile, attitude, the presence you presented when the customer got on the elevator. Tina could see your personality and proudness. She could see that you had class.

Our uniform was a dark green shirtwaist-style long-sleeved dress, princess line, slightly fitted. Every morning we would put on a clean white detachable collar. Each woman had their personal handkerchief in their pocket, and some had crocheted the border of the handkerchiefs themselves, and they were spread out like a specially grown orchid. It was a prestigious job. It was proudness.

We knew we played a great part in representing Stix, and each day we looked forward to going to work; it was a clean, pleasant environment in which to go to work. Some of the most important people in the area shopped at Stix; the wealthy, the most knowledgeable people, wives of educators from the universities, the wives of politicians and city planners shopped in the store and would meet their husbands for lunch in the restaurant called the Missouri Room. It was something special just like the Tea Room at Famous Barr, and the elevator girls there felt the same way.

Stix, Baer and Fuller was full of pride. The families that owned the store were wonderful people to us. They were used to being good with their employees and treated each person like a human being.

DESPITE THE REAL OUTSIDE WORLD

Though I liked art, never really followed it too much, but the Display Department at Stix, Baer and Fuller was something that I liked. The only way I could get from being an elevator operator into the Display Department was to become their maid. I befriended one of the girls who told me that they needed someone to clean the platforms on which the mannequins sat, and in the early 1960s I applied for the job and I got it. I was given a list of my duties, and number eight on the list for the maid was: *She will, at no time, change or assist in the change of clothing on the mannequins other than shoes.* Number nine said: *She will, however, assist the Fashion girl on the third floor in dressing the Frankel blouse and skirt units now used on the ledge with the Blouse, Sweater and Sportswear Department.* This meant I could change the metal forms, which was like a wire, like a scarecrow

look. I could do those, but I could not do the mannequins. I resented this. I thought it was degrading. You could *do* the work but you were not permitted to do it, but because the lady I worked with was lazy, she let me dress the mannequins, so—*I* did it anyway, even though I had been hired just to clean the platforms. Society decided what types of jobs blacks would have; that was across the country, it was not just in St. Louis; that was everywhere you would be. You had not left the status of being a maid. This was 1958.

Some people did not want you to do your job even if they knew you *could* do it. They did not want to lose that service you gave. Some said, "I'm better than you; you're under me so I want to see you stay there so that I can talk about you and tromp on you."

What did I feel? At that time I wasn't, say, angry about it. I disliked it. I felt I was being left out, like I didn't belong. You feel that you're capable, you know you can do the job, but you feel pushed aside, so—you're not happy. You really aren't. This was the time when some Negroes spoke their feelings. A lot of them didn't get any retaliation, but there were some that did, and you didn't always hear about those that were fired off of their jobs.

When I was a little girl and went downtown, I knew there were things I couldn't do, places I couldn't go and sit down and eat, but I never gave it much of a thought because I guess you could say I was happy with my surroundings where I was. Some of our worlds were smaller than others, so that did not bother me then. I only felt those feelings when I started working. I disliked what I was facing. I couldn't see any reason why it was happening. It took a while for me to understand it. A lot of things were on the surface, but as you got older and you faced these things, then you knew there was some depth in it. You started remembering what you had read, what you had heard, I mean, the puzzle starts coming together.

I don't think you are ever prepared for what you actually have to face. Your feelings are not hurt to tears. Your feelings are hurt to be determined to try to do something about it, and you do it on a personal basis. I tried to prove to them that I was capable of doing my job, and I think people adjusted to seeing me work with this white woman and it became clear that I could do this job and be accepted as a Negro woman working in that department. As time went by, I also assisted her in picking up what was chosen to go on the mannequins. We made the rounds of the departments with a clothes rack, and we would gather the clothing that was chosen by her and the buyer, and also the accessories, the shoes, hats, handbags, hose, gloves, jewelry and scarves. Then I would take the

clothes to the pressing shop so that the mannequins could be dressed and presented to the public.

After a while, an opening came when someone left. Times were changing, and it was a chance for me to be a co-worker. I was hired full time as a coordinator in the Display Department. It was a wonderful feeling, and I received more money.

I shall never forget it was 1961 when the River Roads store was built, and soon after they were going to send me out there to do displays. My boss, Mr. Dawson, talked to me about going out there. It was like a pep talk preparing me to accept what might be said to me by the white employees and the white customers. He asked me how I felt about going out there, and he said—I can't quote him but remembering what he meant was "Will you be able to remain there, regardless of what will be said, if they'll be unpleasant remarks made? We feel you can handle whatever situation may arrive. If you feel that you cannot, be sure and let Ray know." He was my manager in the Display Department.

I went out to River Roads. I worked there for a long time. Nothing ever came up. Things were nice, and I had no problems. I had a feeling of advancement.

LIMITED BOUNDARIES AND SIGNS

In 1958, I saw St. Louis as a limited area, and it *was* a limited area at that time. There were borders of where you had to live, and you *had* to live there because there was no open policy where you could go into other neighborhoods to rent or purchase a home. I think at that time very few people were owners anyway, and the only thing they could do in freedom was within the boundaries in which they had to live, and in these areas we felt very free. But when you went downtown—some people refer to the city now as downtown, but at that time it was where the business was conducted and where big department stores and Woolworth's Five and Dime were situated—so when you'd go down there it was limited. There was no place to eat, and the only time you sat down was if you happened to buy a pair of shoes, but you could not sit on a stool to have a sandwich.

I'm sixty-six and don't remember seeing signs ever prohibiting coloreds; I was never embarrassed by that. But my husband—it was the early '60s when

Ralston Purina burned—he was a city fireman, and when that building burned the black firemen learned there were signs that read "Restroom—Colored Only." My husband read these signs. It was very provoking. They *never* thought they would see anything like that in the city of St. Louis even though there was a limit to where you could go and what you could do.

FOR WHITE MEN ONLY

How did we learn we couldn't go certain places and do certain things? I think in any household you hear adult conversations. It was just something you knew you couldn't do so you were happy with what you could do and you made the best of what you could do. There were a lot of people who knew better, and today people *want* their rights, *know* their rights and they *exercise* their rights. That's what blacks have been saying, "Let us exercise our rights!" I think these laws were made without considering blacks in mind. Blacks often say that when laws were made for people, there were eight, ten, twelve white men—not white women—who sat around a table and made decisions about rules with no one else in mind but themselves. They knew their women were to be at home taking care of their babies and they knew the blacks were to work only for them. The rules for this country, for the business, for the land, were made for white men only.

LEARNING

My husband and I found out early in life who we were. We learned by exchanging the experiences of our days and we listened to the experiences of our friends. We learned who we were, what our strengths and our experiences told us we were capable of doing, what we could put up with and what we would not put up with. We learned that we were very tolerant people and we were very strict people.

We reared our children with little income. We enjoyed the civic things, the public things that we had in the city—the zoo, parks, Shaw's Garden, the Muny Opera and the art museum. We used to go down to the riverfront, and we saw the five or six transitions that took place there. We exposed our children, and when they became young adults, teenagers, they volunteered

where we took them as children, the art museum, Shaw's Garden, and they also became candy stripers for a hospital.

Learning who you are early in life makes life wonderful. Because you are intolerant of ignorance, you know how to move away from it, you don't have to wallow in it. Because you are poor you don't have to be dirty. You can have a clean house, clean clothes and a clean body. You learn to do your own hair in the styles that young women were wearing their hair. You learn to be proud and you have shame because you didn't do it that way before, but yet you had enough nerve to come back and redo that which you were ashamed of, that which was wrong. You always in life rub elbows with something better, and it touches on you deep inside that you want better.

EPILOGUE

When I spoke with the people profiled in this book, my intention was to learn about racism and race relations. But, of course, the lives of black people are not limited to reactions to racism. The testimonies in this book cover a lot of ground. They show how people make meaningful lives for themselves and their children under circumstances they do *not* control. They reveal diversity within the black community, its fragmentation and its unity, its pervasive dignity and its periodic demoralization. There is not one way to be black, any more than there is one way to be white or to be a woman. I have learned a great deal from these stories, and I hope that readers will as well. But in the end, I return to the point where I began—to my desire as a white woman to learn about race and to do something about racism. I hope the things you have read in this book work the same way for you, no matter who you are.

ABOUT THE AUTHOR

Vida "Sister" Goldman Prince has been researching, conducting and recording oral history interviews for the past thirty years. Among her research and oral histories are works for Asian Americans, Holocaust survivors and, now, African American St. Louisans. She interviewed and recorded twenty-four subjects for this book, thirteen of whom are documented in *That's the Way It Was: Stories of Struggle, Survival and Self-Respect in Twentieth-Century Black St. Louis*, published by The History Press of Charleston, South Carolina, in 2013.

As chairman of the Oral History Project at the Holocaust Museum and Learning Center in St. Louis, Prince interviews survivors, liberators, witnesses and rescuers, including people of other faiths. As a consultant, she developed an oral history project in Naples, Florida, for the Holocaust Center of Southwest Florida.

Prince's work "I Bless the Day" was published in the *Oral History Review Journal of the Oral History Association* [*Oral History Review Journal* 29, no. 2 (Summer/Fall 2002): 79–81]. *Ain't But a Place*, an anthology of African American writings about St. Louis edited by Gerald Early and published by the Missouri Historical Society, includes an excerpt from her interview with Demosthenes DuBose. Excerpts from interviews with DuBose, Salimah Jones and Pearl Shanks appeared in *Gateway Heritage*, the Missouri Historical Society publication [*Gateway Heritage* vol. 17, no. 4 (Spring 1997): 14–29].

A plaque on the wall of the museum library where Prince spent countless hours researching the archives notes Martin Luther King's speech there in 1960 before two thousand persons.

Visit us at
www.historypress.net